Los Angeles

Neon

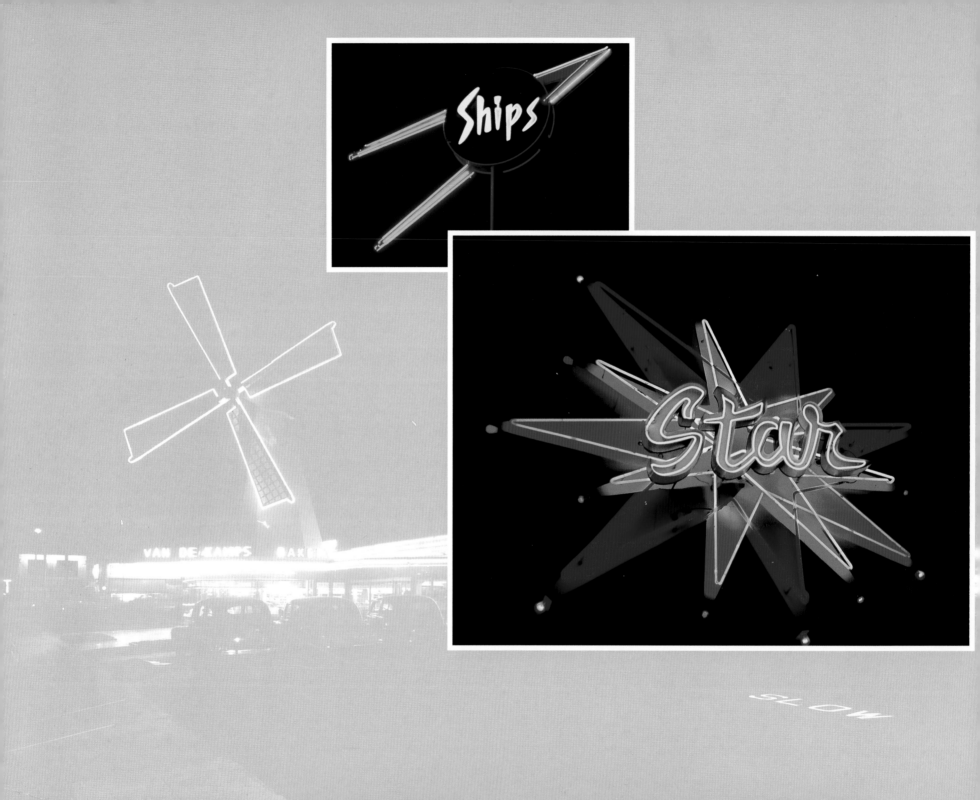

Los Angeles Neon

Neon

Schiffer Publishing Ltd

4880 Lower Valley Road, Atglen, PA 19310 USA

Nathan Marsak and Nigel Cox

Designed by Bonnie M. Hensley
Cover design by Bruce M. Waters
Type set in LasVegasD/Zurich BT

ISBN: 0-7643-1542-0
Printed in China

Published by Schiffer Publishing Ltd.
4880 Lower Valley Road
Atglen, PA 19310
Phone: (610) 593-1777; Fax: (610) 593-2002
E-mail: Schifferbk@aol.com
Please visit our web site catalog at **www.schifferbooks.com**
We are always looking for people to write books on new and related subjects. If you have an idea for a book, please contact us at the above address.

This book may be purchased from the publisher.
Include $3.95 for shipping. Please try your bookstore first.
You may write for a free catalog.

In Europe, Schiffer books are distributed by
Bushwood Books
6 Marksbury Ave. Kew Gardens
Surrey TW9 4JF England
Phone: 44 (0)20 8392-8585; Fax: 44 (0)20 8392-9876
E-mail: Bushwd@aol.com
Free postage in the UK. Europe: air mail at cost.
Please try your bookstore first.

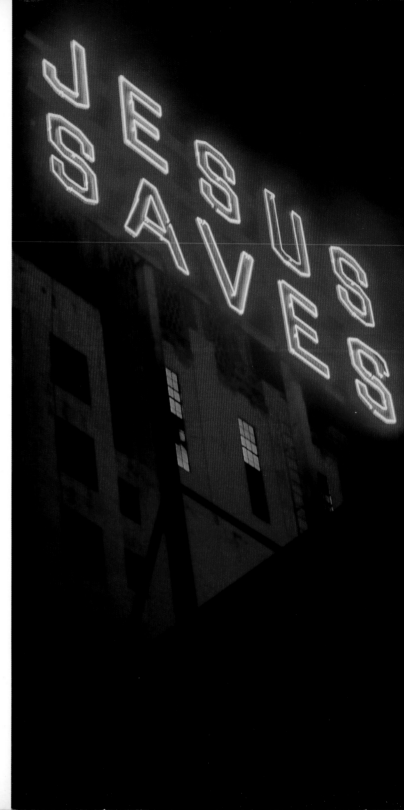

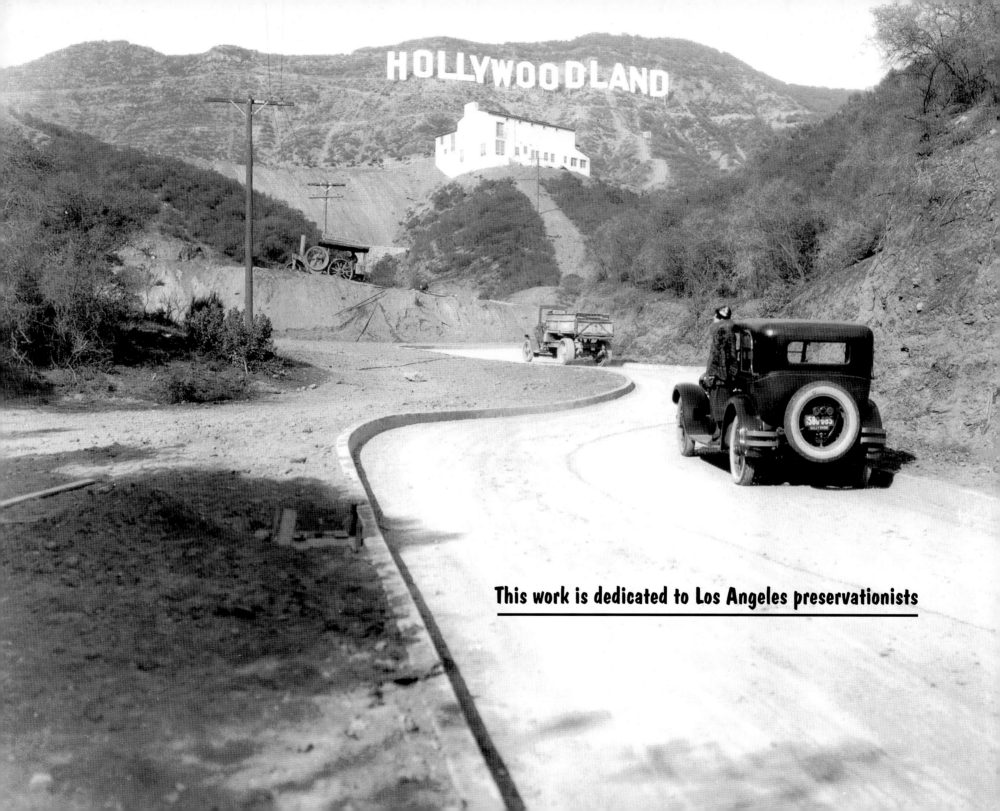

This work is dedicated to Los Angeles preservationists

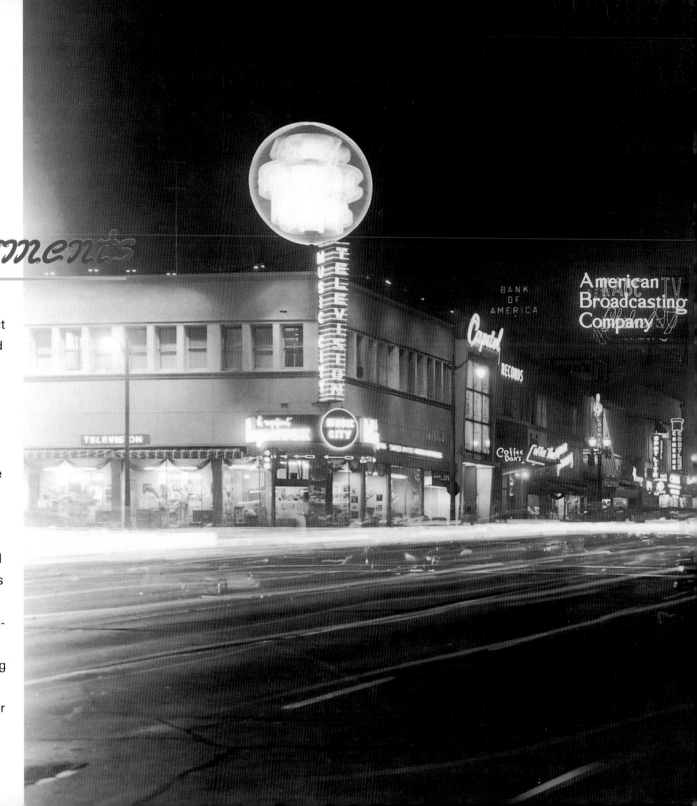

Acknowledgments

Invaluable to the fulfillment of this project were: Scott King, Kim Koga (and all the good folks at the Museum of Neon Art), Leonard and Ann Marsak, James McDemas, Morgan Neville, Lara Jo Regan, Richard Schave, Rob at The Icon, and Dr. Jetta Tarr. Heartfelt gratitude goes out to Carolyn Cole, John English, Scott Hopper, J. Eric Lynxwiler, Jane Newall, Chris Nichols, Daniel Paul, Charles Phoenix, and Dace Taub for their selfless contributions of time and materials to the book. Photographers Larry Lytle and Michael Burke also went out of their way to make this undertaking a reality. We also thank the innumerable shop owners and neon aficionados whom we've encountered during our travels and travails across Los Angeles during the preparation of this book. And special thanks to Nathan's former professors, Reyner Banham and Narciso Menocal.

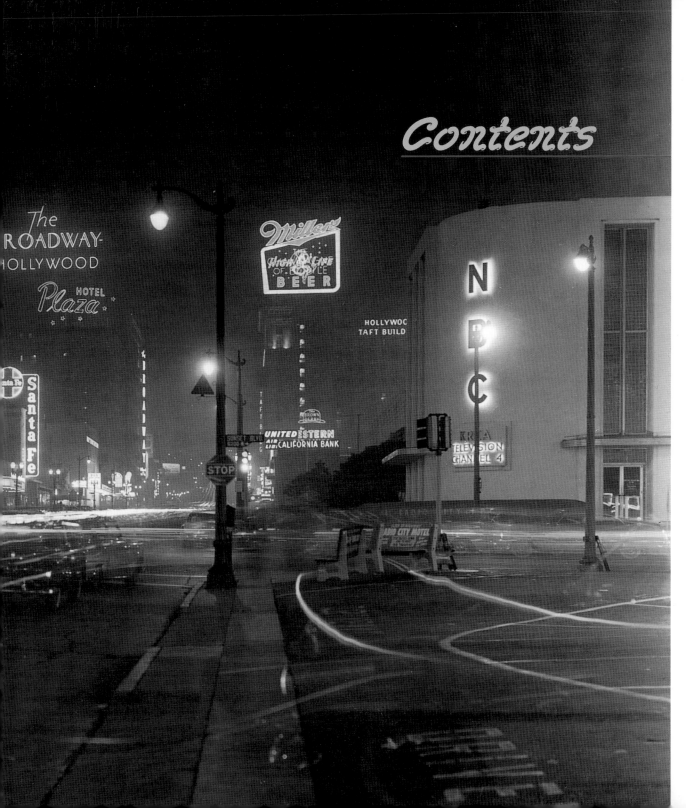

Contents

It was 1993, and I was living in the Midwest. I'd completed my schooling. Money was short. There were no job prospects. Where to? I took the course of action most fundamentally ingrained in American culture: I went West. Wagons ho, if you will. What else does one do when the passion for reinvention raises its ugly head? You begin that great migration, directed by Manifest Destiny, in search of permanence and a place to put down roots. And you end up in Los Angeles, an ephemeral world. That's where you stop because once you hit L.A., for better or for worse, there's nowhere left to go.

I made it into town late one afternoon, the blinding sun sinking beneath the horizon. As the glare of the sun faded, the lights of the city grew and burst into a whirlwind of signage. The City of Angels, which coalesced around the automobile, was vying for *my* attention. Signs that beckoned, signs that screamed. Some were silent, dead shadows of their former selves. Some were recently relit—bright and shiny (but still fundamentally threatened, like an actor fresh out of rehab).

Everywhere I went, there were new treasures to be glimpsed (and near-accidents to be had, as I halted in traffic to gape at a neon sombrero or some such). Signs atop other signs. Signs that bespoke a history of shifting class and ethnic demographics. The story of Los Angeles right there, waiting to be unraveled by the urban archaeologist. Meanwhile, signs were vanishing left and right. Many shop owners didn't see fit to do anything with these pieces of our past other than cut them up and toss them in the dumpster.

I wasn't surprised to learn that the first neon signs in America came straight to Los Angeles. These signs, now lost, advertised a Packard dealership (as a Packard owner myself, I was doubly pleased). Those signs started a landslide. Neon began to overtake the nightscape of Los Angeles, leaving it awash in magical, lyrical tubes infused with noble gasses, competing with each other to delight the eye. Neon is of course the granddaddy of the sign-lover's cadre, but I would stumble repeatedly onto earlier incandescent signs and even began to appreciate the (gasp!) backlit plastic signs of the 1960s and 70s.

Besides the neon pole signs and movie marquees, I was shocked by the wonderland of painted awnings, murals, and company logos that oozed with historic and aesthetic importance. "Ghost signs" were everywhere––faded paint on brick, advertising five dollar furnished rooms and defunct liquor companies. Buildings were signs in and of themselves: a hot dog stand shaped like a giant hot dog, for example. Of course, in true Los Angeles style, the giant tamale had become the establishment of an Asian manicurist; the camera-shaped storefront, a Mexican restaurant; and a giant donut had been reborn as a giant bagel.

Nathan Marsak

Los Angeles, 2002

Preface

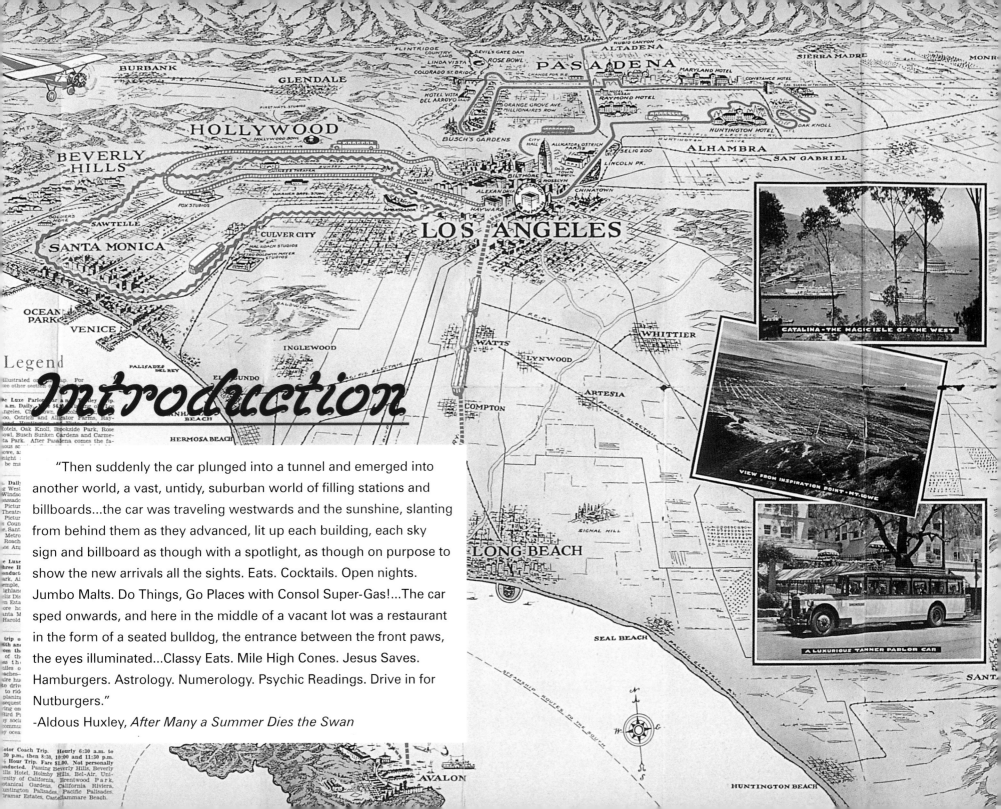

Introduction

"Then suddenly the car plunged into a tunnel and emerged into another world, a vast, untidy, suburban world of filling stations and billboards...the car was traveling westwards and the sunshine, slanting from behind them as they advanced, lit up each building, each sky sign and billboard as though with a spotlight, as though on purpose to show the new arrivals all the sights. Eats. Cocktails. Open nights. Jumbo Malts. Do Things, Go Places with Consol Super-Gas!...The car sped onwards, and here in the middle of a vacant lot was a restaurant in the form of a seated bulldog, the entrance between the front paws, the eyes illuminated...Classy Eats. Mile High Cones. Jesus Saves. Hamburgers. Astrology. Numerology. Psychic Readings. Drive in for Nutburgers."

-Aldous Huxley, *After Many a Summer Dies the Swan*

Los Angeles has always been about symbols. The city is ripe and rife with symbols—sex symbols, status symbols—and every tattoo and pointless car accessory is signage. People love their advertising here, and every t-shirt is a little billboard with which to advertise how unimaginative one is. The printed t-shirt is, of course, a Los Angeles invention, a children's novelty borne of the early television days of Roy Rogers and Davy Crocket. The printed tee's initial boom of popularity was courtesy of LA car customizer Big Daddy Roth's mid-'60s "Weird-Oh" Rat Fink series.

Los Angeles is full of other signage firsts. It was E. Joseph Cossman, the famous gag and novelty distributor, who began adding weekly epigrams to the sign outside his Hollywood office, e.g. "A friend is a gold link in the chain of life" and so on. He wrote thousands of faux Confucianisms, and the idea spread to churches ("Give Satan an Inch and He'll Become a Ruler") and anyplace else with a sign having movable letters, thereby allowing businesses an outlet for homespun wit and wisdom.

There's precious little escape from signage in Los Angeles. It would seem that ever since the erection of the Hollywoodland sign, we've been awash in signage public and private, from the great neon rooftop crowns, to personalized license plates, to Liberace's piano-bedecked tomb at Forest Lawn. Some even believe that graffiti is a piece of living Los Angeles signage; cooler heads disagree.

One could argue the nature of signage for an eternity, but at the end of the day, we all want to see an animated neon dachshund wagging his tail while reclining in a hot dog bun. Too many signs disappear every single day, victims of ignorance and cultural terrorism. Even when a threatened building is saved by preservationists, oftentimes the sign is not included in the building's adaptive reuse. Sometimes all it takes is one customer chatting up a shop owner about the "cool sign" to save it. Preserving signs won't put sign companies out of business—with L.A. adding the size of *two* Chicagos to its population in the next fifty years, there will be more than enough work for the sign manufacturers.

This book is not intended for the sign enthusiast alone, but also for the student of Los Angeles. For a city with purportedly "no history," L.A.'s past lives on despite those who deride it. A large part of this town's life can be told through her signage and images of her signage. But it takes too much exposition to feature a photo of, say, the Dodger Stadium parking lot sign, and remark "what this sign *really* says is 'welcome to the site of a mass expulsion of L.A.'s working class, who were promised the Neutra-designed Rose Hills low-cost housing project in return, only

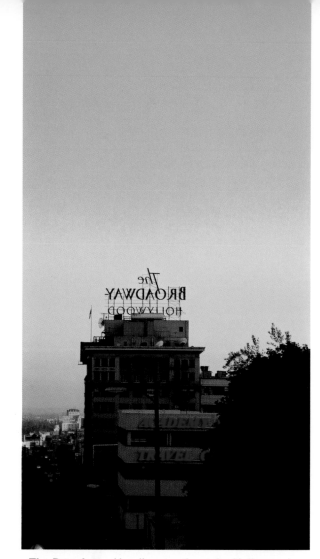

The Broadway. Heading south on the Hollywood Freeway. Your first time into Los Angeles. But you're not there yet. The Valley sprawls out for an eternity. Finally, you head through that L. A. stretch of hills. The exit names suddenly have a familiar ring: Cahuenga, Vine. Round the long curve, and there before you is your first vista of the City of Angels: the Broadway Hollywood sign, its mighty back turned to you with stylish insouciance. Maybe it's a warning from this teeming metropolis: Don't expect me to take notice of you. But maybe, you think, it's an invitation: If you want to get to know me, you'll have to try harder than that. *Photo by Nigel Cox.*

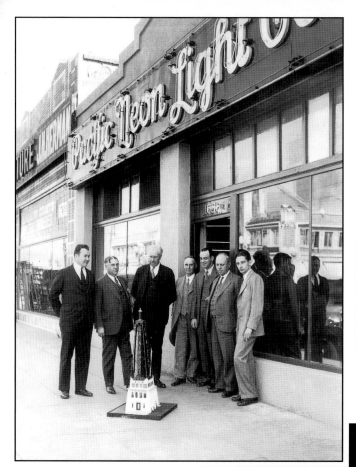

to be sold out by the city, who instead built this.'" After all, there are no signs that read "Zoot Suit Riots Welcome" or "Please Dump Black Dahlias Here" or "Garden of Allah (where Hollywood's great writers and actors used to live and play) Memorial Mini-Mall."

Therefore her signs—what are left of them—are important. Old-school Angelenos will recognize many; newer transplants and those just visiting should seek out the city's remaining treasures. Los Angeles may indeed tend to destroy her past and reinvent her future—but maybe this is what draws us to her. She doesn't whine or shriek to beckon us. Los Angeles instead entices us with whispers of a lost, strange, and magical disappearing world.

Pacific Neon Light Company. Here, the gents of Pacific Neon Light Corp. show off their plans to electrify the tower of the Los Angeles Airport to city councilmen, June 1928. *Photo courtesy Herald Examiner Collection/Los Angeles Public Library*

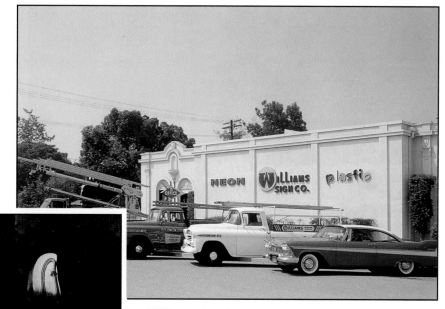

Williams Sign Company. The oldest remaining sign company in Los Angeles, the Pomona establishment been family-run since 1937. *Courtesy of Charles Phoenix*

Neon Terrier. Neon craftsmanship blossomed in the 1930s. This little doggie was born in 1936. By 1940 there were over thirty shops dedicated to neon sign making, including Luminart, Electro-Lite and TruAd. *Courtesy of University of Southern California, on behalf of the USC Specialized Libraries and Archival Collections*

Bigger, Better, Brighter

Los Angeles, the world of possibility. Los Angeles, a wonderland of fantasy. Generations before Las Vegas (another creation of Angelenos) there was Los Angeles, a big, strange, wonderful world that made little sense but delighted the eye. Thomas Alva Edison can be seen as an honorary Angeleno—although deaf and totally unschooled, he sought to make the world brighter, faster, noisier. Between inventing the moving pictures and the record player, which were to aid in LA's genesis into the hellish megalopolis it is today, he invented the incandescent bulb.

Before the incandescent bulb, advertising consisted of simple images, á la primitive cave painting—image of a trussed hog represented a trussed hog, also to be read as "yummy." Such sign language was common currency, and common courtesy to the illiterate. But the incandescent bulb came on the scene to make life showier, splashier, more wondrous.

From the oughts to the mid-Twenties, Los Angeles was replete with animated, multicolored billboards that replicated the explosion of fireworks, the soaring cadence of an eagle's wings, and bowlers who rolled perpetual strikes to the astonishment and envy of all and sundry. Yet with the introduction of neon, these pieces were instantly dated, replaced and destroyed as style dictated. Few have survived the decades, and those that have rarely receive the respect their art form and construction deserve.

While few and far between, the remaining incandescent rooftop crowns and "spectaculars" in Los Angeles have been or are being restored. LA officially constitutes the largest remaining arena for this type of

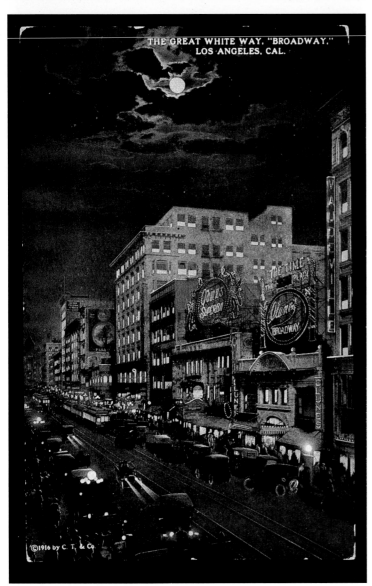

THE GREAT WHITE WAY, "BROADWAY."
LOS·ANGELES, CAL.

©1916 by C. T. & Co.

Courtesy of J. Eric Lynxwiler

signage, although sadly even those that have been restored quickly fall into disrepair at the hands of misers and miscreants—those who see no worth or value in our shared cultural heritage.

Another type of signage to be routinely murdered is programmatic architecture, that type of building wherein the building itself is the sign—a subject covered extensively in Jim Heimann's seminal *California Crazy*. Before the advent of neon, Angelenos were loony for buildings shaped like zeppelins, chili bowls, and barnyard animals, as was their right. The roadside vernacular also included billboards, paint on brick, and porcelain signs swinging in the wind—such was the world of the Angeleno before neon took center stage.

Boston Market. Before buildings were built to resemble giant cows, the gents at Boston Market saw fit to simply paint a bull's head on their signage. They are here seen standing before their establishment at the southeast corner of Spring and Fifth Streets, now the site of a contemporary high-rise. *Photo Collection /Los Angeles Public Library*

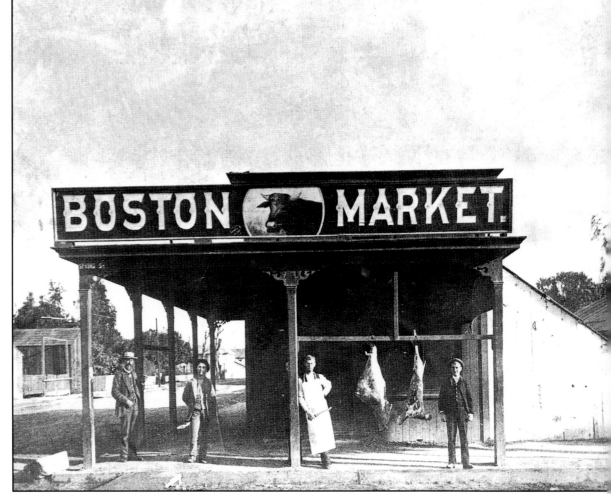

BOSTON MARKET.

The Dog Café. A piece of programmatic history, once down on West Washington, lives on in a Silverlake miniature golf course. *Photo by Nigel Cox*

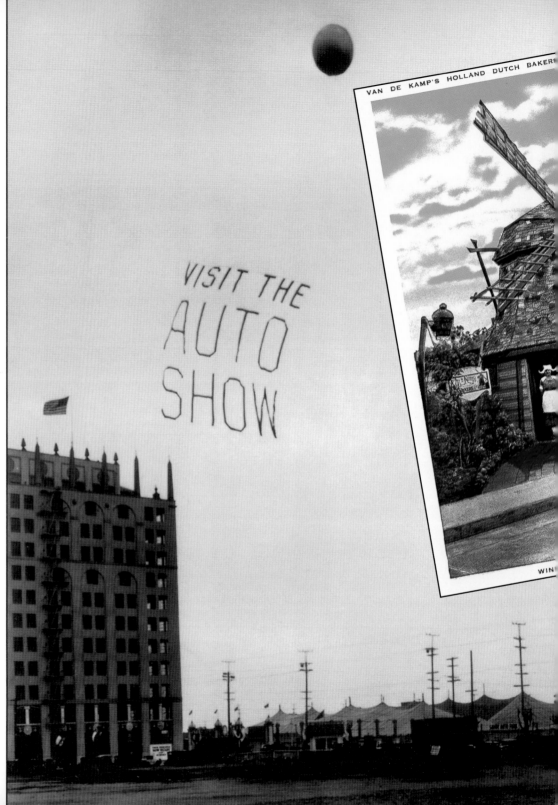

Visit the Auto Show. Predating the days of illuminated dirigibles, and the dreaded "aero-plane" routinely pulling banners like so much excrescence, simple balloons held signs aloft for the populace of our low-rise city. Was the irony of an air-based advertisement plugging a ground-based method of transportation lost on anyone in 1915? *Photo Collection /Los Angeles Public Library*

Van de Kamp's. Windmills were almost as ubiquitous as oil derricks in early Los Angeles. Van de Kamp's Holland Dutch Bakers were spread across Southern California, and while windmill bakeries like these (circa 1930) were comparatively rare, the tradition lived on in the neon spinning windmills of the '40s. *Authors' collection.*

RE NO. 1

Despite their common reputation as gentleman in diminutive automobiles, the Shriners are an extremely sophisticated group who, during the nascent days of urban electrification, went over the top to spread their good works. The Western Shrine opened in Los Angeles in 1906, and soon the Shriners and the Studios went hand in hand––Harold Lloyd was Leader of the Western Shrine. Daryl Zanuck was a higher-up. Cowboy actors had a particular affinity: John Wayne, Gene Autry, Buck Jones, Tom Mix, and Roy Rogers. Glenn Ford and Ernest Borgnine are still active members. The electrical parades were their hallmark, but these were bested by the likes of Walt Disney in the fifties, and Shriner electrical parades fell in importance compared to their work with children's hospitals.

In 1907 the Shriners had surmounted downtown's Broadway with a giant incandescent fez. A thousand red and green bulbs spider webbed the edifice with the moral injunction "Don't Worry," speaking volumes to the citizens below. The Elks followed suit in 1909 with a giant electrified paean to their mascot. In these postcards, from a Shriner Electrical Parade, are "The Stork" and "Castle

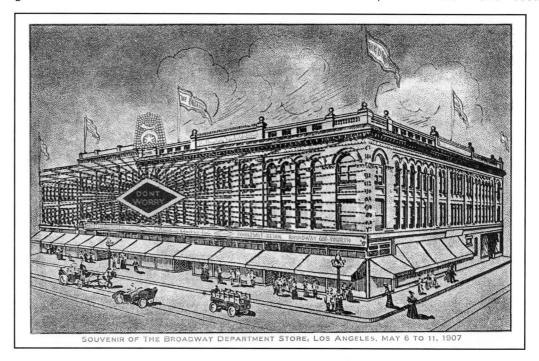

SOUVENIR OF THE BROADWAY DEPARTMENT STORE, LOS ANGELES, MAY 6 TO 11, 1907

in the Air." Such was the high point of the 1912 social season in Los Angeles. The Stork is busy mystifying youngsters about childbirth; the Castle in the Air is roughly analogous to the Heavenly Jerusalem spoken of in Revelation.

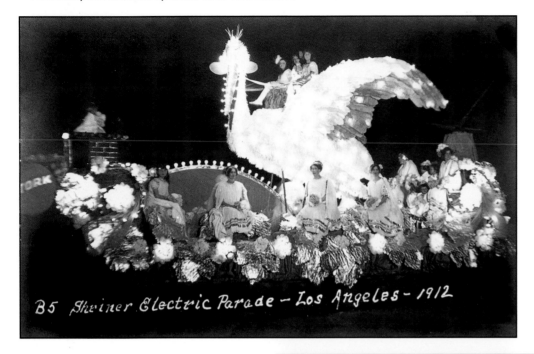

B5 Shriner Electric Parade – Los Angeles – 1912

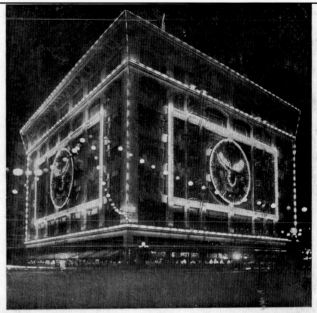

Bullock's
Broadway at Seventh

Elks Reunion, Los Angeles, Cal.
July 11 to 17, 1909

Bullock's 1909. The Shriners weren't the only fraternity to be heralded by Los Angeles. Here, the Elks are ostentatiously welcomed to town. *Authors' collection*

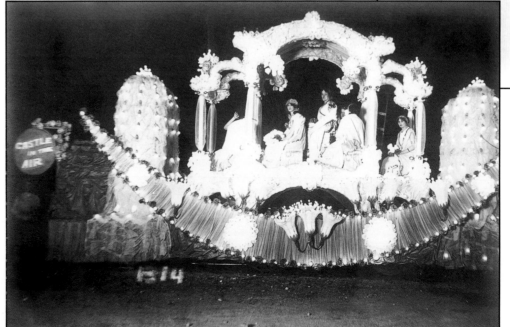

Tally's Theater. Thomas L. Tally became L. A.'s first motion picture exhibitor in 1896 with his Kinetoscope and Vitascope parlors, and then opened the first proper picture-house, the Electric Theater, in 1902. Tally went on to open the New Broadway, which featured this remarkable incandescent which most likely was animated to flash bulbs up and down to the star. Here, patrons mill about between showings of 1911's *Roosevelt in Africa*. *Courtesy of University of Southern California, on behalf of the USC Specialized Libraries and Archival Collections*

Below
Samuel Goldwyn Studio Float. This rolling electrified yacht delighted thousands as ploughed its way up Broadway during the "L. A. Fiesta de Los Angeles Billion Dollar Electrical Pageant" in 1931. *Authors' collection.*

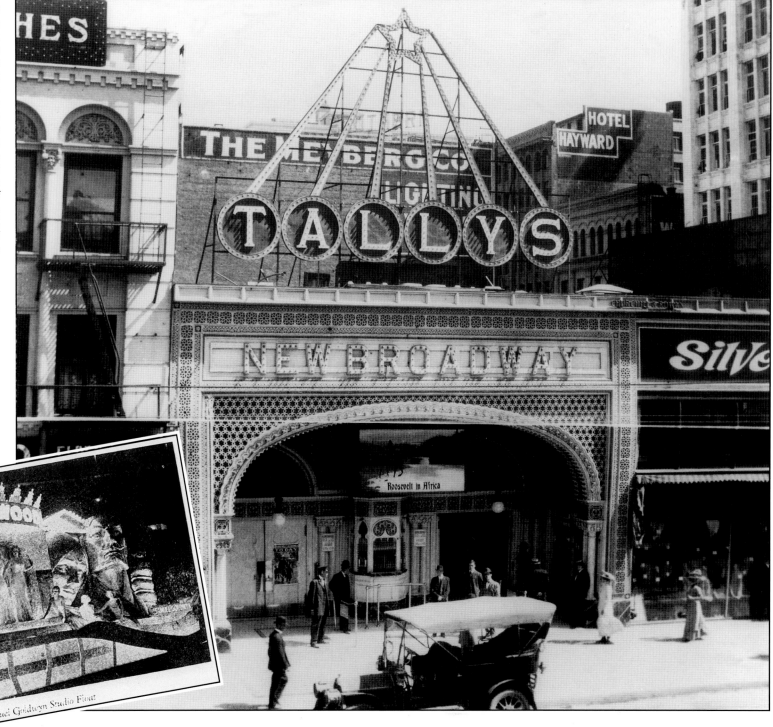

Samuel Goldwyn Studio Float

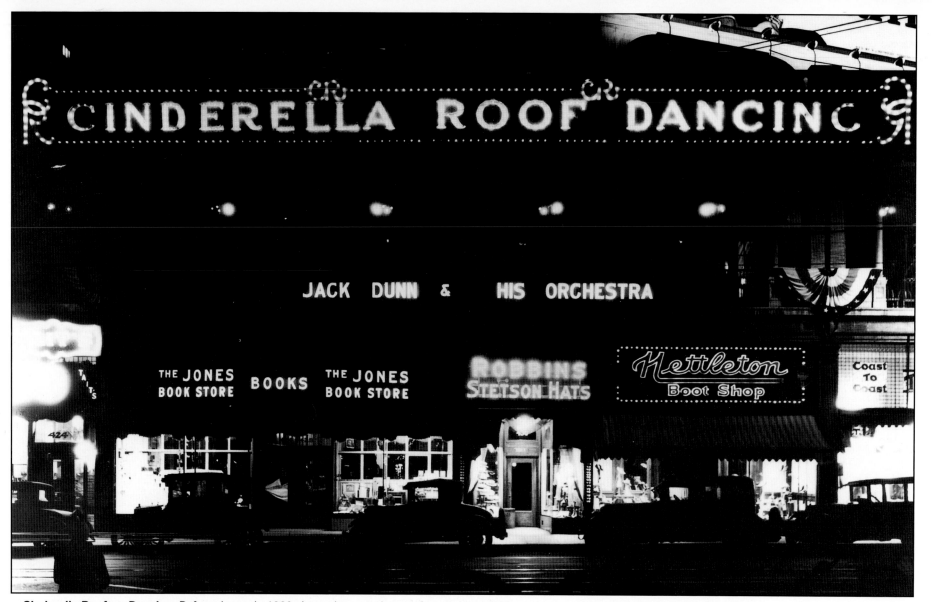

Cinderella Rooftop Dancing. Before the early 1920s incandescent signage focused its blinkless electron eye on the city below, beckoning patrons to a smoky, decadent whirlwind of dance, chance and romance. Those on the roof were one with the sign, peering out on the teeming city. *Courtesy of University of Southern California, on behalf of the USC Specialized Libraries and Archival Collections*

Opposite page
Bottom left: **Foster and Kleiser.** The Pashgian billboard is one of the last, if not the last, Foster & Kleiser billboards left in Los Angeles. It itself may not be long for this world, since the Pashgians—who also have wonderful neon over their entryway—are revamping their signage. *Photo by Nathan Marsak*

Right: **Incandescent Examiner.** William Randolph Hearst started the Examiner in 1903 as a voice for his anti-union rhetoric. His Examiner Building was known for its incandescent rooftop crown and American flags; in this photo, circa 1910, a large Shriner's symbol welcomes the fraternity to town. All this electrified wonderment disappeared when the Examiner moved into the Julia Morgan (of Hearst Castle fame) designed Examiner building in 1915. *Courtesy of University of Southern California, on behalf of the USC Specialized Libraries and Archival Collections*

Auto Park. Animated spectaculars are just that, but of course are not representative of the more everyday signage as it existed in L. A. before the mid-1920s. Whither the poor incandescent sign of lowly heritage, that common denominator that simply says "I have persevered" without benefit of exploding stars and stroboscopic bewonderment? Here, in the parking lot behind Sid Grauman's 1922 Egyptian Theater, sits this noble warrior, stalwart in the face of the decades. The Egyptian recently went through a major restoration, but apparently this humble sign was deemed unworthy of such attention. *Photo by Nigel Cox*

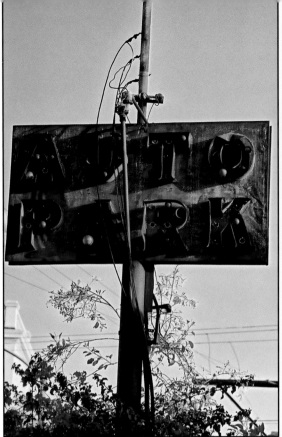

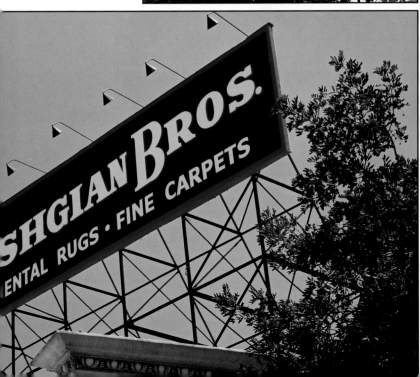

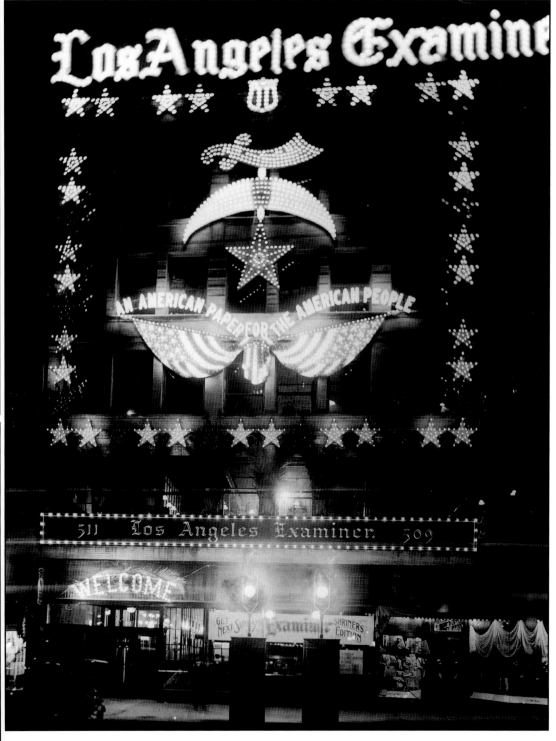

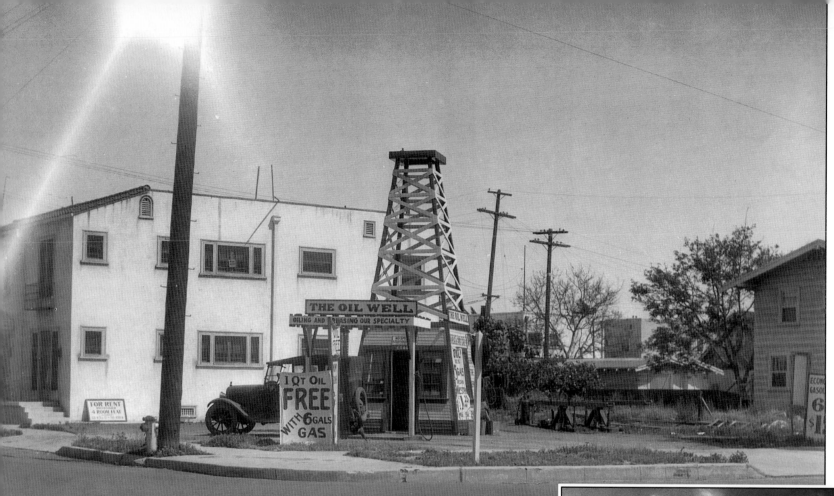

The Ubiquitous Oil Well. Tell a visitor to L. A. that our town is full of angular unconformities, they'll raise an eyebrow but will probably agree. It's true—geophysically, the western edge of the Los Angeles basin is full of subsurface anticlines that stretch from Beverly Hills to Huntington Beach. In layman's terms, underground we've got these arches of rock...which fill with oil. By 1930, L. A. had become a forest of innumerable drilling rigs; at one point, derricks lined Wilshire Boulevard. All the derricks are gone now, although beam-pumping units still bob up and down throughout areas like Dominquez Hill, their grasshopper-like bodies still sucking out what's left of low volume wells (there's even one hidden inside the Beverly Shopping Center). The famous oil fields of Texas and Oklahoma were rural, but derricks were so ubiquitous in urban L. A. they became part of our culture. Sign of the times, symbol of oil culture, call it what you will; made for some nifty programmatic architecture. This L. A. service station is shaped like an oil derrick, circa 1920. *Photo Collection /Los Angeles Public Library.*

Oil Patch Liquor. Vernacular architecture lives! While the oil derrick is long gone, the oil industry is so deeply rooted in the Angeleno's consciousness that another rig sprouted up, in 1976 yet. Oil Patch Liquor, on Signal Hill, is not only crowned with a derrick, but their parking posts are capped with old tri-cone drill bits! *Photo by Nigel Cox*

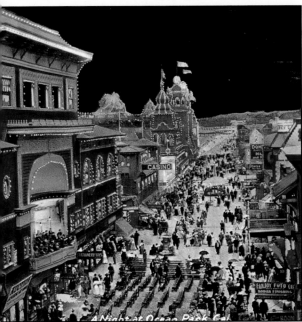

Ocean Park. This incandescent wonderland was intended to rival the likes of New York's Luna Park and Coney Island. Abbot Kinney, who later founded Venice, built the oceanfront promenade intended to dazzle Edwardian America. Most of Ocean Park was demolished in 1975. Ocean Park is best remembered for its depiction in *They Shoot Horses, Don't They? Authors' collection*

Rolling Billboards. Billboards flourished across L. A., although a billboard suffers from its static position, since it can only be viewed by passersby moving in one direction. Aha! The clever gent with something to sell took his billboards on the road, never missing the widened eye of Mr. and Mrs. Los Angeles. *Photo Collection /Los Angeles Public Library*

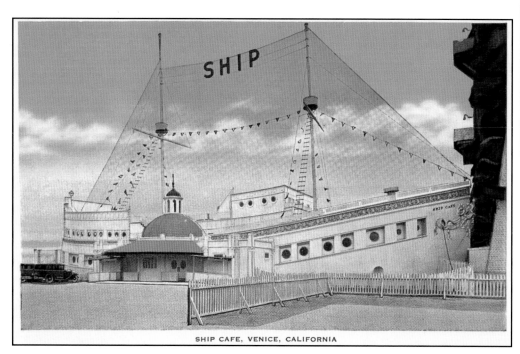

SHIP CAFE, VENICE, CALIFORNIA

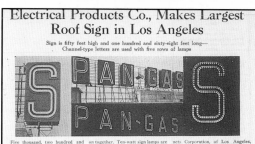

Signs of the Times magazine, September 1925. *Authors' collection*

Electrical Products Co., Makes Largest Roof Sign in Los Angeles

Sign is fifty feet high and one hundred and sixty-eight feet long— Channel-type letters are used with five rows of lamps

Five thousand, two hundred and seventy-seven lamps to illuminate twelve letters is the record set by the Pan Gas sign on the roof of the Pan-American Petroleum Building at Tenth and Flower streets in Los Angeles, shown in this article. This is the largest roof sign in that city, the structure being 50 feet high and 168 feet long. Each letter is 28 feet high, and the sign reads "Pan Gas" on both sides.

The illumination of the sign is very unique. The letters are channel type, illuminated by five rows of lamps, the center row is red, the rows on either side of this are white, and the outside rows are green. The sign flashes first red, then green, then white, and then all the colors come on together. Ten-watt sign lamps are used for illumination and the colors are secured by using Reco color hoods. The Pan-American Petroleum Building is one of the finest structures in Los Angeles and the building has just been completed. It is 150 feet high, which is the height limit of buildings in Los Angeles, and it is built of cut stone, steel and concrete entirely of class "A" construction.

The design of the sign carries out the ideas of E. L. Doheny, chairman of the Board of Directors of the Pan-American Petroleum Company and is the largest electrical advertisement of any petroleum company in the United States. The sign was built and erected by the Electrical Prod-ucts Corporation, of Los Angeles, which is one of the leading electric sign companies on the Pacific coast.

FISCHER RECEIVES CONTRACT FOR SPECIAL FEATURE ELECTRIC

Frank H. Fischer, Atlantic City, N. J., has secured a contract to erect a huge electric sign for the Atlantic City Electric Company. This sign will contain a feature which no other sign now contains and that is a track around the entire structure for the second line of lettering, so that the from the storage rack to their respective places on the face of the sign with very little difficulty. The idea is to change the copy on the sign weekly.

Each letter is backed up with a solid panel, making it as readable during the day as at night. The sign will be 45 feet high and 105 feet long, and will face all railroads and the principal highways leading to Atlantic City.

The Ship Café. Purported to be the SS Cabrillo, "permanently" docked at Venice Beach, this vessel was in fact, built into the pier, and not long for the world. Despite it being the home of the local Lion's Club, the city demolished the "boat" and the pier to which it was attached after illegally wresting land from the family of Abbot Kinney. *Authors' collection*

The Lankershim. "The City of the Future" has been rendered repeatedly and with great enthusiasm over the course of human history, but never more so than during the machine-age heyday of the Twentieth Century's early years. Impossibly high structures, streamlined bridges connecting buildings, and a sky thick with aeroplanes and dirigibles were the basis of visionary urbanism. There are two important hallmarks of technological utopianism from this period: they usually picture a futuristic New York, and they never, ever feature any signage of any sort whatsoever. The famous 1920s renderings produced by Hugh Ferriss or Harvey Wiley Corbett, or even the giant model of "New York 1980"——built by Fox in 1930 for the "first science-fiction musical" *Just Imagine*——envisage a future without signage. Even early on, in 1908 and again in 1910, did popular futurist Moses King depict "New York of 1930" as a frenzied Cosmopolis...without signage.

But New York can have her de-signaged future. In this 1909 postcard, The Lankershim—always up to date—has taken over the skies, with giant rooftop crown, advertising on dirigibles, and on their aerial bus transport. The implication is clear: they go to such lengths because, we must assume, the other hotels in the area are competing with bigger and better signage themselves! *Authors' collection*

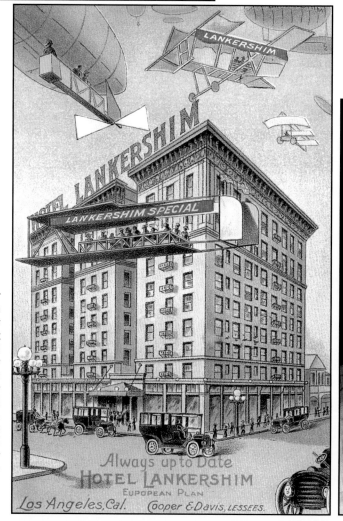

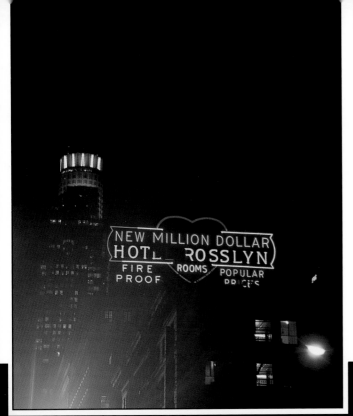

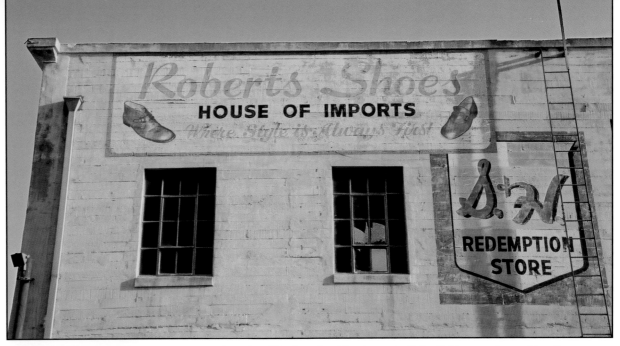

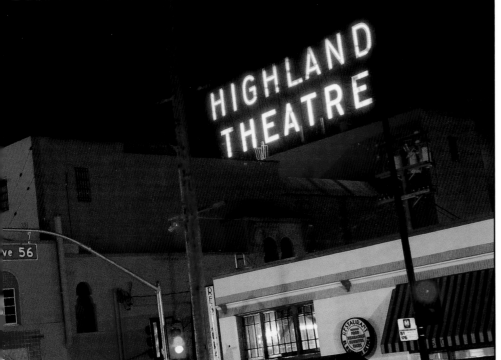

Top left: **The Rosslyn.** The Rosslyn Hotel was built in 1919, complete with a five story, fully incandescent, magnificently verbose rooftop crown. The Hart Brothers (who used an incandescent heart to full effect) expanded and in 1922 built the second Rosslyn, also with grandiose rooftop signage. They fell dark by World War II. In 1999, Al Nodal and Ray Neal restored the signs, although supplanting a good bit of the original incandescents with neon. They were brilliantly lit for six weeks, heart stopping and visible for miles, until the building's current owner decided that the hundred dollars a month to keep them lit was too much, and they have subsequently gone dark once again. *Photo by Nigel Cox*

Bottom left: **Highland Theatre.** Highland Park was, in the first years of the Twentieth Century, like much of L. A.—scrub brush, chaparral, and an uneasy relationship between people and coyotes. But Highland Park soon prospered as L. A.'s first arts community, with art collectors like Charles Lummis patronizing tile manufacturers like Batchelder. The bohemian climes of Highland Park would, of course, need a movie palace; hence Highland Theater. Thanks to the Highland Park Heritage Trust, her 1200 bulbs gleam brilliantly again, after having been dark as the grave for seventy years. "Highland" was originally green—not actually green bulbs, but each bulb was fitted with a green plastic casing through which the light shimmered. *Photo by Nathan Marsak*

Top right: **Robert's Shoes.** Paint on brick has always been the cheapest and easiest way to advertise; as they fade over time they become known as "ghost signs." Because of the relative simplicity of painting them over, they are also some of the rarest. Just during the compilation of this book, three have been painted over before they could be included. One of these was an unbelievable "Nash" wall sign along Brand Boulevard—aka L. A.'s historic "Automobile Row"—in Glendale. The present owner found no charm in the sign, however. "We just bought this place," he said. "That thing on the wall did not matter. It was stupid. And old. It does not matter now anyway that it is gone, we are selling this place." On the seldom seen "backside" of Hollywood Blvd., Robert's Shoes remains. *Photo by Nigel Cox*

23

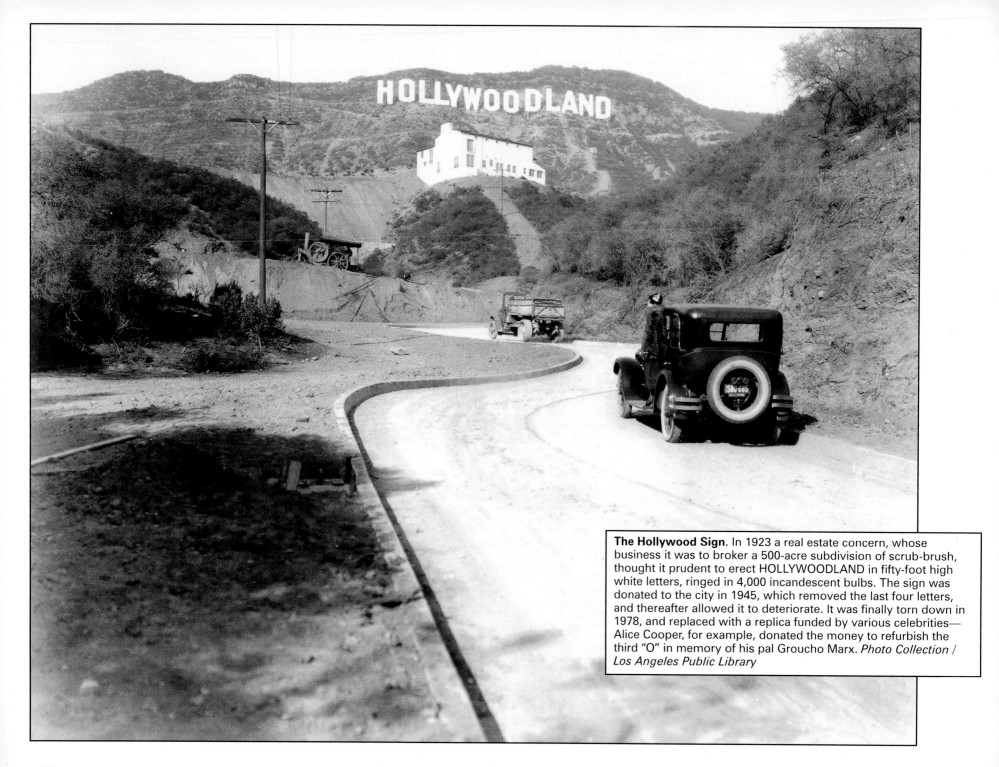

The Hollywood Sign. In 1923 a real estate concern, whose business it was to broker a 500-acre subdivision of scrub-brush, thought it prudent to erect HOLLYWOODLAND in fifty-foot high white letters, ringed in 4,000 incandescent bulbs. The sign was donated to the city in 1945, which removed the last four letters, and thereafter allowed it to deteriorate. It was finally torn down in 1978, and replaced with a replica funded by various celebrities— Alice Cooper, for example, donated the money to refurbish the third "O" in memory of his pal Groucho Marx. *Photo Collection / Los Angeles Public Library*

A Night on the Town

"Hollywood is best seen at night, when countless chromatic signs flash their iridescent pattern of color down the converging lines of their length."
-Ralph D. Cornell, Los Angeles, Preface to a Master Plan, *Pacific Southwest Academy, 1941*

"'I want a very large steak,' she said to Les Godwin in a restaurant on Melrose at eight o'clock that night. 'And before the very large steak I want three drinks. And after the steak I want to go somewhere with very loud music.'"
-Joan Didion, Play It As It Lays

Los Angeles—millions of people, millions of jobs. Desk jobs, driving jobs, people in Hollywood whose jobs are so nebulous even they don't know what they do. But the sun sets, Los Angeles takes a collective shower, the lights come on, and it's time to go *out*.

There's an absurd quantity of things to do at night. Every movie palace, dance hall, bar, and nightclub switches on their signage to draw us inside for the chance of finding love, escape, distraction, and danger. Flashing, blinking, glowing, undulating signage around every corner, from which there is no escape.

New York has Times Square, that concentration of electricity that glows bright like a collapsing star. Los Angeles is such concentration exploded—like a shattering windshield scattering jeweled fragments across the city.

Fly into LAX at night, and from your window seat you sit gape-mouthed at the miles of lights below. Down there, humming away, are more movie marquees and dazzling pleasure domes than you could visit in two lifetimes. The light, the light, the light.

Like the transmogrification of a great electric beast, the world of light shifts and changes. The great be-neoned nightclubs of the past are no longer with us—Ciro's, the Trocadero, the Mocambo, the Earl Carrol, the Cocoanut Grove, all gone. Even the Hollywood Palladium, legendary venue of Benny and Frankie and the Dorseys, is being razed for a housing development. New venues are formed: bars like the Good Luck construct signage reminiscent of the glory days of LA's past. Klieg lights are still trotted out and hauled around town for the openings of Korean nightclubs and Latin movies.

But remember, it's all Hollywood. The floodlit nightscape promises scintillation, but as the Situationists would say, it's the society of the spectacle. Your money runs out, the lights are snapped off, and you're pitched into the Stygian night. Come the morrow the world is ablaze with daylight, you hide in your cubicle at work, waiting for the sun to set. And then, it's back into the strange, luminescent hologram of the Tinseltown night.

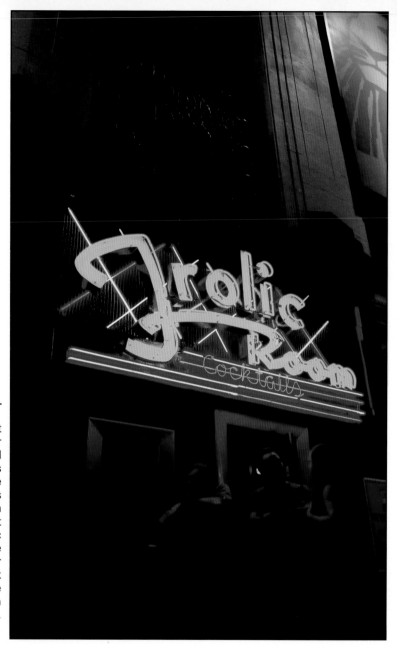

The Frolic Room. This infamous West Coast speakeasy was made part of the Warner theater complex in 1934. Howard Hughes bought, owned and ran the Frolic for the duration of the 1940s and '50s and installed this eye-popping sign. The Hollywood and Vine focal point of serious drinkers and dealmakers for half a century (and a swell movie location, e.g. Kevin Spacey's exit from the Frolic in *L. A. Confidential),* the Frolic Room nearly lost its neon when, in 2000, the Disney Corporation rented the Pantages theater next door, and cited that the signage didn't work with the Disney image. This resulted in some strongly worded letters and bad press, which fortunately convinced The Mouse to back off.
Photo by Nigel Cox.

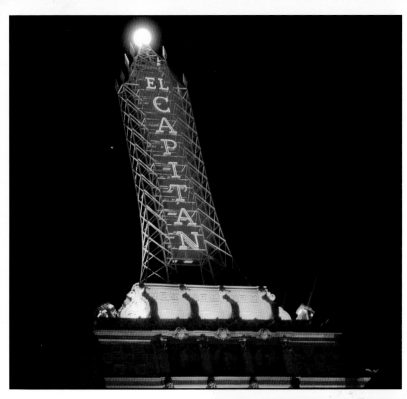

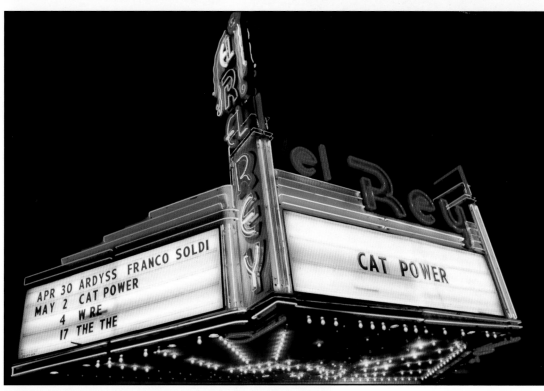

The El Capitan. The El Capitan was a Hollywood Boulevard landmark, a 1926 six-story theater and furniture store with gleaming neon tower that rivaled the Richfield Building downtown. When Hollywood hit the skids in the 1970s, the stores disappeared and the El Cap became the Paramount. The owners had neither the time nor money to tear down the giant tower. It remained, and in the 1990s the El Cap was restored by Disney (who often take over the neighboring Masonic Temple for live accompanying shows), and the tower once again glows fiercely in the night sky. *Photo by Nigel Cox.*

The El Rey. *Photo by Nigel Cox.*

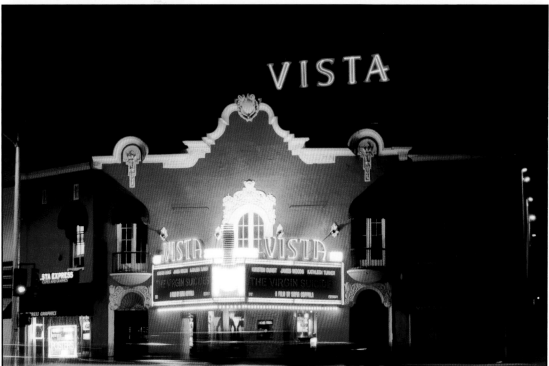

The Vista Theater. Across the street from D. W. Griffith's mammoth soundstages, the Vista opened in 1919. After the discovery of King Tut's tomb in 1922, the Vista remodeled to become L. A.'s *other* Egyptian-themed theater; they added the rooftop sign in the late 1920s and the animated marquee in the 1930s. All went dark for decades as the neighborhood slipped—the Vista became East Hollywood's dingiest porno venue. Refurbished after the 1994 quake, it is now again a first-run movie palace. How else would you want to see *The Mummy Returns*, for example, besides surrounded by thirty-foot mummy cases? *Photo by Nigel Cox*

27

The Many Faces of "The Chinese"

The Chinese Theater is arguably the best known and best loved theater in the world. After Sid Grauman built the Egyptian on Hollywood Boulevard, he moseyed up the street to construct the Chinese. Not only can one loiter in the concrete forecourt and compare hand and foot sizes with the stars of Hollywood's Golden Age, one can see a film in the shockingly cavernous and completely original theater. The 1927 neon blades in the postcard are long gone now, so are the 1950s dragon marquees. These Chinese symbols of luck and fortune were made up of ten separate colors of neon, which blinked in sequence to form the whole *rara avis*.

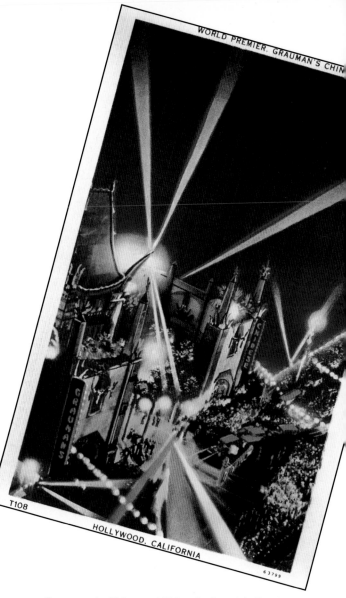

Grauman's Chinese 1920s. *Authors' collection*

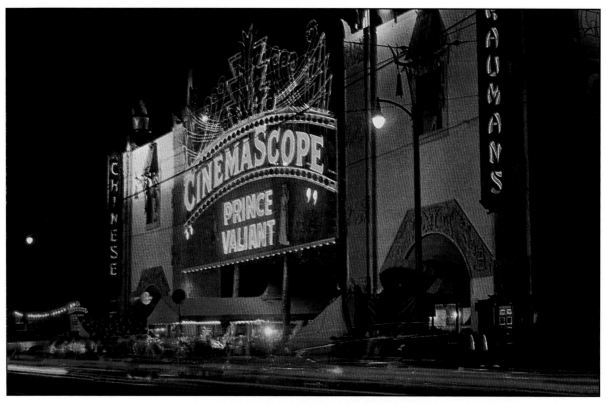

Grauman's Chinese, 1957. *J. Eric Lynxwiler*

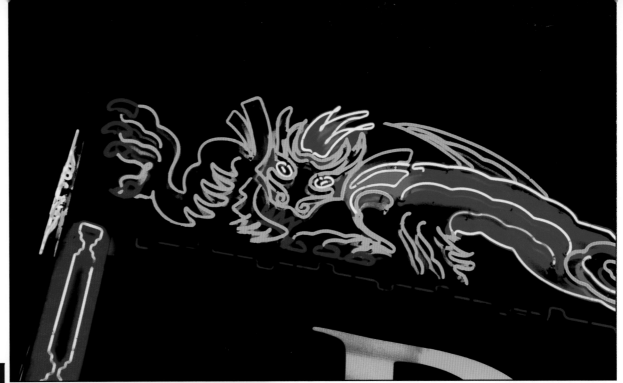

Grauman's 1950s dragons. *Photos by Nigel Cox*

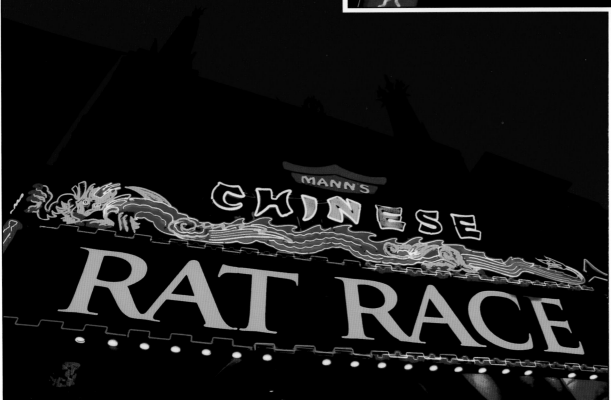

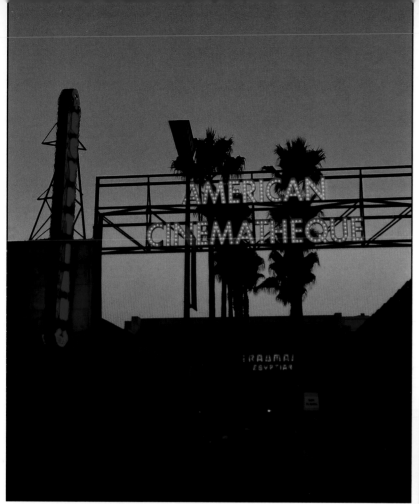

Grauman's Egyptian. Sid, who had built the Million Dollar theater downtown, had a crazy idea: he went into Hollywood to build a motion picture palace. Hollywood in 1922 was still pretty ramshackle, full of bungalows and dirt roads. Grauman conceived The Egyptian, done in the Egypto-proto-deco of those crazy King Tut early 1920s. Back in the day there were mummy cases and cages filled with wild animals. The migration of theaters to Hollywood killed the downtown Broadway district (that, and the postwar flight to suburbs filled with multiplexes). Hollywood was next to fade away: for many years the Egyptian's hieroglyphics were sprayed with stucco and the whole forecourt encased in a canopy. The 1990s are best known for the Egyptian being filled with warring colonies of homeless people and wild cats. The theatre has since been restored by the American Cinematheque, who have correctly recreated the incandescent bulb lighting of the pre-neon era over the doorway, and a large projecting neon blade now snakes down the outside of the building. *Photo by Nigel Cox*

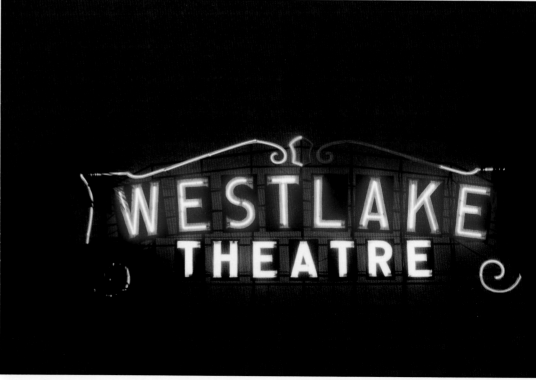

The Westlake Theater. The Westlake Park district was once a fashionable locale for the well to do (the area is still full of magnificent 1890s homes) and so naturally the area needed a spectacular theater. The 1926 Westlake Theater loomed over the grassy expanse, and did brisk business after Wilshire Boulevard sliced through the park in 1934. Its interior was pure 1780s Adam-esque, replete with plaster garlands and urns, coffered ceilings, ornate organ screens, and a gold and ivory lobby. But shifting demographics doomed the park (now renamed MacArthur park), and spelled the end for the Westlake. The inside of the theater is now a flea market, chockablock with tiny cubicles selling socks, cheap electronics and unnamable pork products. The interior still retains some of its original appointments, including an Art Nouveau theater curtain, which proudly proclaims "Asbestos!" The building's marquee is gone, but its mammoth rooftop signage somehow remains, and was relit by Al Nodal and the Cultural Affairs Department. *Photo by Nigel Cox*

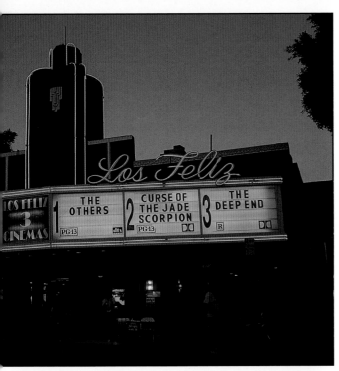

The Los Feliz Three. This is a striking example of neon's ability to accent and accentuate. The white horizontal banding wants to say "streamline moderne" and the vertical neon want to play off the symmetry of the central tower to say "art deco." This is a building to which one listens intently. *Photo by Nigel Cox*

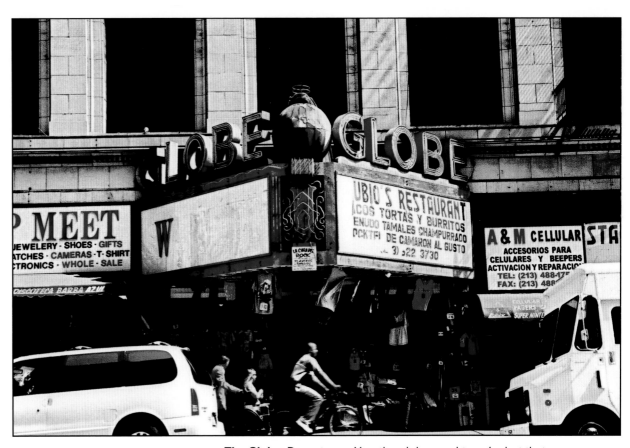

The Globe, Downtown. Yes, the globe used to spin, but that was another time and another world. *Photo by Nathan Marsak*

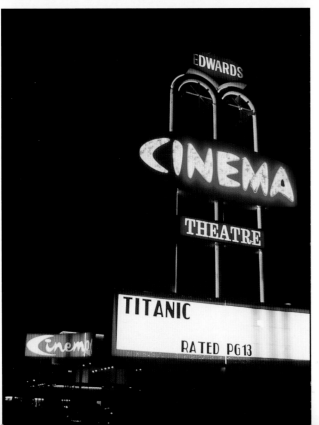

Edwards Cinema. The Edwards, down in Costa Mesa, blazed its fifties signage from on high, and had more wrap-around googie lettering for its marquee. Angelenos would travel into Orange County just to take in the time warp. Edwards has since removed and demolished all of its original signage. *Photo Courtesy Model Colony History Room, Anaheim Public Library*

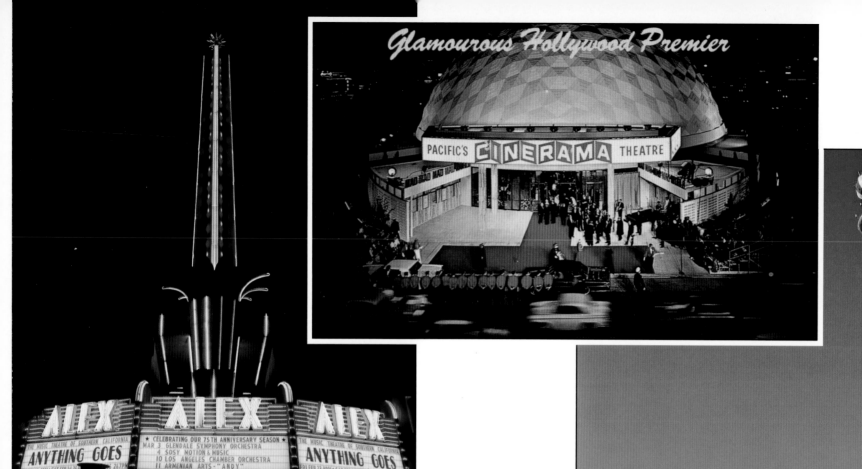

Glamourous Hollywood Premier

The Alex Theatre. While the original Greco-Roman themed theater dates from 1925—the Alex recently threw some lavish 75th anniversary parties—this undulating façade and giant blinking multicolored tower were added in 1939. *Photo by Nigel Cox*

Academy Theater. In 1939 master theatre designer S. Charles Lee outdid himself with this slender swirling agitator that spears the sky from a modern base of curved walls and glass brick. Now a church, still a jaw-dropper. Lee was Beaux-Arts trained, and designed Louis XVI style wonders like the Los Angeles Theater and the Spanish Revival Fox Theater in Bakersfield early in his career. He is known, though, for his legacy of deco and moderne office buildings, bowling alleys and, most notably, theaters, that stretches from Mexico to Central California. Some, like the great Tumbleweed Theater in El Monte, have been torn down, and more recently, the Mayfair Theater in Ventura, in preparation for becoming a swing dance hall, was gutted by fire (although the neon marquee remains), but by and large his work perseveres. *Photo by Nathan Marsak*

32

Opposite page, top center: **Cinerama Dome**. Words fail to describe the majesty of seeing a movie at the Cinerama Dome. There hadn't been a major theater built in Hollywood in 35 years, so in 1963 the Pacific chain decided to build the Best Theater On Earth. The world's only concrete geodesic dome (316 interlocking concrete hexagons) is so acoustically precise that before the picture, when seated in the front row, one can hear the whispers of patrons in the back row crystal-clear. From the back of this postcard: "It is an endless network of electronic marvels. Gold is the dominant color in the richly fabricated carpeting and drapes. Striking innovations in lighting and luxurious seating provide unbelievable comfort and beauty." All true. And very nearly all gone…the Dome is being revamped. It was slated for removal of its signage, its interior destined to be carved up into nine separate screens. Preservationists fought and won the retention of the Dome signage and its curved Cinerama screen, although the interior is being refurbished. While the Dome once rested like a magnificent spaceship having touched down on its own block, it is at present being engulfed by a $70 million three-story entertainment and retail expansion. *Authors' collection*

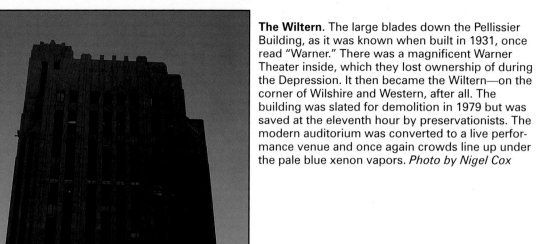

The Wiltern. The large blades down the Pellissier Building, as it was known when built in 1931, once read "Warner." There was a magnificent Warner Theater inside, which they lost ownership of during the Depression. It then became the Wiltern—on the corner of Wilshire and Western, after all. The building was slated for demolition in 1979 but was saved at the eleventh hour by preservationists. The modern auditorium was converted to a live performance venue and once again crowds line up under the pale blue xenon vapors. *Photo by Nigel Cox*

Greetings from Joan Crawford. Joan Crawford was just an MGM second-rater who did twenty pictures before she became a star in 1928's *Our Dancing Daughters*. Here, at the Criterion Theater on 642 South Grand, aka the "House of Hits," Joan decided to upstage the old incandescent signage with a message to her fans, over the marquee advertising her 1930 effort *Paid*. "The most amazing role of her career?" That title would instead go to 1945's *Mildred Pierce*, which is, of course, the greatest movie ever made about Glendale. *Photo Collection /Los Angeles Public Library*

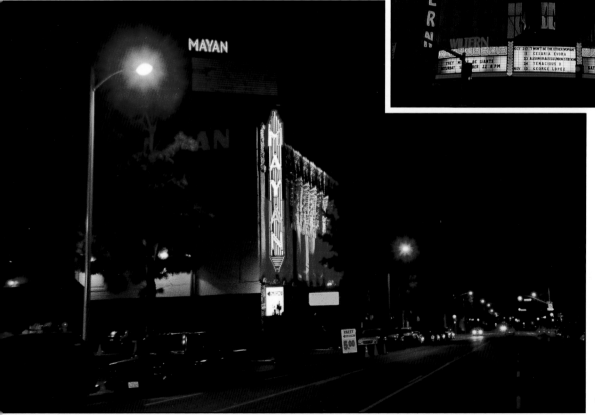

The Mayan. *Photo by Nathan Marsak*

Fox Carthay Circle. *J. Eric Lynxwiler*

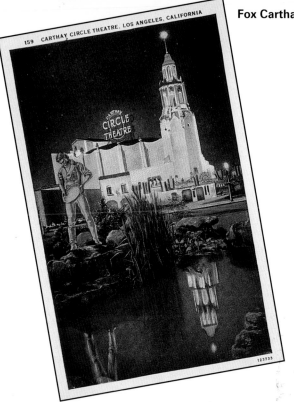

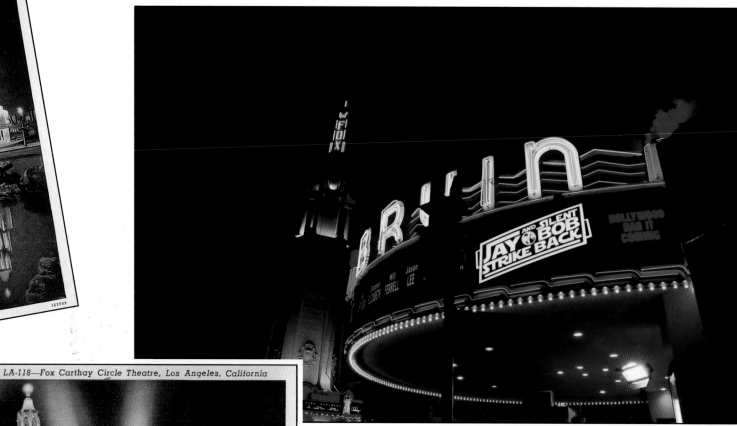

The Fox and The Bruin in Westwood. *Photo by Nigel Cox*

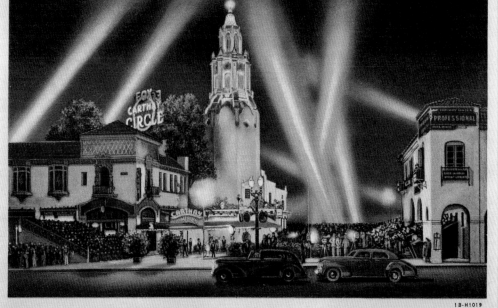

Another View of the Fox Carthay Theater. According to the postcard: "The Carthay Circle Theater in Los Angeles is the home of gala world premieres. Thousands of cheering fans line the streets and stand outside the theatre, and enthusiastically greet the hundreds of illustrious stars who attend." This, while basking in the fires of giant neon and colored lights that illuminated this first-rate Spanish Baroque structure. It opened in 1926 and hosted the lavish premier of *Gone With the Wind*. Even with continued patronage through the 60s, someone decided that the West L. A. landmark was ripe for demolition, because what West L. A. really needed was another uninspired office complex. The entire block, neon and all, was at the bottom of a landfill by 1969. *Authors' collection*

The State. *Photo by Nathan Marsak*

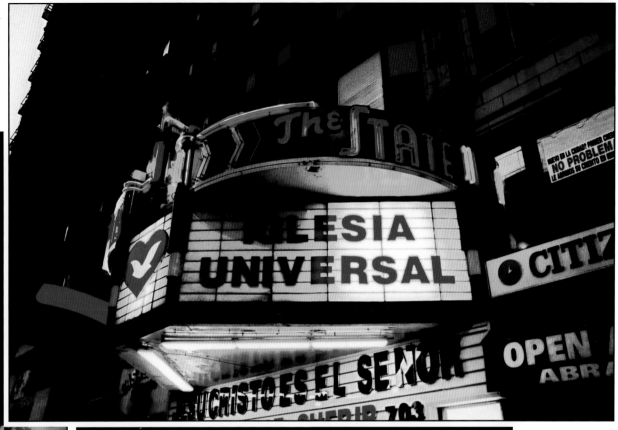

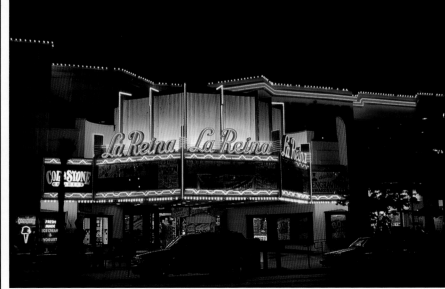

La Reina. This is the Valley's best remaining example of prewar theater, designed by S. Charles Lee in 1940. *Photo by Larry Lytle/ MONA*

The Pantages Theater. This old Hollywood landmark now enjoys a successful run with Disney's patronage. *Photo by Nigel Cox*

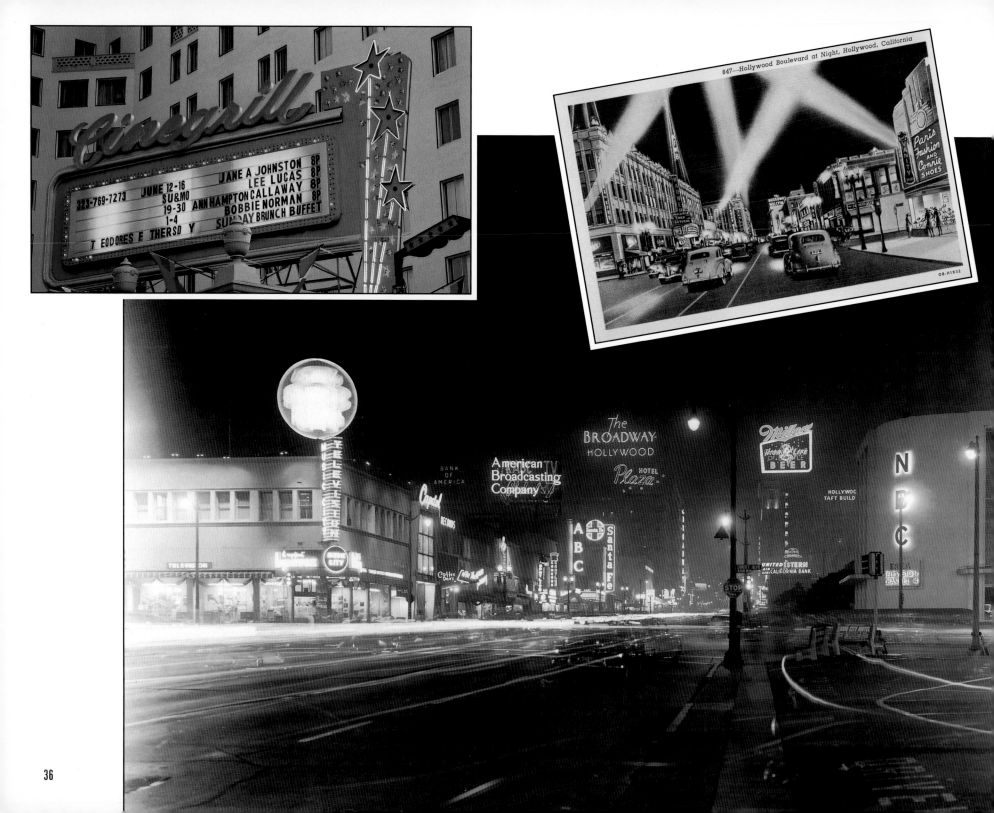

847—Hollywood Boulevard at Night, Hollywood, California

36

Opposite page, top left: **The Cinegrill.** Located in the Hollywood Roosevelt, the Cinegrill opened in 1935 and formerly sported freestanding art deco backlit script over its door. That was deemed unnecessary when the hotel put up this neon beauty in 1957, complete with green animated shooting stars. *Photo by Nigel Cox*

Top right: **Hollywood Boulevard at Night.** "World famed Hollywood Boulevard with its fascinating shops, cafes and theaters, is the main thoroughfare of the motion picture capital. Brilliant at night with colorful lights and blazing searchlights, it is a never ending pageant of celebrated characters of stages, screen and radio." Unfortunately, the "never ending" pageant ended. The KFWB towers have been relit, sort of; they have read "Pacific" since Pacific bought out Warner, and the theater became the Pantages. Those with a sharp eye will note the marquee reads "Invisible Man Returns," which dates this card to 1940. All of the other signage you see is gone. Easter egg colored Klieg lights were not used at the time, but the fact that the postcard company took such a liberty underscores the importance of light in selling the Hollywood dream. *Authors' collection*

Bottom: **Hollywood and Vine.** The night pulsates as we gaze north toward Hollywood and Vine, as it appeared between 1938 and 1955. This stretch has since fallen into blackness. The NBC Studios have been razed to make way for a bank; the Brown Derby is a parking lot; the building harboring the ABC signage (once a bowling alley, then Tom Brenneman's) is burned and gutted; the remaining buildings between Sunset and Selma on that side of the street are now dirt fields awaiting development. The Plaza neon is obstructed by a billboard and the Broadway signage is threatened with demolition— or "renovation" as the developers loosely describe it. The Miller High Life sign disappeared in 1965; ironically, it was neon restorer Ray Neal's first job, at the age of nineteen, to tear down the structure. A billboard stands in its place. *Courtesy of University of Southern California, on behalf of the USC Specialized Libraries and Archival Collections*

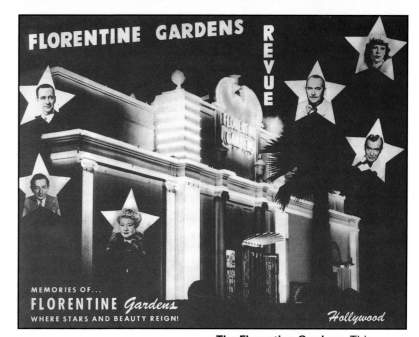

The Florentine Gardens. This building and its name remain, but the signage is long gone. *Authors' collection*

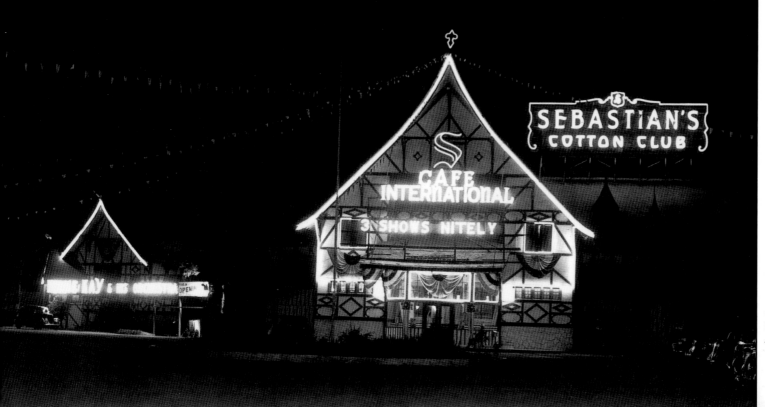

Sebastian's Cotton Club. Once upon a time, this was a Culver City landmark, home of smoky blues and jazz. The Club opened in 1926, quickly becoming a Prohibition Era hotspot. The building burned down in 1948. *Courtesy of University of Southern California, on behalf of the USC Specialized Libraries and Archival Collections*

The Earl Carrol

The Earl Carrol was a wonderland of neon — the word "THEATER" blinked in sequence to read "EAT"..."AT"..."THE"..."THEATER." Besides the giant woman's head, surrounded by the legend "Thru These Portals Pass the Most Beautiful Girls in the World," the interior was bedecked with a huge amount of neon to augment the lavish stage productions. The building later became the Moulin Rouge, with yet more neon; it now serves as the studios for Nickelodeon, and is painted with giant ads for children's television programs.

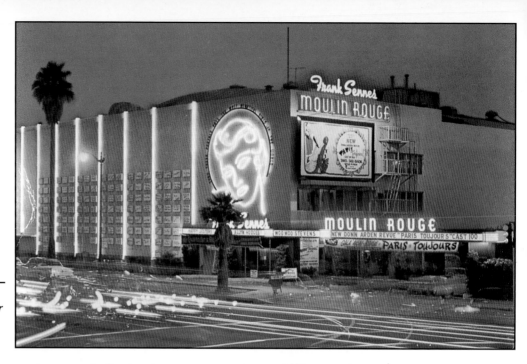

Frank Sennes Moulin Rouge. *Courtesy J. Eric Lynxwiler*

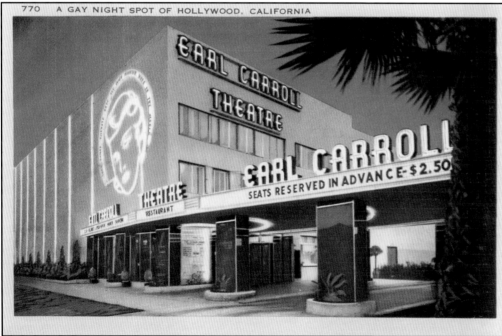

The Earl Carrol. *Authors' collection*

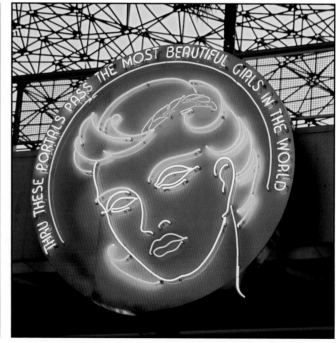

A Reproduction at Citywalk. *Photo by Nigel Cox*

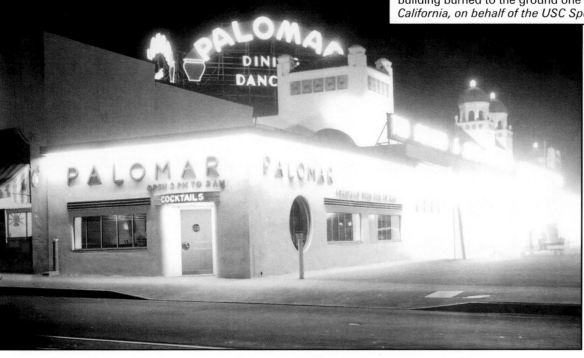

The Palomar. The massive block-long Palomar at Third and Vermont packed 'em in during the thirties, and while its stage was graced by every known big band in America, it is best remembered for making Benny Goodman a star. Its immense neon glowed to the end, right up until the entire building burned to the ground one evening in October 1939. *Courtesy of University of Southern California, on behalf of the USC Specialized Libraries and Archival Collections*

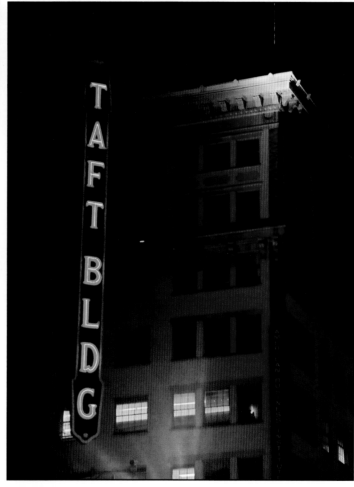

The Taft Building. Recently relit, the Taft is the sole remaining blade neon on Hollywood and Vine. The Broadway and Equitable blades fell victim to the slings and arrows in the 1970s. *Photo by Nigel Cox*

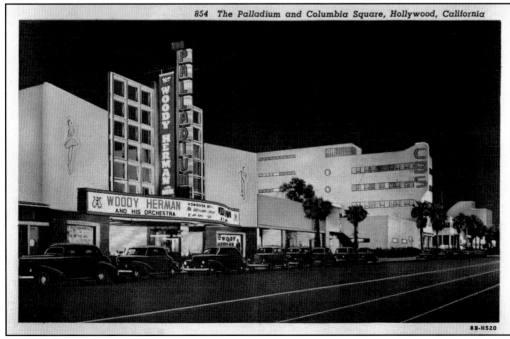

854 *The Palladium and Columbia Square, Hollywood, California*

The Palladium. This remarkable nightclub, home of Frankie and Benny and the Dorseys, had amazing neon dancers and was the center point of Hollywood nightlife. It is soon to be replaced by a low-income housing development. *Authors' collection*

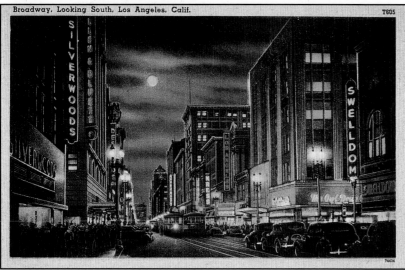

Broadway, Looking South, Los Angeles, Calif. T605

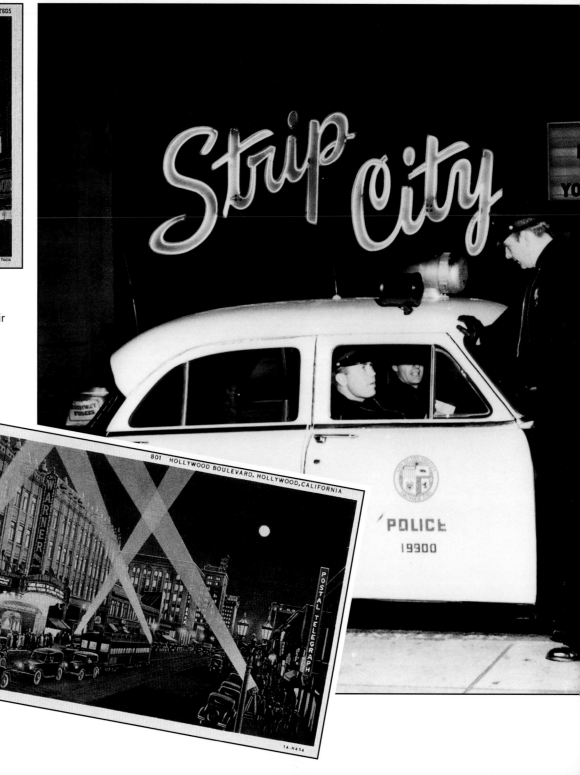

Broadway After Dark. Once upon a time, people strolled Broadway after dark. They could take the streetcar into town, shop at the Swelldom, catch a flick at the Los Angeles, and dine and dance to their heart's content. "Broadway at night, in downtown Los Angeles, is aglow with brilliant lights. The many attractive shops, theatres and cafes afford great interest to visitors of the Southland" reads the caption on the back of the postcard. But that was a long time ago, here, circa 1949.

Today the very mention of downtown at night evokes images of abandoned buildings, displaced citizens, random noises and abject terror. But could it be brought back? The L. A. Conservancy has begun the Broadway Initiative to renovate B'way between Third and Ninth—the first Historic Theater District in the U.S. listed in the National Register of Historic Places. The L. A. C. is helping old office buildings become artists' lofts; they aid building owners in bringing structures up to disabled/fire/seismic codes; they're battling one current plan to turn three adjacent prewar theaters into one giant swap meet. Meanwhile, Al Nodal, although recently retired from the Cultural Affairs Department, is looking to relight all of the extant signage along Broadway. *Courtesy J. Eric Lynxwiler*

801 HOLLYWOOD BOULEVARD, HOLLYWOOD, CALIFORNIA

A World Premier Night in Hollywood, California. The lights, the lights. Looking onto Hollywood Boulevard, c. 1937. *Courtesy J. Eric Lynxwiler*

40

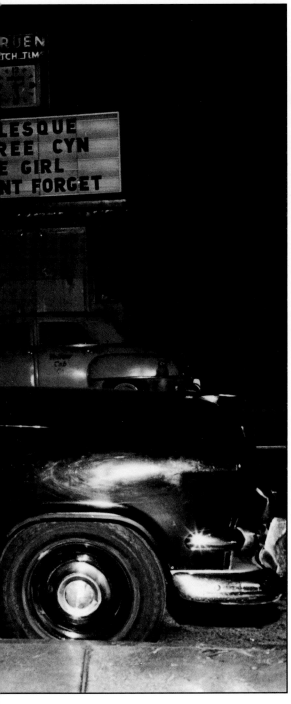

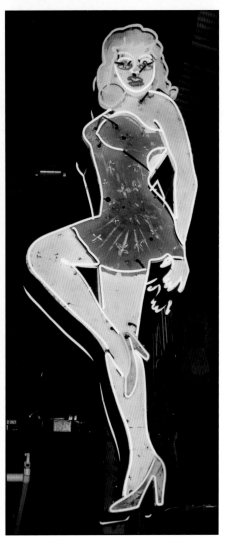

Downtown Lady. This obviously excitable and comely vixen was a siren for gentlemen seeking excitement in downtown 1950s Los Angeles. She has since been removed and now leads a more sedate life in a private collection. *Photo courtesy Scott Hopper, Track 16*

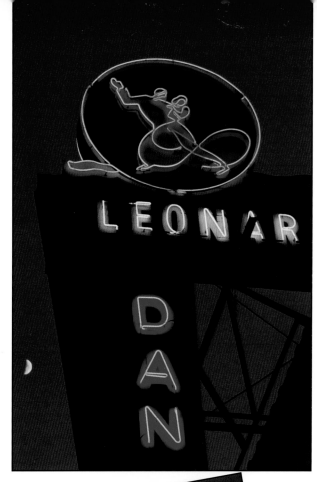

Leonardo's. On La Brea south of Wilshire, the weekend arrives, and Leonardo's (looking empty and abandoned during the week) swings into life. *Photo by Nigel Cox*

Strip City. Here, two of L. A.'s finest survey the scene outside the infamous L. A. nudie bar, 1956. You know the drill: smoke in your eyes, bourbon on your necktie, poker-faced ladies bumping and grinding to an awful duo of drum and saxophone. *Courtesy of University of Southern California, on behalf of the USC Specialized Libraries and Archival Collections*

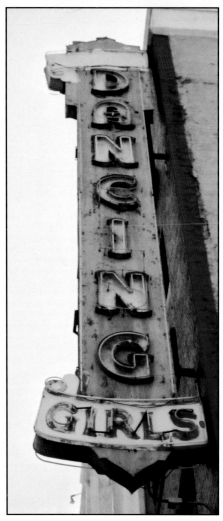

Dancing Girls. Deep in the garment district, downtown L. A., this holdout from a seedier era, remains. *Photo by Nigel Cox*

The Ubiquitous Cocktail Lounge. Sometimes a night on the town begins early. And here, Al Levy's Tavern, c.1955, was a good place to start. *Photo courtesy Los Angeles Public Library*

How To Find Your Perfect Bar

There are a few distinctions when it comes to wettin' your whistle. If you're the discriminating type, a "club" might be right for you. You can sink down in a leather booth, imagining yourself part of a private society. Or perhaps, strolling along after a late dinner, you'd rather kick back in a comfy "lounge." But when a lounge is too laissez faire, there is always the feeling of privacy in a "room." When it comes right down to it though, the truly parched can always find solace in the ever-present, simply put: "cocktails."

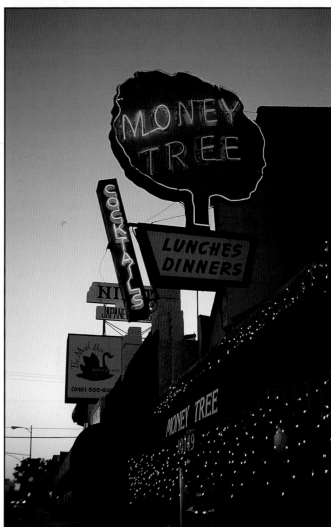

The Money Tree. Money may not grow on trees, but big steaks and scotch-and-waters apparently do at this Toluca Lake institution. *Photo by Larry Lytle/MONA*

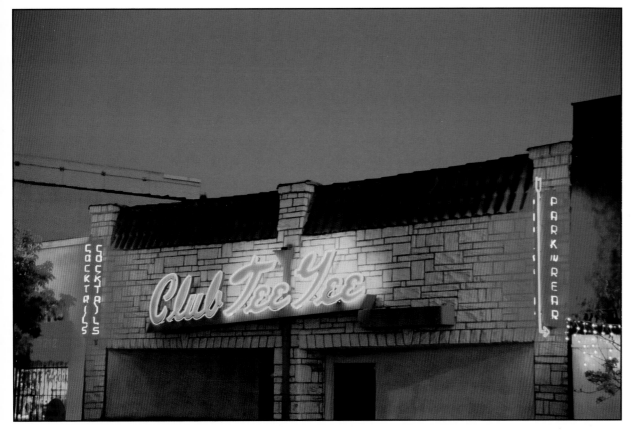

Club Tee Yee. Like many a small enclave in Los Angeles, Atwater Village is a residential community flanked by low-rise, inter-war commercial structures. Village inhabitants are routinely seen sauntering under the yellow 1937 neon into this watering hole—a haven for afternoon highballs. *Photo by Nigel Cox*

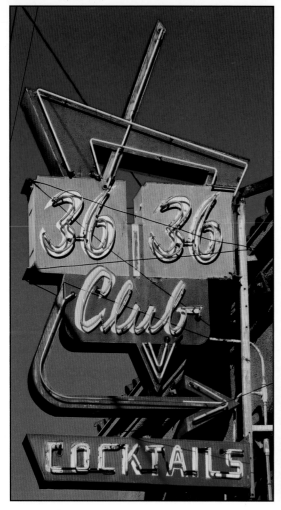

36 36 Club in Long Beach. *Photo by Nathan Marsak*

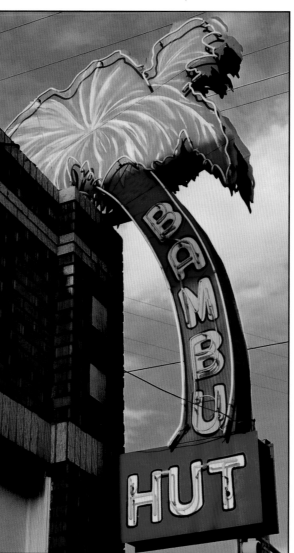

Bambu Hut. *Photo by Nigel Cox*

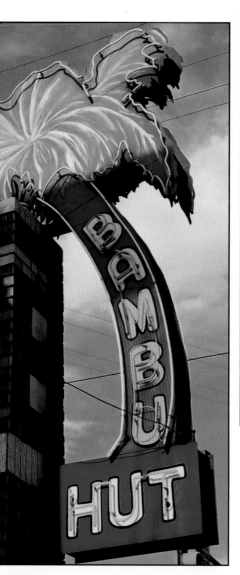

The Blue Room.

Behind the Blue Room. On the roof, over a neon sign that promises cocktails, a pink papier-mache elephant, faded to the color of old nicotine, wields a pistol and a hoop, a symbol of warning or protection? *Photo by Nigel Cox*

44

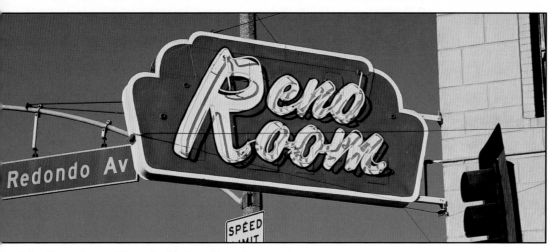

The Reno Room. *Photo by Nathan Marsak*

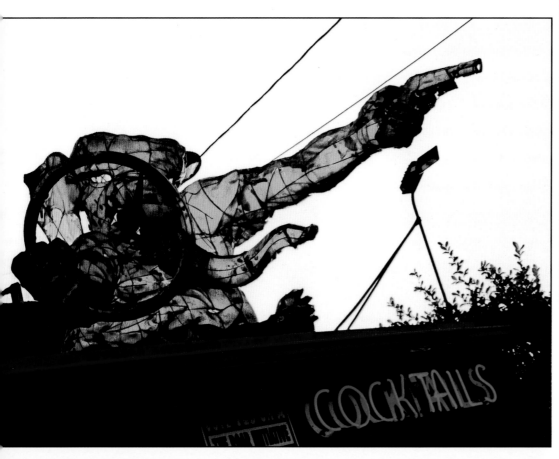

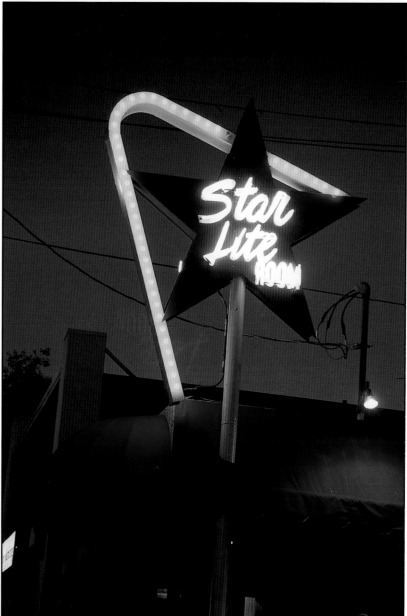

Star Lite Room. *Photo by Larry Lytle/MONA*

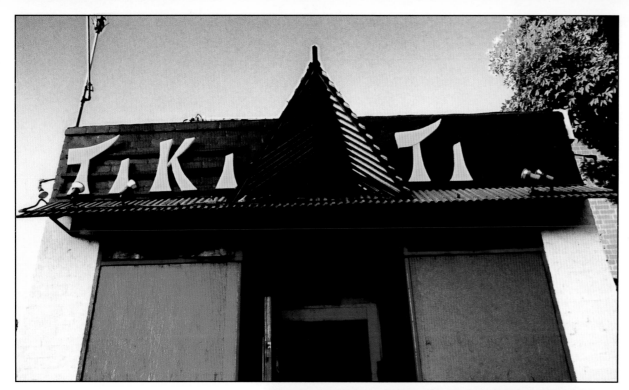

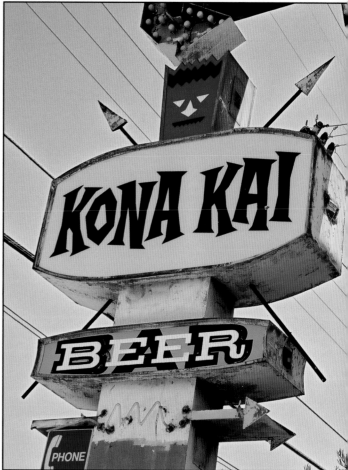

The Tiki Ti. Despite having lost 90% of her historic South Seas establishments, L. A.'s 1961 Tiki Ti survives. The modest building, with its modest but charming signage, is the haven for those of us addicted to fishing nets, plastic palms, embalmed puffer fish, and absurdly strong drinks consisting of a multiplicity of rums and esoteric fruit juices. *Photo by Nigel Cox*

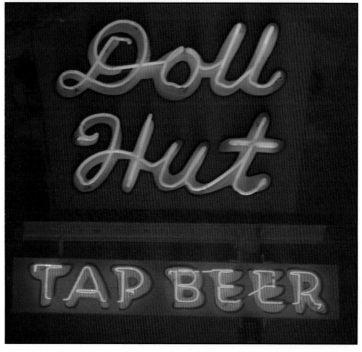

Kona Kai. Apparently, Kona Kai is the Polynesian God of Beer. His spears ward off those who would dare to consume otherwise. *Photo by Nathan Marsak*

Doll Hut. An Anaheim beer joint with a neon can shaped like a dollhouse. There is a special kind of titillation in architectural perversity. *Photo courtesy Model Colony History Room, Anaheim Public Library*

46

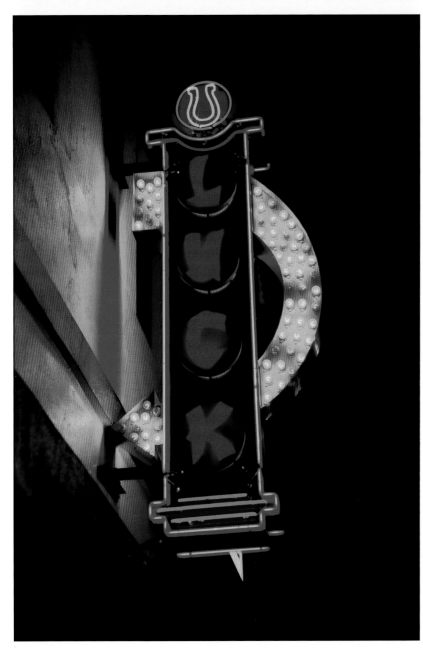

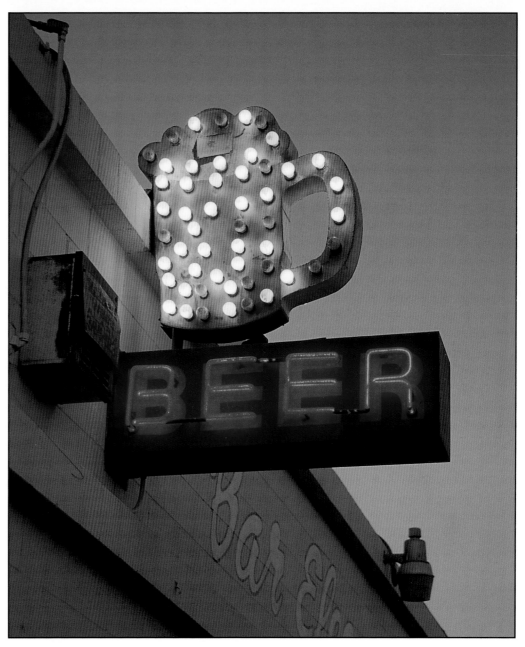

The Good Luck Bar. This contemporary use of neon tubing and flashing bulbs harkens back to an age of booze-sipping, when going to a bar meant red banquettes swathed in a smoky haze, a bartender who knew your name, and only the sound of ice clinking to remind you that other compatriots were hunkered down in this dim, warm cave. *Photo by Nigel Cox*

A Frosty Mug. The bar may be "Elegante," but the light bulbs and neon proclaim all the thirsty need to know. *Photo by Larry Lytle*/MONA

Chapter 3

Fine Dining

*"the cab came. I waved to the
driver, paid for the coffee and
doughnut, got out into the night,
got in, and told him, 'Hollywood
and Western,' and that particular
night was just about over."*
- Charles Bukowski, "Stolen,"
Love is a Dog from Hell

Photo by Nigel Cox

Time was, restaurants in Los Angeles were entertainment in and of themselves. You could gaze at the stars—Bogart and Bacall waltzing into the Trocadero, or watch in terror as Lionel Barrymore released live monkeys in the Cocoanut Grove. Before the rise and fall of Planet Hollywood, Clara "The It Girl" opened the It, and Preston Sturges would collar patrons in his restaurant to be extras in his films. There were also giant tamales and cafes shaped like giant owls and everywhere were glittering, glistening neon signs that alternately soothed and titillated. Today, fast food restaurants may spread like an incurable disease, but to LA's credit, it is the only city in America where they routinely go out of business.

Angelenos dislike conformity—why eat in a restaurant identical to the one they grew up with in Boise or Scranton or Tallahassee, or Seoul or Minsk or Mexico City, the very cities they escaped to set up a life here? Why not "Eat in the Hat," or find a hot dog stand shaped like a giant hot dog? (Despite this fact, LA is also known for having given the world Burger King, In-N-Out, Denny's, Bob's Big Boy, and Carl's Jr.)

LA has the highest restaurant-to-citizen ration of any community in the world. Some of the world's foremost Temples of Gastronomy are situated in our humble city. But when driving across town, and in need of some sustenance, where does one grab nuriture? The array is dizzying: Vietnamese noodle houses, El Salvadoran pupuserias, roadside Bulgarian borscht stands. Every corner has a Thai restaurant, an Armenian eatery, and a Southern rib joint filling the sky with smoke. Mexican food lurks around every bend; hard-shell tacos filled with iceberg lettuce and gray ground beef are forsaken for luscious mounds of conchinita pibil and carne asada.

As L.A. reinvents itself, its eating landscape changes. Its historic 50s coffee shops (Ships, Googies, Snaps, Tiny Naylors, all gone) have become a precious commodity. Even Pann's, remarkably intact, is threatened with demolition. Steak houses, those blankwalled bastions of bloody meat and baked potatoes, vanish in the blink of an eye. Faux-Polynesian joints, where tikis eyed you beneficently as you gobbled up syrupy pineapple-soaked fish, have become parking lots left and right. In their places, the fast food hovels pop up and die out (although in some areas one can still find marvelous old fast food signage—a Taco "Bell" or a pre-"KFC" Kentucky Fried Chicken bucket forty feet up a metal pole).

Chic eateries with pine nuts and pesto come and go. While in the past, restaurants understood that bigger, crazier signs attracted more clientele, the au courant canteens of today frequently pride themselves on having no signage whatsoever. Old school

restaurants and their remarkable signage, which manage to remain, standing the test of time, do so in the face of fire, flood, and shifting eating habits. And, as you walk toward the parking lot to your car, patting your tummy, you can bask in the light of a neon sign that satiates your hunger for eye candy.

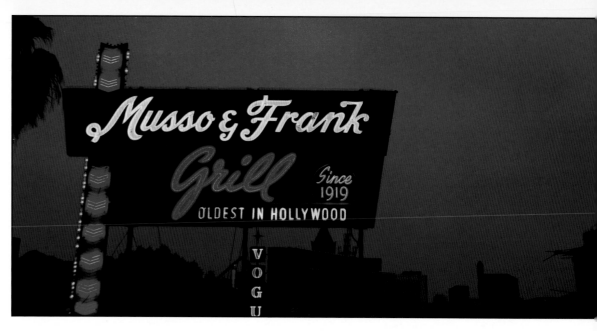

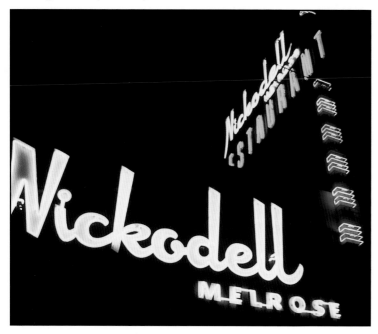

Nickodell. Another shockingly original postwar restaurant that sadly ended up ripped, torn and shorn. Her signage, however, is now comfortably ensconced in the living room of Ms. Hope Urban. *Photo by John English*

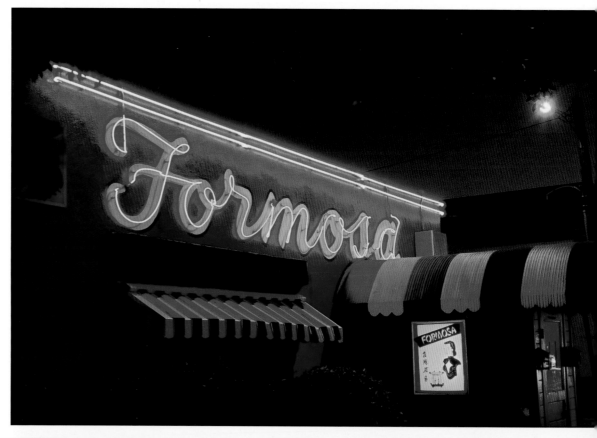

The Formosa. The green glow of the Formosa irradiates the trees and oozes over the street. It wails and intones, the call of the succubus: O, enter Mortal, Chinese food and whiskey sours abound.
The Formosa overflows with tales of old Hollywood. Mobster Mickey Cohen squirreling away his loot in a private safe in the back quarters. Bugsy Siegel dining here with soon-to-be-shanked pal Johnny "The Stomp" Stompanato and wife Lana Turner. Elvis giving his waitress a special tip one night—one of his pink Cadillacs. The neon pulsating with excess, murder, and those damn whiskey sours. *Photo by Nigel Cox*

Opposite page, top right: **Musso and Frank Grill**. "Oldest in Hollywood"—with a menu to prove it: sweetbreads and brains Milanese, lamb with mint jelly, bowls of creamed spinach. Those on a liquid diet appreciate the un-stumpable bartenders (there are few in Tinseltown who can make a rye rickey without consulting a book). Opened by Joseph Musso and Frank Toulet in 1919, the restaurant was sold to John Musso and Joseph Carissimi, who erected this sign in the 1940s. Everyone knows Chaplin liked his booth just left of the door, but patrons still argue about which booths housed Musso's regulars...F. Scott Fitzgerald, Dashiell Hammett, Dorothy Parker, William Faulkner, Aldous Huxley, Nathaneal West...Raymond Chandler wrote *The Big Sleep* here as Bogart looked on. *Photo by Nigel Cox*

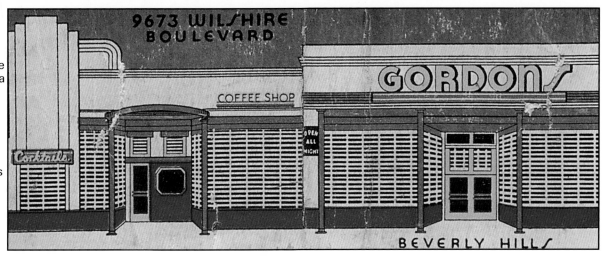

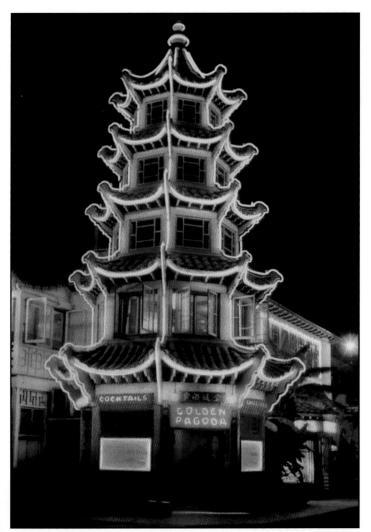

Golden Pagoda. On Mei Ling Way in Chinatown, the destination of choice for Cantonese food in a time-warp setting. Their cocktail lounge is appropriately dark and comfy; their signature cocktail is the Pagoda Delight. The amazing neon that covers the building isn't always in the best shape, but the Pagodans do their best to keep it lit. *Authors' collection*

The Legend of a Simple Hat

As the story goes—one of them, any-way—Jack Warner and Gloria Swanson's ex-husband Herbert Somborn were commiserating over the fact there was no decent nightlife in 1920s Los Angeles. "Heck," quipped Somborn, "if the food and service were good, people would eat out of a hat." And so in 1926 Warner financed, and Somborn built the most legendary piece of architectural signage—both building and sign—in the world. (The neon hat atop the Derby originally read "Eat in the Hat" but was changed when the Derby picked itself up and moved a half-block over in 1936.)

The waitresses were known less for their waitressing skills than for looking comely in their derby-shaped skirts, but by that time it didn't matter; the Hat was King. In 1929 the Hollywood Brown Derby, designed by one of Warner's art directors, hit the scene, and became the dazzling haunt of stars and autograph seekers, a whirlwind of derby-shaped kitsch, Cobb salads, telephones brought to one's table, and Eddie Vitch's caricatures of the stars. The Beverly Hills Derby opened in the mid-thirties and the Los Feliz "Car Café" in 1941.

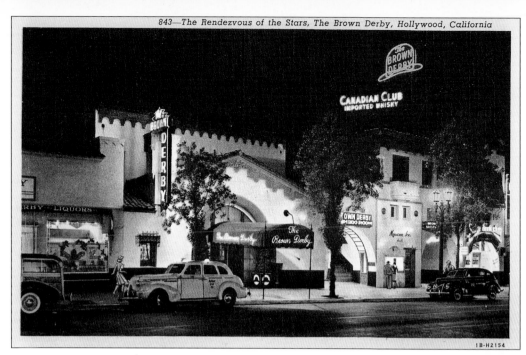

843—The Rendezvous of the Stars, The Brown Derby, Hollywood, California

IB-H2154

The Brown Derby at Hollywood and Vine. *Authors' collection*

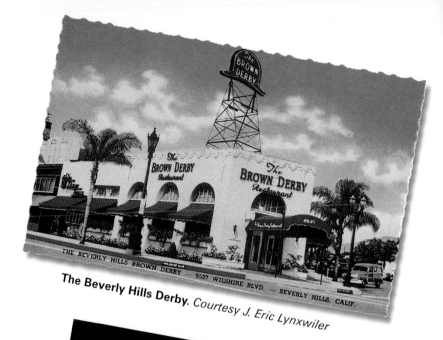

The Beverly Hills Derby. *Courtesy J. Eric Lynxwiler*

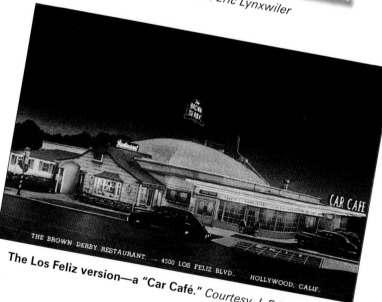

THE BROWN DERBY RESTAURANT. 4500 LOS FELIZ BLVD. HOLLYWOOD, CALIF.

The Los Feliz version—a "Car Café." *Courtesy J. Eric Lynxwiler*

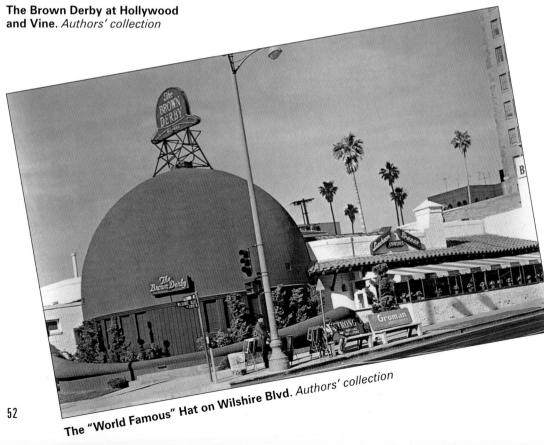

The "World Famous" Hat on Wilshire Blvd. *Authors' collection*

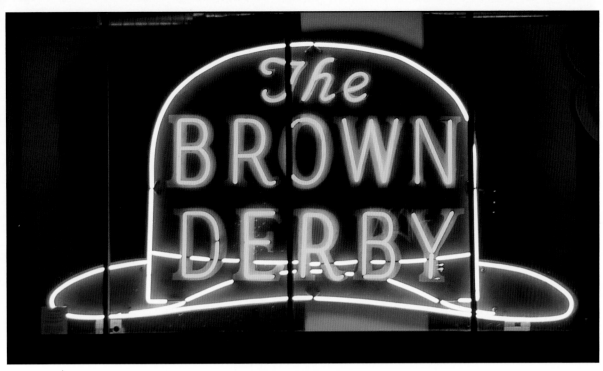

The Beverly Hills location is gone, and the Los Feliz survives as "The Derby" nightclub, although its interior has been cut up and the car cafe enclosed for a chain restaurant. The remarkable Hollywood Brown Derby was unceremoniously torn down in 1994; it is now a parking lot. Stranger and sadder still, the Great Hat itself fell victim to the most ignominious fate ever to befall a landmark. While the hat-shape was saved (quite literally) at the last minute from the wrecking ball in 1980, it ended up brimless and bastardized on the roof at the back of a strip-mall built on the site. To add insult to injury, the collection of nail salons and karaoke bars is now known as "Brown Derby Plaza."

The Derby at the Museum of Neon Art. *Photo by Nigel Cox*

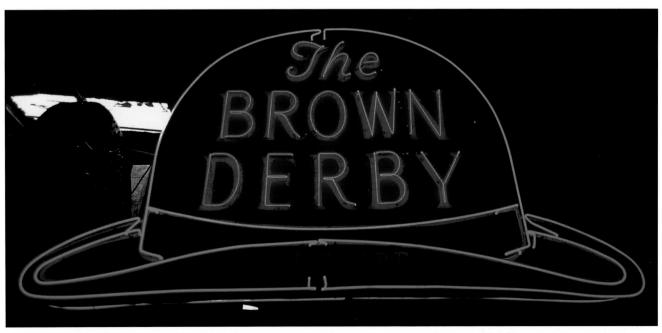

The Hat. This derby was saved and resides at Track 16 in Santa Monica, California. *Photo by Nigel Cox*

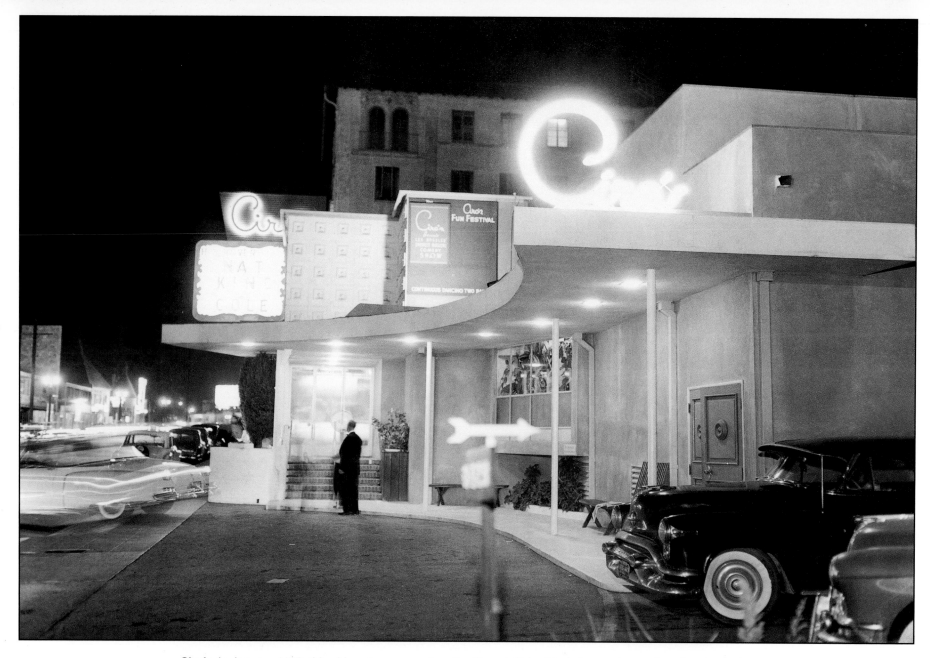

Ciro's. In January 1940, this chic eatery opened on the Sunset Strip. Ciro's boasted a modern facade, and its sophisticated neon and opulent interior reflected the demise of the large nightclub and the rise of the supper club, where stars sought to take refuge from their fame rather than exploit it. Near nightly regulars included Bogart and Bacall, Clark Gable, Judy Garland, Ginger Rogers, Frank Sinatra, Orson Welles, Barbara Stanwyck, and a certain Mr. Howard Hughes, whose habit it was to adjourn to the parking lot with young ladies. The party lasted until 1959; it has since become The Comedy Store. *Courtesy of University of Southern California, on behalf of the USC Specialized Libraries and Archival Collections*

Bob's Big Boy

This striking building, designed by Wayne McAllister in 1949, is a moderne-meets-googie wonderland of neon. It is the oldest remaining Bob's in America (and second built; the first, in Glendale, was torn down in 1990). This masterpiece was scheduled for demolition in 1992, until the Los Angeles Conservancy Modern Committee fought for and won its declaration as a California Point of Historical Interest. The owners restored its mid-century splendor, neon and all. They added weekend carhop service and car shows; it is now the highest-grossing Bob's in the world.

Photo by John English

Photo by Nigel Cox

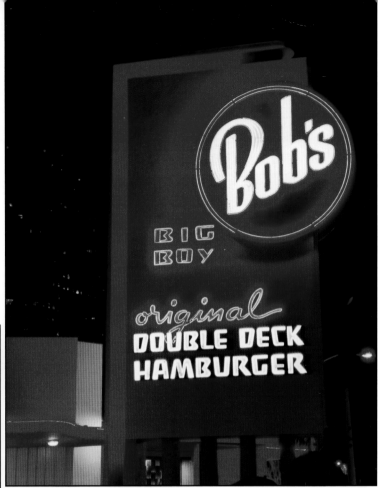

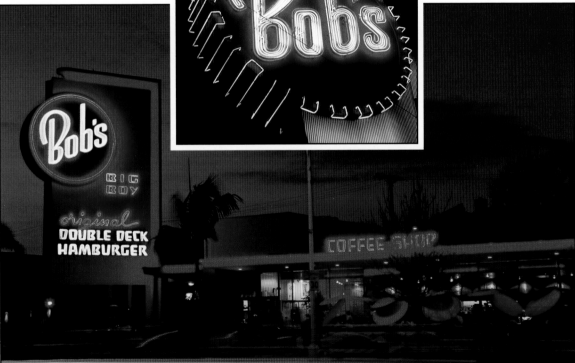

Photo by Nigel Cox

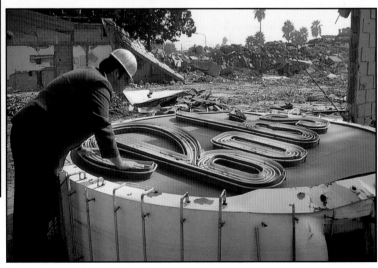

Before and after. Archivist and preservationist Chris Nichols mourns the sign's corpse. *Photo by John English*

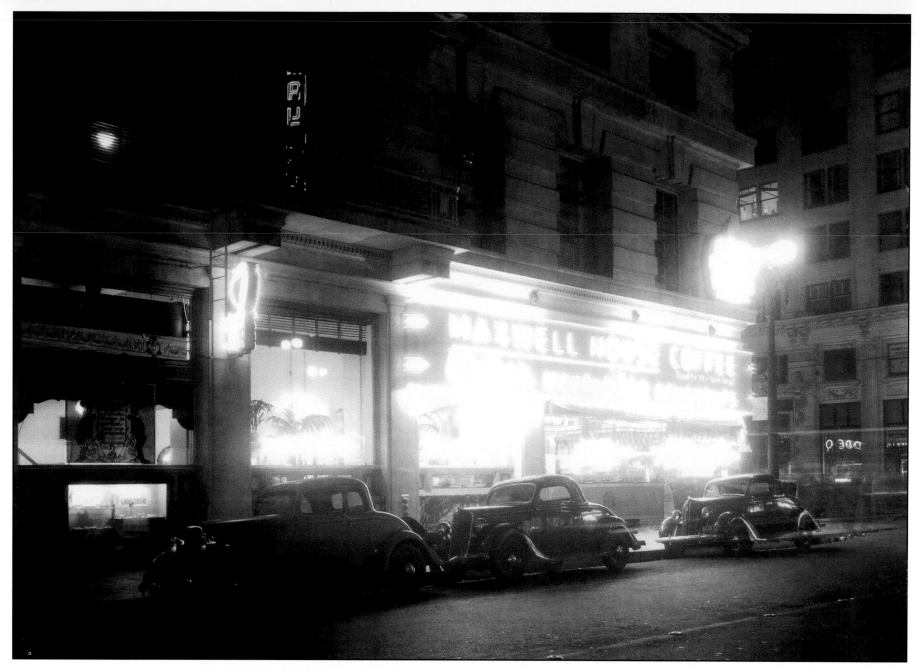

Maxwell House. As night devolves into day, and you find yourself stumbling home without an open cocktail lounge in sight, there is always refuge to be found in coffee at your friendly Maxwell House stand. Their neon is like a bonfire signaling you in. Provided you're downtown in the mid-1930s, of course. *Photo Collection /Los Angeles Public Library*

The Wonderful World of Los Angeles Donuts

L.A. has a strange affinity for the repulsively titanic: giant egos, giant apartment developments, giant breasts. And giant donuts. Perhaps the donut is a magical symbol for the "circle of life." More likely it's just something the Angeleno picks up on the way to an AA meeting. In any event, donuts are key to existence in Los Angeles, and the bigger the better.

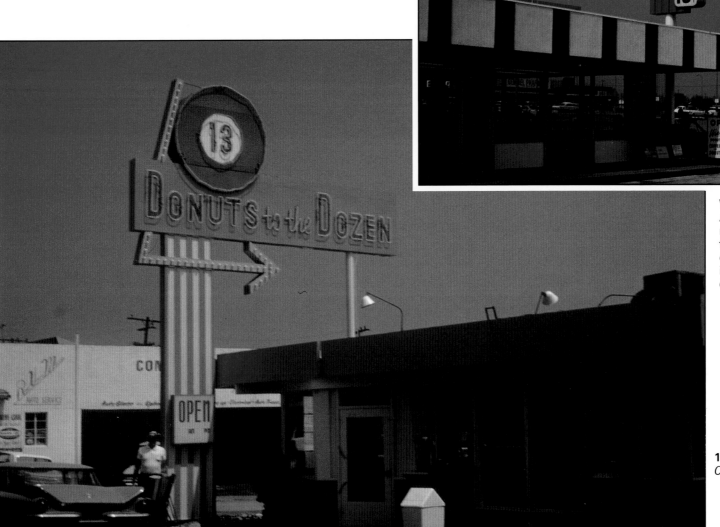

Winchell's. Thirteen donuts unlucky? Apparently. This donut shop was recently razed. The Upland Winchell's, from 1960 (here seen c.1962), is still extant and is the oldest Winchell's sign in Southern California. *Photo courtesy Charles Phoenix*

13 Donuts To The Dozen. *Photo courtesy Charles Phoenix*

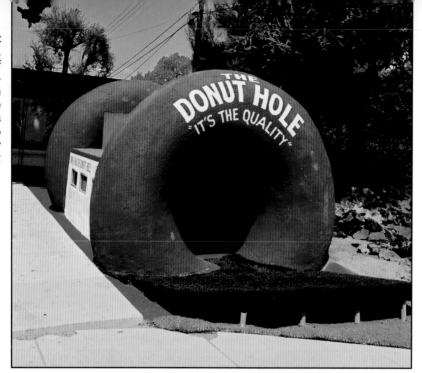

La Puente's Donut Hole Miniaturized. An exact replica of the famous drive-through, although intended for the course of golf balls as opposed to autos. *Photo by Nigel Cox*

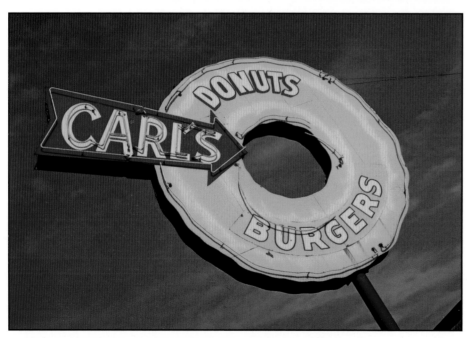

Carl's Donuts. A landmark of 1956 Pomona. *Photo by Nigel Cox*

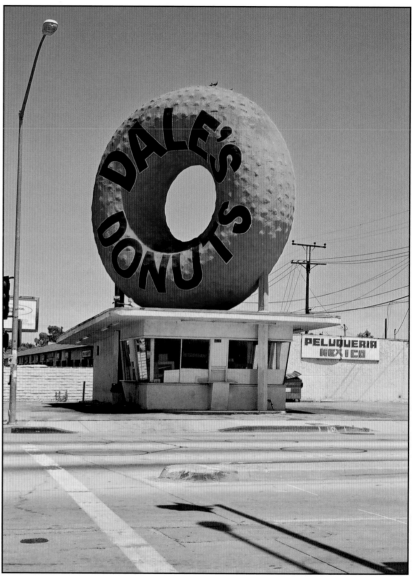

Dale's Donuts. Of the grand myriad of gargantuan donuts, Dale's in Compton is perhaps the most historically accurate. *Photo by Nathan Marsak*

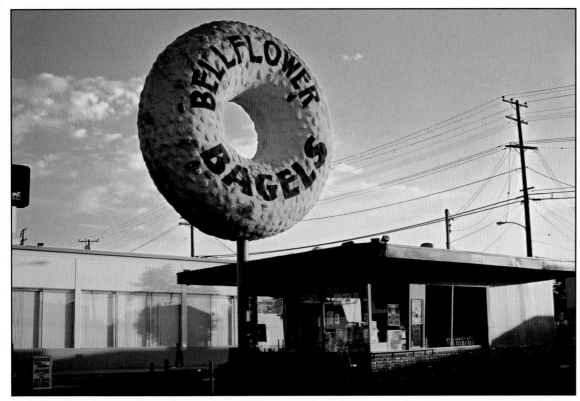

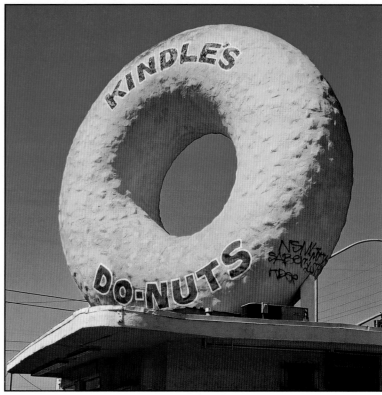

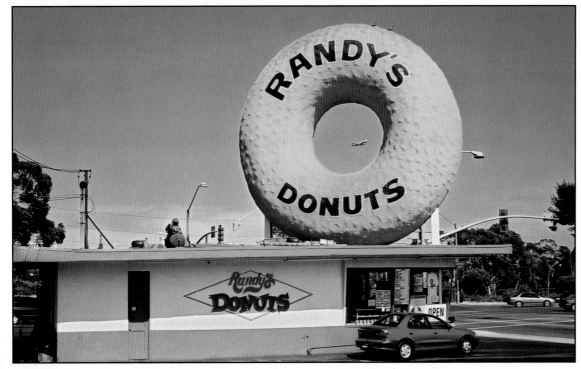

Top left: **Bellflower Bagels**. Anyone familiar with L. A.'s magnificent Giant Donut signage would recognize that this giant bagel— apparently painted to approximate the addition of onions—began life as a donut. Who do they think they're fooling? *Photo by Nathan Marsak*

Bottom left: **Randy's Donuts**. Because of its proximity to the airport, Randy's is justifiably the most famous of L. A.'s dozen donuts. "The first thing people say when they see the 80-foot glazed donut on the roof is 'Wow, that's big!'" according to Larry Weintraub, who has owned the shop with his brother Ron since 1978. People from across the globe come to see the donut made famous in countless movies and television shows. "The donut sign was put up in 1952. It's really a landmark," Weintraub said. "It's so big that people tell me they can see it from the airplane when they fly over Los Angeles. People always want to know how many calories there are in it. And kids come in and ask for the donut on the roof!" said Weintraub with a guffaw. "Thank goodness for that donut…you see, it's a giant donut. People see it and right away get hungry for donuts." *Photo by Nathan Marsak*

Top right: **Kindle's Donuts**. Kindle's, down Normandie, was reputedly named after famous financial wizard Holly Kindle, although this cannot be confirmed. *Photo by Nathan Marsak*

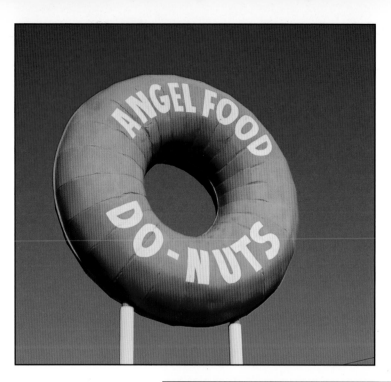

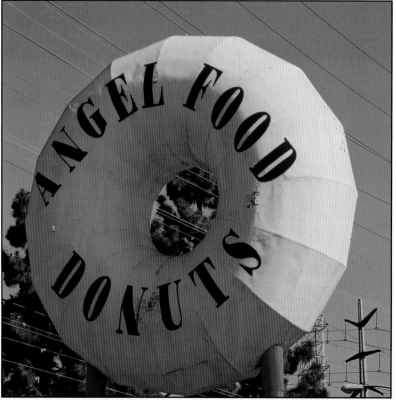

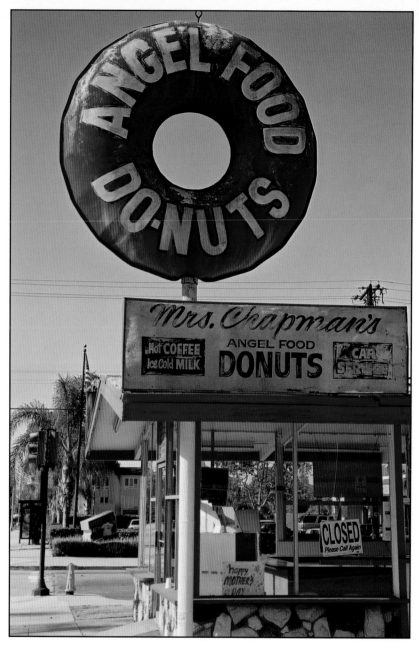

Angel Food Donuts. There are three giant Angel Food donuts in the Long Beach area alone. *Photos by Nathan Marsak*

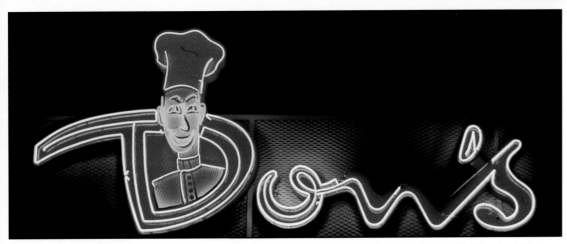

Don's Coffee Shop. This amazing grinning chef used to grace the front of this 1947 drive-in. When the drive-in element closed up in 1963, Don's family (who still own the establishment) moved their neon Don to the side of the structure and then had an exact duplicate built for the opposite side. *Photo by Nigel Cox*

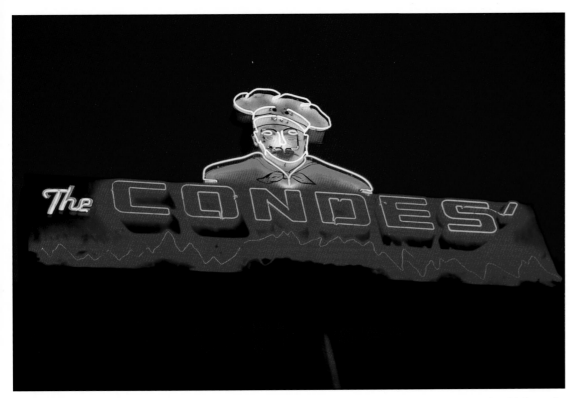

Condes'. Once lording over a Los Angeles steakhouse, the Condes' chef is now located at Universal Citywalk, courtesy of the Museum of Neon Art. *Photo by Nigel Cox*

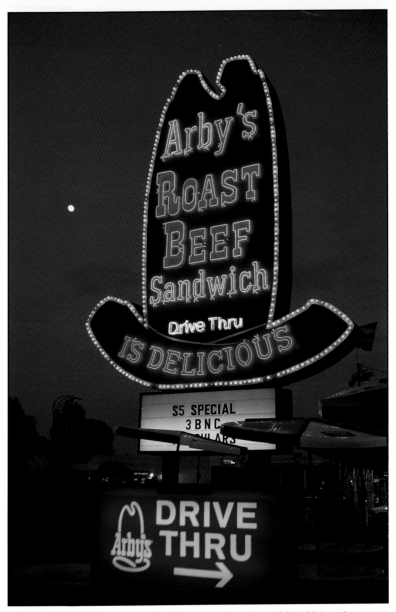

Arby's. These chuck wagon hats were introduced in 1964 and continue to blink madly all over the Southland. The residents of Santa Monica recently fought for and won the retention of their hat. *Photo by Larry Lytle/MONA*

61

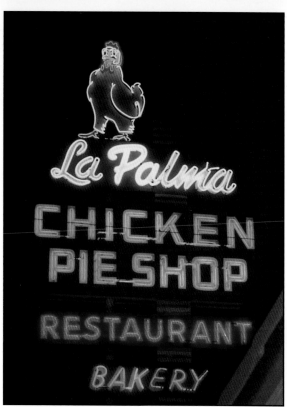

Chicken Pie in La Palma. *Photo by Daniel Paul*

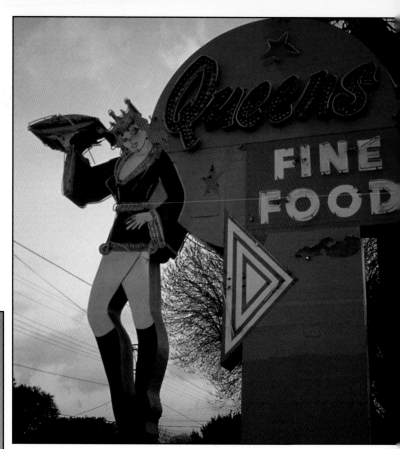

Queen's Fine Food. This is one saucy sixties queen! Politics would be a lot more interesting if nations were run by female monarchs in ermine-trimmed mini-dresses and thigh-high leather go-go boots. This pie-presenting beneficent leader reigns over the Kingdom of San Bernardino. *Photo Courtesy Model Colony History Room, Anaheim Public Library*

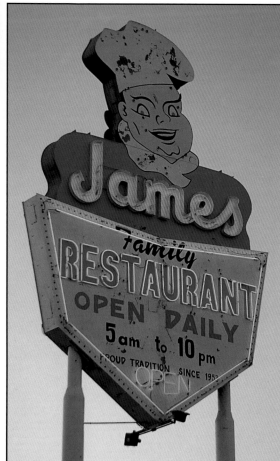

James Restaurant. The original James had an artist put his actual likeness on the sign in 1966. *Photo by Larry Lytle/MONA*

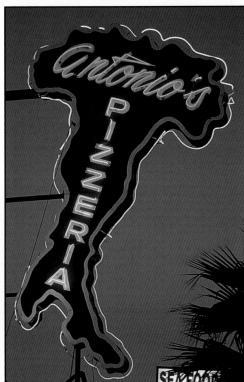

Antonio's Pizzeria. *Photo by Larry Lytle*/MONA

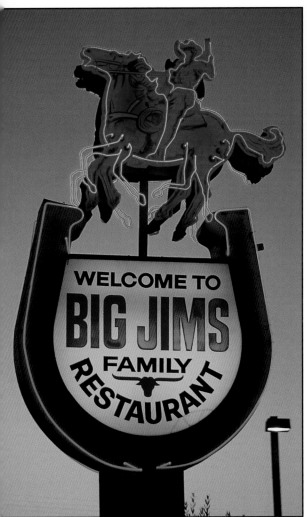

Big Jim's. *Photo by Larry Lytle*/MONA

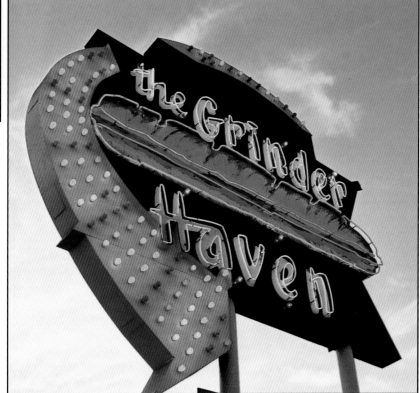

Grinder Haven. This Pomona haunt for submarine sandwiches is now owned by a man who worked there when it opened in 1958. He meticulously restored the sign, up to and including ripping up the parking lot to get at the original wiring. *Photo by Nigel Cox*

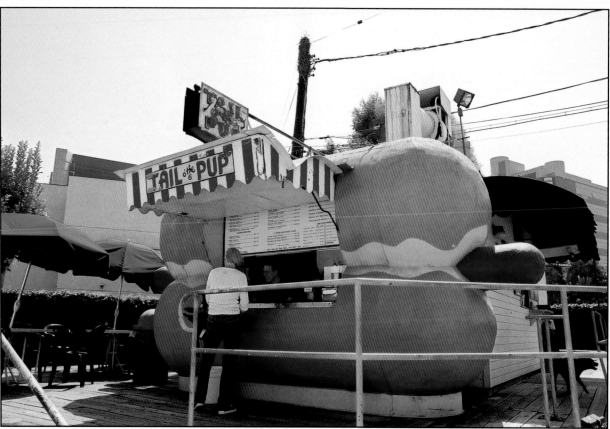

Opposite page, top left: **Papoo's Hot Dog Show.** This neon doggie lives just across the street from Bob's Big Boy, but not in the shadow of. Also built in 1949, and also recently relit, Papoo's Hot Dog Show is a real head-turner. There's even an animated dog up on a pole, which is scheduled for relighting. *Photo by Nigel Cox*

Bottom left: **Papoo's 1939.** The sister neon pooch, in Upland, c. 1939. This neon and her sister, out in Ontario, have gone to neon doggie heaven. *Photo courtesy Charles Phoenix*

"Tale" o' The Pup. This sign is both honored and vilified for representing the "Los Angeles architectural viewpoint," as one wag termed the giant plaster weenie. Possibly because it has survived, it has since outranked the Brown Derby to become "top dog" in the programmatic architecture game. Besides the structure's obvious charms, it retains its 1945 box neon, evident in the postwar Life Magazine photo of Donna Reed hungrily ingesting a polish dog at the great frankfurter's opening. "We bought the stand in 1973 from the famous Hollywood dance team Yolanda and Velez. They were a big hit in the black and white ballroom pictures," said Maria Blake, owner of the Pup. Supposedly, the name makes fun of the old Tail Of The Cock restaurant. The little hot dog stand once stood at Beverly and La Cienega, a mere three doors away from the upscale Tail Of The Cock. Developers went to demolish the Pup in 1987, but after it was declared a landmark, the developers relented and shunted it off to a less noticeable parcel up San Vicente. *Photo by Nigel Cox*

Larry's Chili Dog. This happy pooch was once animated, wagging his tail in anticipation of his own consumption. *Photo by Robert Landau*

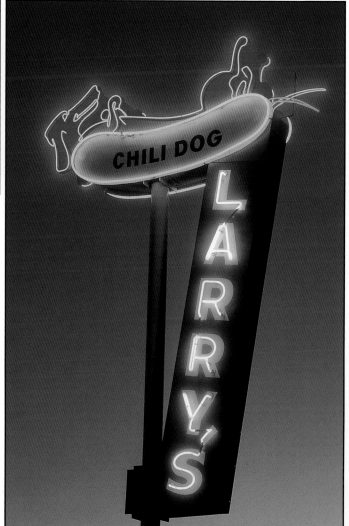

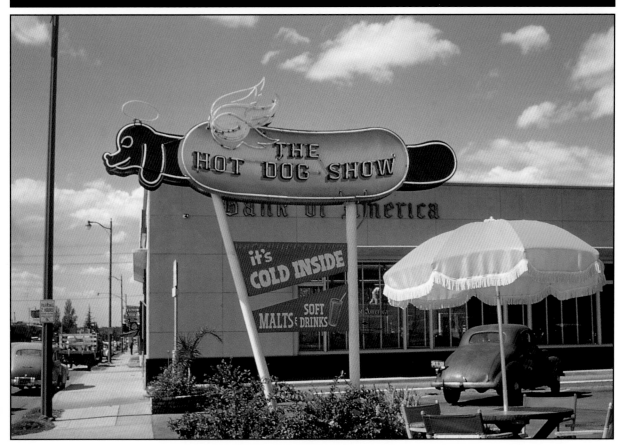

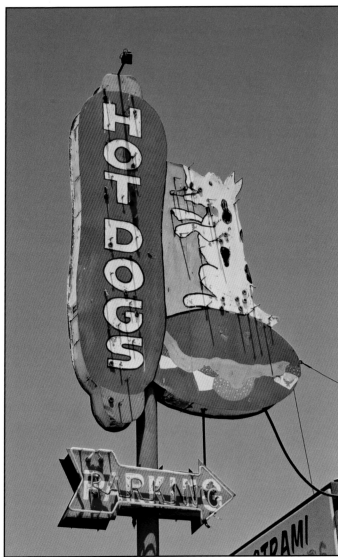

Hot Dogs. What doggie doesn't dream of standing on a giant hamburger, licking a giant hot dog? This may be the luckiest terrier in the world. He would be luckier still if some kind person would replace his neon. *Photo by Nathan Marsak*

Sombreros in the Southland

In 1846, Los Angeles was taken by Lt. Archibald Gillespie and 50 marines. Although Mexico may have lost that battle, they've won the war. By the year 2000, Mexicans regained their numbers as the primary residents of the Los Angeles basin.

In the early years of Los Angeles, enterprising Mexicans introduced their cuisine to the pallet of Angelenos by opening restaurants catering to the adventurous American as well as the well-to-do Mexican. Despite their industriousness, many chose to represent their culture with a stereotype of laziness—the sleepy Mexican under a sombrero. This iconic image was used in films and advertisements throughout much of the 20th Century—and so permeated the consciousness of the American mind that such typecasting pervades to this day.

Don Antonio's Zapata mustache in West L. A.

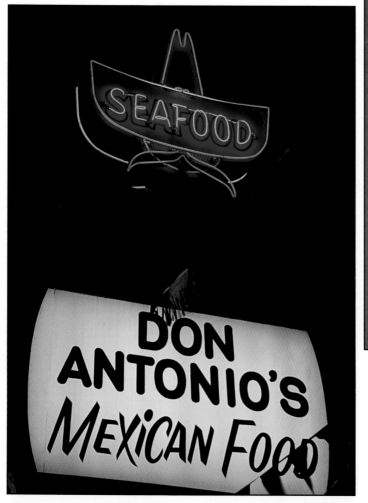

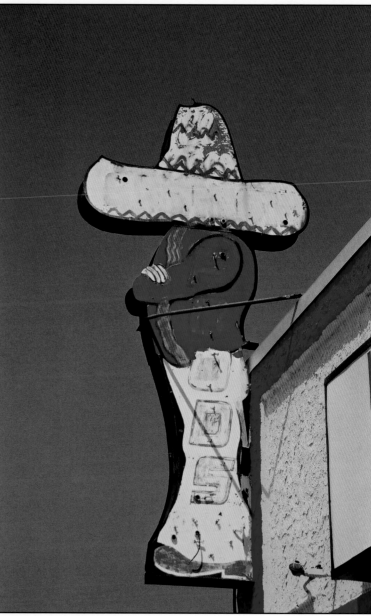

Spanish Foods. This insouciant gent has lost his neon outline, and where his hat read "Spanish" and his body "Foods," he now advertises "...ods." *Photo by Nathan Marsak*

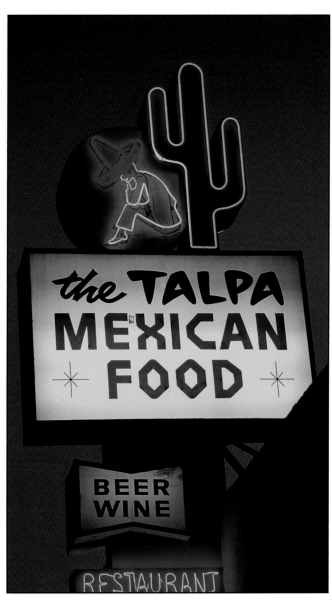

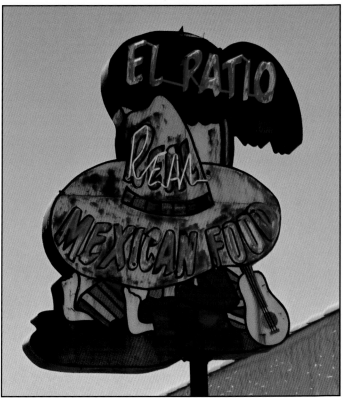

The El Patio. This sleepy Mexican has survived more than his share of adversity. Nicolas Jara moved from Jalisco, Mexico to Los Angeles in the late 1920s, only to be met by the hard times of the 1930s. He opened El Patio in 1930, and his mother's "Depression Soup," full of potatoes and ground beef, is still on the menu. His original location was on Sixth and San Gabriel in Azusa, until the telephone company mysteriously forced them out and tore down the building for no apparent reason. Nevertheless, he relocated three blocks south and opened the present El Patio on Thanksgiving Day, 1956.

Nicolas' son, Joseph Jara, designed this sign as well as their mascot, Kiki Jara, the booze-and-gun toting chicken. The original (and more politically correct) 1930 Patio sign still blazes along near the back of the building. Third generation Elizabeth Jara recounts: "People used to come here on the trolleys from all over L. A., before they took them away." El Patio is now in its fourth generation of family operation in L. A., and people still come in droves to sample Mexican food as it was had seventy-plus years ago. *Photo by Nathan Marsak*

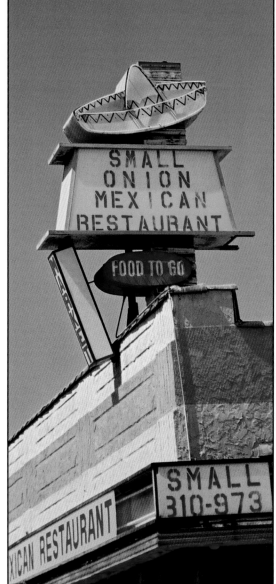

The Small Onion. *Photo by Nathan Marsak*

The Talpa on Pico Boulevard. *Photo by Nigel Cox*

67

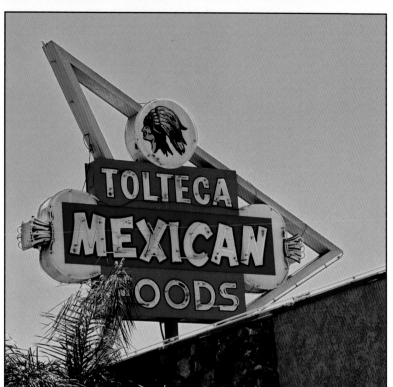

La Tolteca. This eatery began life in 1948 as a tortilla factory with a Mexican take-out window. Azusa's neon tamale started out as a simple arrow, but had the Indian head and tamale added later over time to draw attention to the food. Said owner Ben Arrietta, "The sign has moved twice, in 1965 and again in 1982. We are thinking of relocating again and we're going to move the sign. Where we go, the sign goes."
Photo by Nathan Marsak

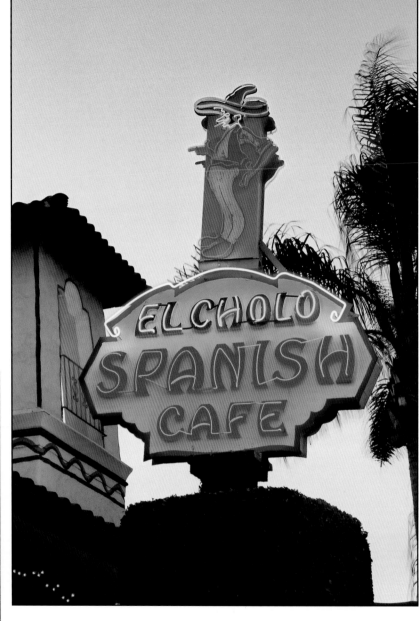

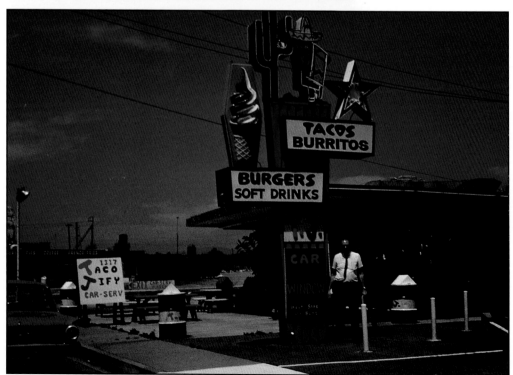

Tacos, Burritos… and ice cream cones, c. 1962.
Photo courtesy Charles Phoenix

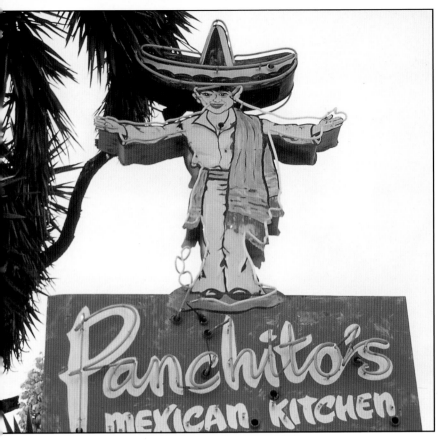

Panchito's Mexican Foods. *Photo by John English*

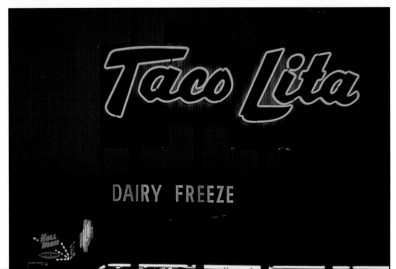

Taco Lita. Torn down. *Photo by Charles Phoenix*

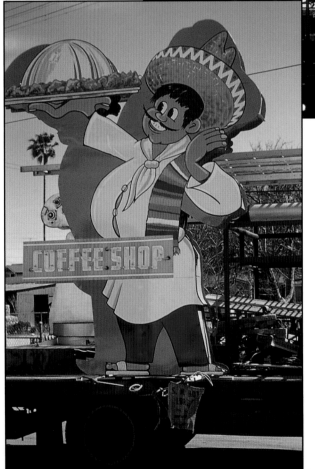

A 1953 Williams' Sign. Fernando bids adieu to Pomona, his birthplace at Williams' Sign Company, to take up residence at some Southland coffee shop. *Photo courtesy Charles Phoenix*

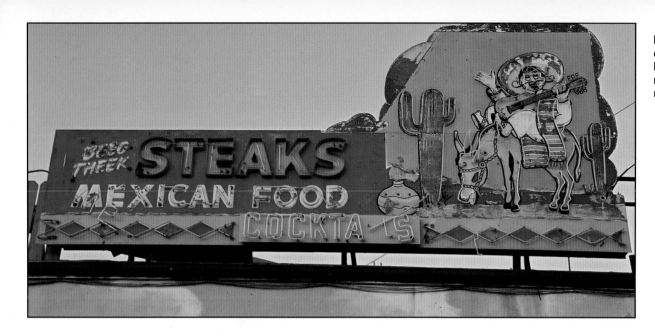

Beeg Theek. This El Monte fixture may not be politically correct, but is still a favorite among residents who remember the El Gordo restaurant. Mr. Beeg Theek has been rescued from a date with the junkyard and now awaits restoration at the Mueum of Neon Art. *Photo by Nigel Cox*

Algemac's. Located across from the Glendale Forest Lawn Cemetery, Algemac's is the Fifties coffee shop of choice for the grieving set. *Photo by Nigel Cox*

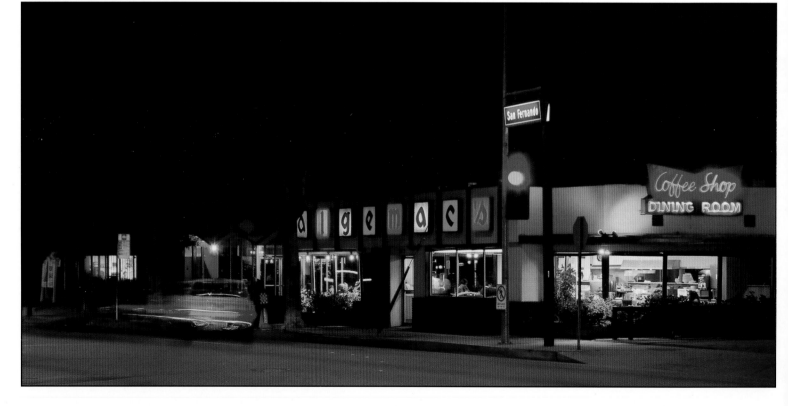

Bun N Burger. Arturo Sanchez is justifiably proud of his famous Bun N Burger sign. This neon has been bringing people to the restaurant since it opened in 1941. "It is a historical sign. It's even listed on a registry," Sanchez said. "I just had it fixed a couple of months ago because I really like it to work perfectly and look good." Sanchez, who has owned the Bun 'N Burger since 1987, added "people talk about the sign all the time. They like to come and take pictures of it. It's even been in some magazines. You know, lots of people have lots of memories about the sign and about this restaurant. I would never want to change this sign." *Photo by Nigel Cox*

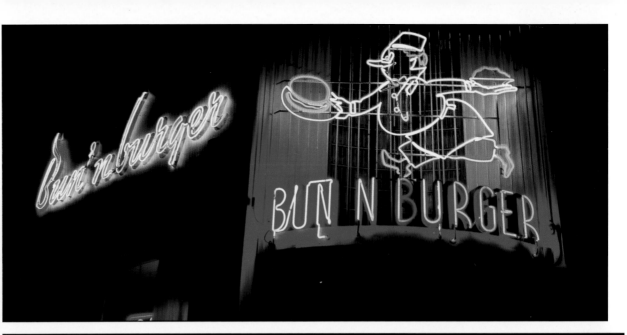

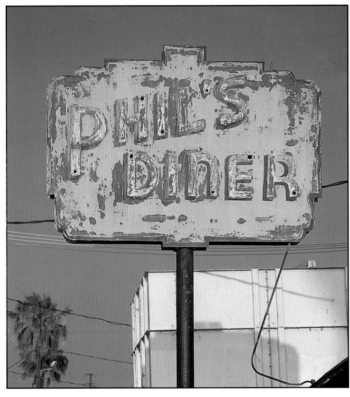

Phil's Diner. This sad and derelict diner signage still holds court at its original location in the Valley; it and the diner stay alive through film and TV appearances. *Photo by Larry Lytle/MONA*

In-N-Out. This venerable Los Angeles In-N-Out chain has replaced nearly all of its original signage with backlit plastic, but this example perseveres in North Hollywood. *Photo by Larry Lytle/MONA*

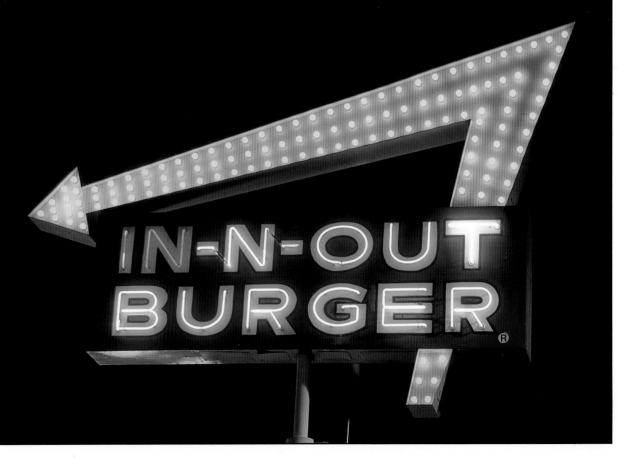

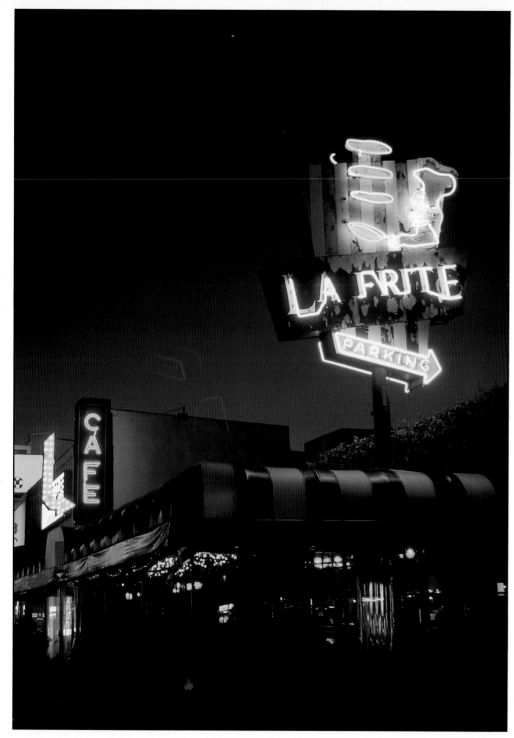

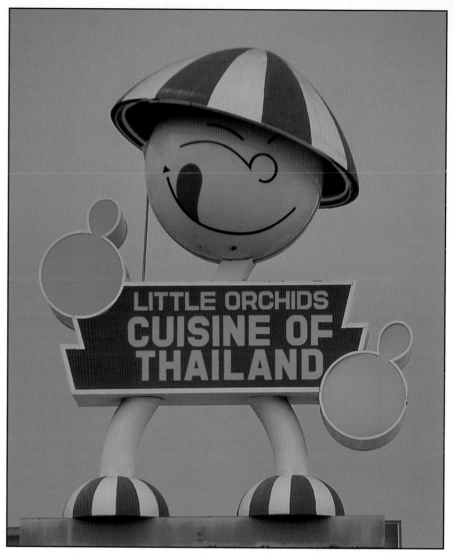

Little Orchids. In another world, apparently, this sort of Asiatic representation was *de rigueur*. Once part of the ever-present "Number One Son" Los Angeles restaurant chain of the mid-1960s, this round headed and slant-eyed boy is the sole remaining example of totemic Johnson-era Orientalia in the Southland. *Photo by Larry Lytle*/MONA

Sherman Oaks' La Frite. *Photo by Larry Lytle*/MONA

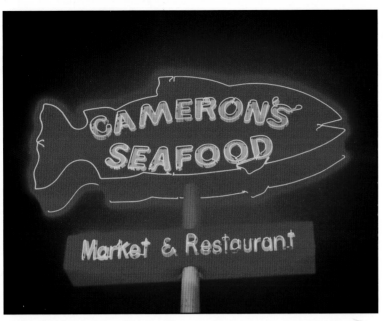

Cameron's Seafood. Proof that there are still fine, large figurals erected in the modern day. The 1980s were a nadir for this type of work. Representational signs were on the wane. But this sign, installed during that time, was a high-water mark in otherwise lean years. The noble gas "neon" is responsible for this pulsating orange-red glow. Though the word "neon" is used as a general term, it is actually a specific gas that radiates this fiery color when pumped through clear tubing. *Photo by Nigel Cox*

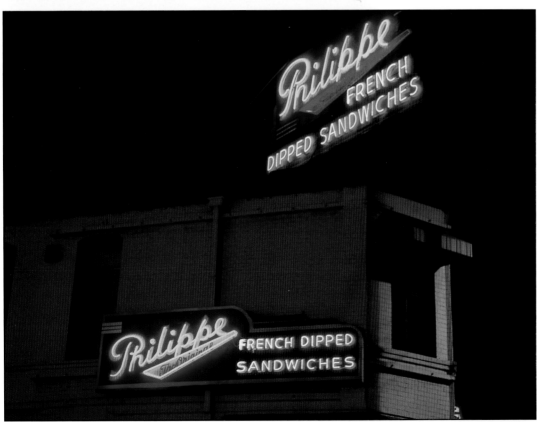

Philippe's. *Photos by Nigel Cox*

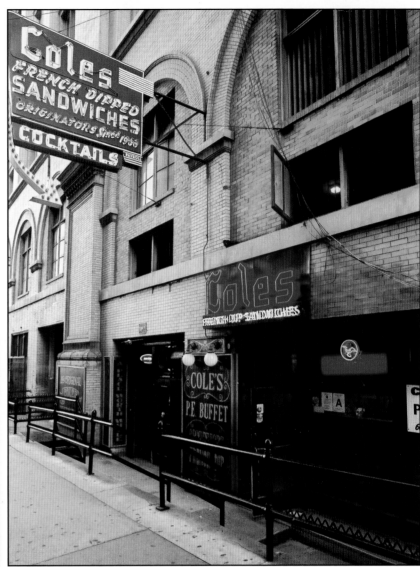

Cole's P.E. Harry Cole had a dream. That dream was the French Dip Sandwich. From this dream sprang Cole's Buffet, which Mr. Cole opened in the Pacific Electric Building, tallest building west of the Mississippi, and terminal for the mighty Pacific Electric Railway. The days of well-dressed Edwardian Capitalism are gone, as is the railway; Coles' tables are made from the old trolley cars. Now Cole's is a stone's throw from skid row, but still the destination of choice for many a downtown worker. Of course, Phillipe Mathieu also claims to have invented the French Dip in 1908. Phillipe's is known for its neon, French Dips, and jars of pickled eggs, but both restaurants are known for the nearly hundred-year-old French Dip rivalry. The two couldn't be more dissimilar—Coles is dark and labyrinthine where Phillipe's is cavernous and brightly lit. Their respective habitués are fiercely loyal. Whether one or the other is the originator of the dunked sandwich that is up to the hungry to decide. *Photo by Michael A. Burke*

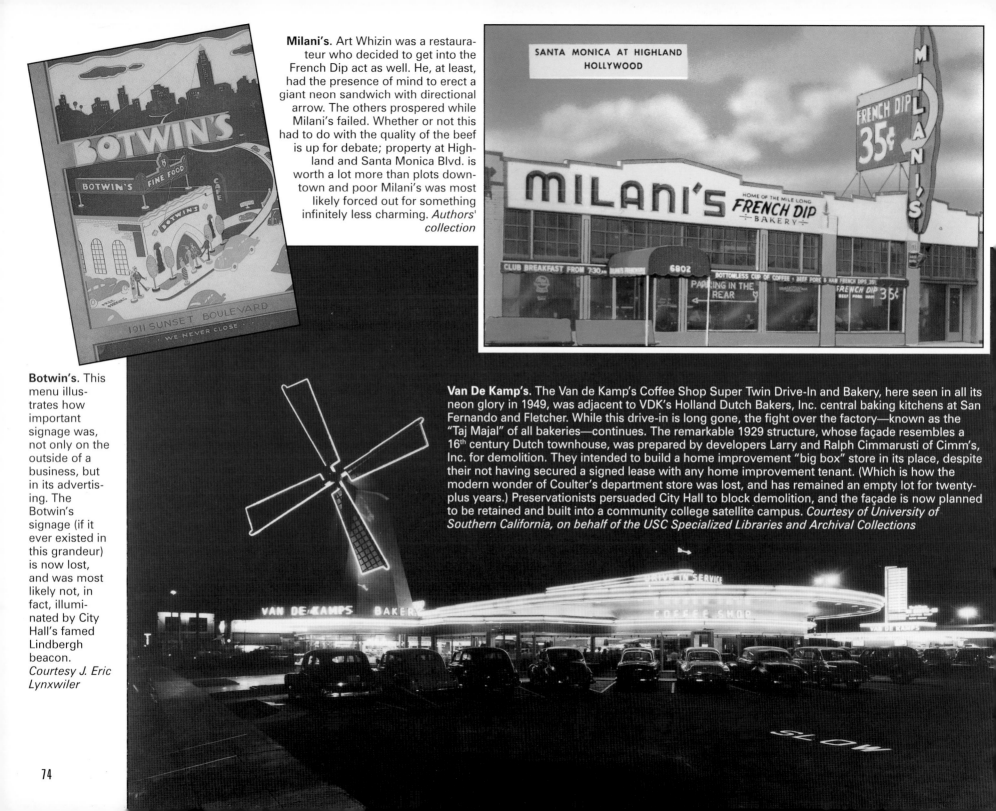

Milani's. Art Whizin was a restaurateur who decided to get into the French Dip act as well. He, at least, had the presence of mind to erect a giant neon sandwich with directional arrow. The others prospered while Milani's failed. Whether or not this had to do with the quality of the beef is up for debate; property at Highland and Santa Monica Blvd. is worth a lot more than plots downtown and poor Milani's was most likely forced out for something infinitely less charming. *Authors' collection*

SANTA MONICA AT HIGHLAND HOLLYWOOD

MILANI'S

FRENCH DIP 35¢

MILANI'S HOME OF THE MILE LONG **FRENCH DIP** BAKERY

CLUB BREAKFAST FROM 7:30 AM 6802 BOTTOMLESS CUP OF COFFEE • BEEF PORK & HAM FRENCH DIPS 35¢ FRENCH DIP 35¢

Botwin's. This menu illustrates how important signage was, not only on the outside of a business, but in its advertising. The Botwin's signage (if it ever existed in this grandeur) is now lost, and was most likely not, in fact, illuminated by City Hall's famed Lindbergh beacon. *Courtesy J. Eric Lynxwiler*

Van De Kamp's. The Van de Kamp's Coffee Shop Super Twin Drive-In and Bakery, here seen in all its neon glory in 1949, was adjacent to VDK's Holland Dutch Bakers, Inc. central baking kitchens at San Fernando and Fletcher. While this drive-in is long gone, the fight over the factory—known as the "Taj Majal" of all bakeries—continues. The remarkable 1929 structure, whose façade resembles a 16th century Dutch townhouse, was prepared by developers Larry and Ralph Cimmarusti of Cimm's, Inc. for demolition. They intended to build a home improvement "big box" store in its place, despite their not having secured a signed lease with any home improvement tenant. (Which is how the modern wonder of Coulter's department store was lost, and has remained an empty lot for twenty-plus years.) Preservationists persuaded City Hall to block demolition, and the façade is now planned to be retained and built into a community college satellite campus. *Courtesy of University of Southern California, on behalf of the USC Specialized Libraries and Archival Collections*

74

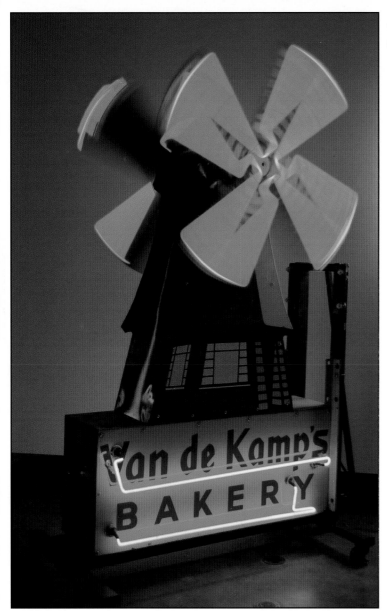

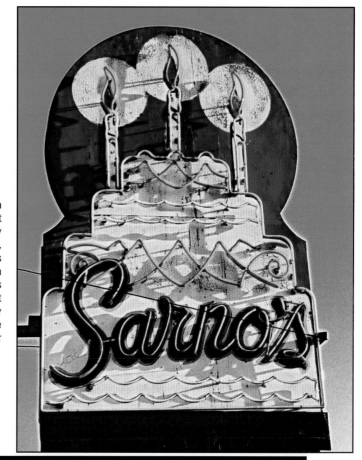

VDK's windmill at MONA. *Photo by Nigel Cox*

Sarno's. This Los Feliz bakery was a third-generation institution at Vermont and Hollywood, until the Sarno family had had enough (the Vermont area, once known for anarchist bookstores and old-world cheese shops, is now a high-rent boutique and Starbucks emporium). The fate of the cake is not known, but there is an effort afoot by the Museum of Neon Art to save the tasty neon. *Photo by Nathan Marsak*

Canter's. This magnificent neon baker graces the outside of Canter's, L. A.'s home away from home for aging punk rockers and aged Hebrew men. This rotund chef is probably serving up a big plate of challah, with which you may soak up matzoh ball soup, and make little sandwiches with your lox and horseradish. Convert-to-Judaism Marilyn Monroe was a regular; Canter's named a sandwich after her. *Photo by Nigel Cox*

Smoke Gets In Your Meat

Barbeque, the various spellings as diverse as the preparations, has quite a following in Southern California. Transplanted Texans, Missourians, and others vie for first place—not only in the sauce category, but also in signage.

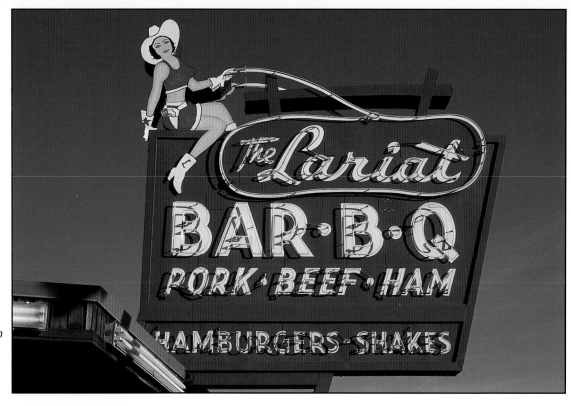

The Lariat. *Photo by John English*

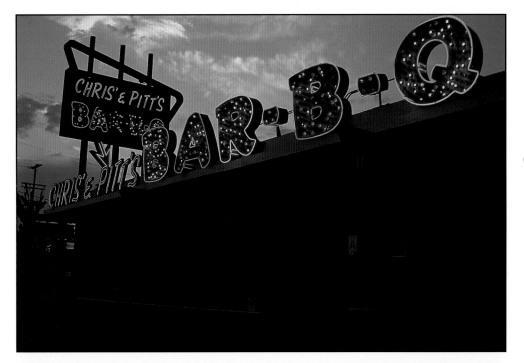

Chris' and Pitt's Bar-B-Q. *Photo by Larry Lytle*/MONA

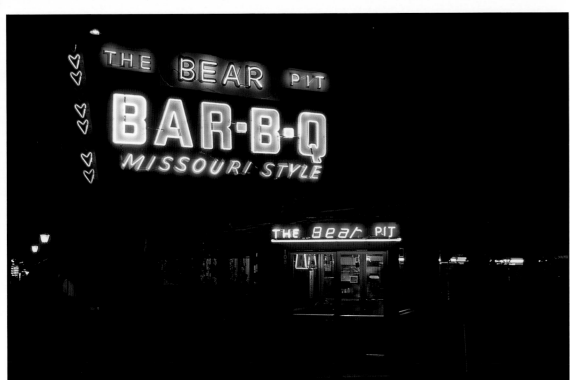

The Bear Pit. *Photo by Larry Lytle*/MONA

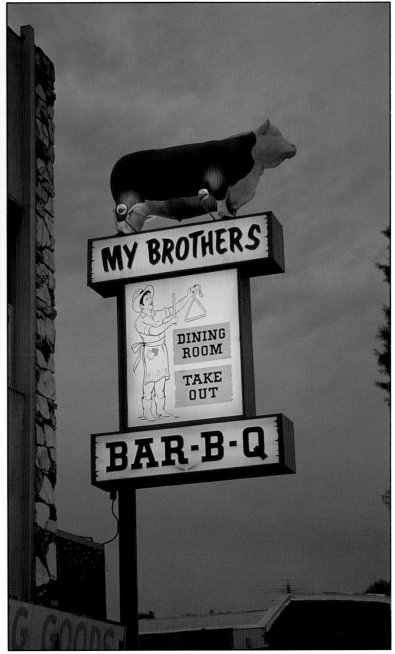

My Brothers Bar-B-Q. *Photo by Larry Lytle*/MONA

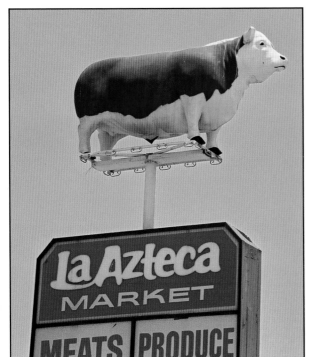

La Azteca. 1957 was a very big year for giant cows. La Azteca grazes down in Maywood; My Brothers' bovine resides up in Woodland Hills. *Photo by Nathan Marsak*

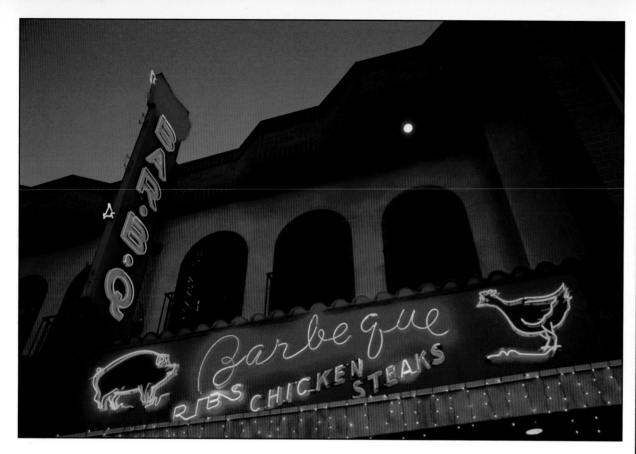

Gus's Barbeque. This is one of Western Civilization's great animated neons. The letters light in sequence while chickens and pigs run down the vertical blade (and presumably into the drooling mouths of those on the sidewalk). The City of Pasadena attempted to force the sign down—presuming that after the Northridge quake of 1995, twenty miles to the west, the sign was unsafe. The owners bravely battled for its retention, and it continues to enchant today. *Photo by Nigel Cox*

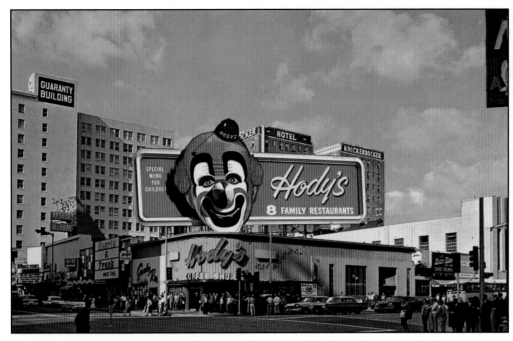

Hody's. Hody the Clown held Los Angeles in a grip of fear for years. Here, he terrifies those denizens unlucky enough to pass through the intersection of Hollywood and Vine, c. 1964. *Authors' collection*

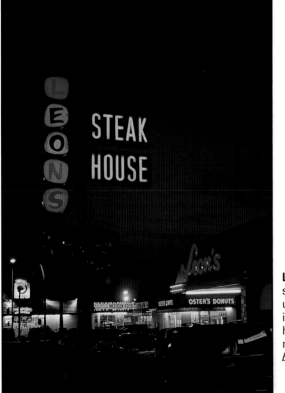

Leon's Steak House. The ironic element of a steak house is that when one sits inside its ubiquitous windowless confines, the carnivore is deprived of gazing at the wondrous signage humming outside. Here, Leon's speaks of meat and potatoes to a hungry world. *Photo by Larry Lytle/MONA*

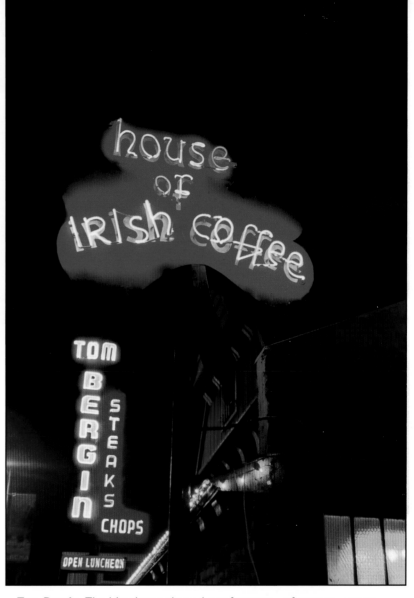

Tom Bergin. The big clover-shaped can features—of course—green neon. Bergin's was an immediate Irish hit when opened on Wilshire in 1934; it moved down Fairfax, and erected this sign in 1947. Matching clovers decorate the inside of the bar. A million Irish elbows have worn divots into the bar, where Irish stew, Irish whisky, and a billion pints of Guinness have been happily consumed for half a century—not to mention the endless Irish coffees, which Bergin's was first to introduce to L. A. *Photo by Nigel Cox*

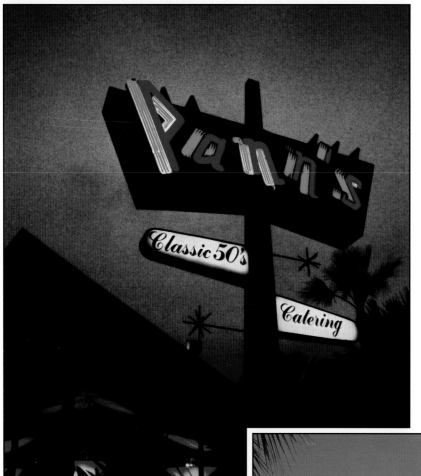

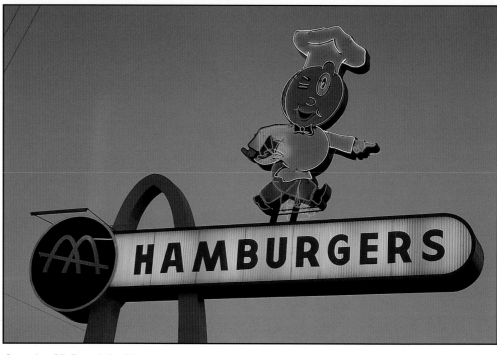

Speedee McDonald's. This oldest existing McDonald's with the original Speedee mascot neon was slated for demolition. The Los Angeles Conservancy Modern Committee stepped in and saved the 1953 Downey landmark. *Photo by Robert Landau*

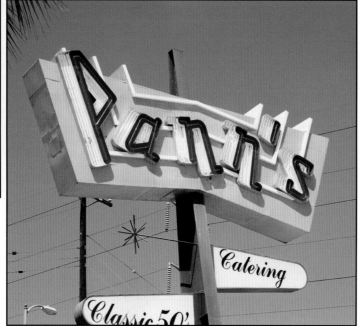

Pann's. The last and best remaining example of coffee-shop modern. Its monumental futurism, designed by Armet and Davis in 1958, is surmounted by a remarkable off-kilter, animated neon. According to owner Jim Poulos "the sign and the roof share the same angles and contours. Even the accent lines are the same. If you were to lay down the sign on its side, you'll see it has the same angles as the roof."

Armet and Davis learned such stylish architectonics from their mentor John Lautner, the architect who designed the celebrated (and demolished) Googie's. Hence the term "Googie" is commonly used to describe this type of extreme modernism, aka "Space-Age," "Jetson," "Populuxe" and so on. The style was marked by expansive windows, cantilevered folded plate roofs, sharp angles and boomerang motifs, integrated landscaping, and of course eye-popping neon. But postwar optimism waned, along with SoCal's aerospace industry, and after the 1968 introduction of McDonald's "Baltimore Roof" (that omnipresent shingled mansard), the restaurant world took on uniformity and backlit plastic signs like there was no tomorrow. There was in fact no tomorrow for the Googie coffee shop, examples of which fell to the bulldozer at an alarming rate. Pann's survives. *Photo by Nigel Cox*

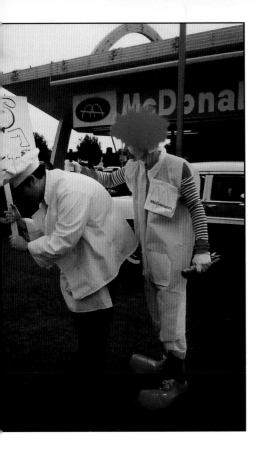

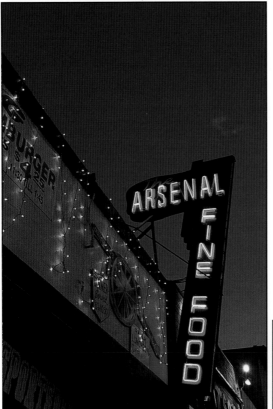

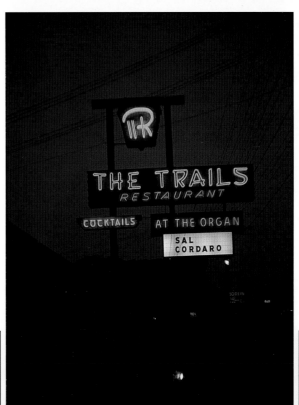

The Trails. Out on Route 66, this was a favorite location of Los Angeles Conservancy Modern Committee birthday parties and celebrations. It was known for its glorious organ recitals and free-for-all old world atmosphere. It closed in mid-2001. *Photo courtesy Charles Phoenix*

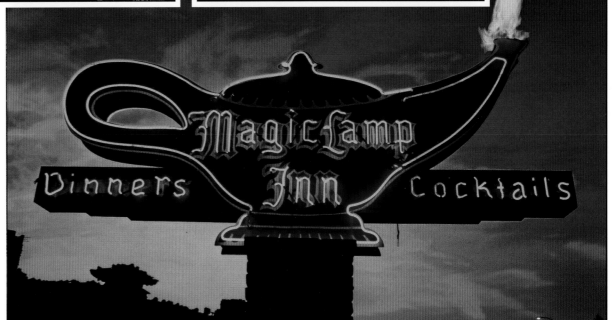

Top left: **Don't die Speedee!** Here you see Ronald stabbing Speedee in the back. Corporate disliked the bad press, and Speedee was saved. Proof positive that activism, especially of the colorful and theatrical variety, gets 'em every time. *Chris Nichols Collection*

Top center: **The Arsenal.** One enters into a dim, unknowable underworld beneath the watchful barrel of a giant gun. This remarkably shaped can was erected when the Arsenal became a weapons-themed restaurant in 1960. Fans agree that there is nothing quite like sinking into a bloody burger in a dark room surrounded by guns, battle-axes and sabers. *Photo by Nigel Cox*

Bottom right: **The Magic Lamp Inn.** Rancho Cucamonga's answer to a world lacking in giant oil lamps spewing fire. This 1955 wonder is well maintained by the owners and well loved by its legions of fans. *Photo by Nigel Cox*

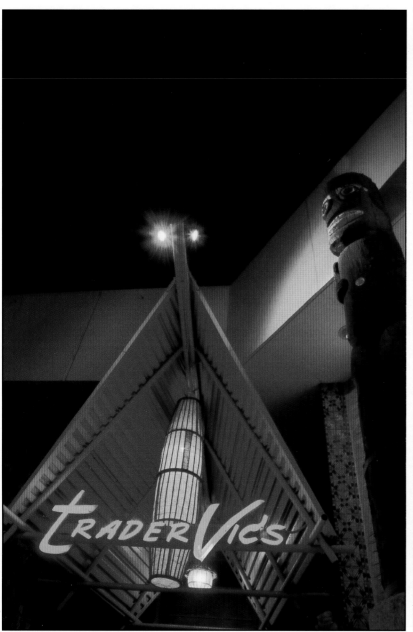

Left: **Trader Vic's.** In the early 1930s ,"Trader" Vic Bergeron ran a beer joint in Oakland called the Hinky Dink, which was renamed in 1937 and revamped in tikified Polynesia after an inspiring visit to Don the Beachcomber in L. A. There were once many a Trader Vic's, though now only four remain in America, one being right here in L. A. Although much of its interior has been compromised, this Beverly Hills landmark retains its outstanding 1955 signage and giant tiki. A great place for Scorpians and Zombies and the deadly Puka-Puka, not to mention the Mai Tai, which was invented by The Trader himself. *Photo by Nigel Cox*

Right: **Don The Beachcomber.** Don's was an early 1930s two-story affair, with open porches, lazily spinning ceiling fans, bamboo shutters and fences, all heavily obscured by unbelievably lush tropical vegetation. Now it's a parking lot. Gone are the glass-encased "chopsticks of the stars" and rain machine that showered the corrugated tin roof. All that remains is this backlit plastic sign, c. 1969. That it still stands is a miracle, but the lone remaining palm trees on the block have fiercely protected it. *Photo by Nigel Cox*

The Original Pantry. Ah, the Pantry—the neon is always lit, steaks always frying, the aged wait staff forever delivering endless bowls of coleslaw. And they are never closed, the doors never locked—never. They have no locks; none were installed in 1924. *Photo by Nigel Cox*

The Bahooka. Neon aficionados might scoff at the Bahooka's backlit signage, but it is an important signpost for those after an unbelievable experience. The Bahooka is a dark labyrinth of army helmets and fish-tanks, awaiting you with open arms and bizarre drinks. *Photo by Nigel Cox*

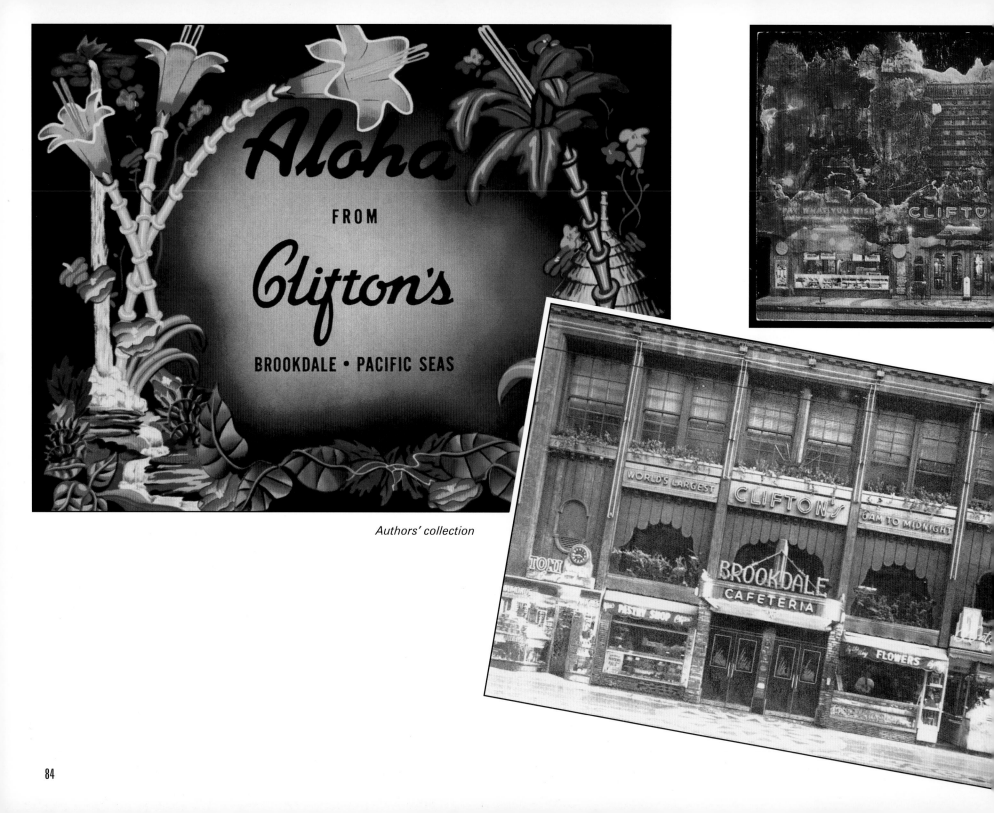

Aloha
FROM
Clifton's
BROOKDALE • PACIFIC SEAS

Authors' collection

Clifton's Pacific Seas. Some buildings evoke other times and places with period and cultural detailing. The Aztec Hotel projected its soul with vaguely Mixteca-Pueblo ornament; Don the Beachcomber was surrounded by sultry South Seas foliage. But Clifton's...Clifton's was its own continent. A gargantuan, looming island rising up from Olive Street smack in the heart of downtown. Its 1931 facade featured enough craggy cliffs, waterfalls and tropical vegetation to shelter and feed an entire colony of Tuamoto tribesmen. The depression-era rationale proffered by Clifford E. Clinton was that anyone without the money for a meal could pay what he or she could afford. Another facet of depression-era thinking was that Clifton's, like the extravaganzae of Busby Berkeley, would distract the everyman from the realities of the world. Inside Clifton's was an oasis of palms and flowers and canaries standing in for parrots. While Clifton's has since been remodeled, Clinton's 1935 Brookdale Cafeteria, around the corner at Sixth and Broadway, maintains its forest motif. *Courtesy J. Eric Lynxwiler*

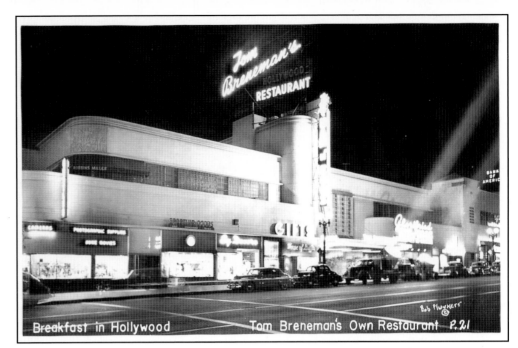

Breakfast in Hollywood — Tom Breneman's Own Restaurant P.21

Tom Brenneman's. Tom Brenneman was the consummate showman, inviting "200,000 for breakfast" every morning via his radio program. He broadcast from Sardi's Cafe near Hollywood and Vine throughout the thirties, but got big enough to require his own place––especially one with lots of neon. Brenneman's Hollywood Breakfast, where filmdom's finest met to eat (and plug their latest projects on the air), had a first-class blade reading "Ham n' Eggs," topped by a neon pig. *Authors' collection*

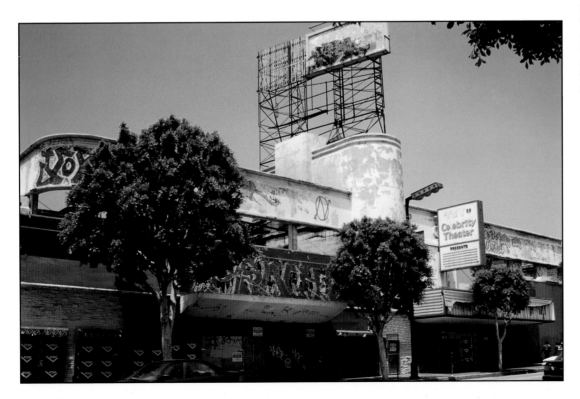

Tom Brenneman's Today. *Photo by Nigel Cox*

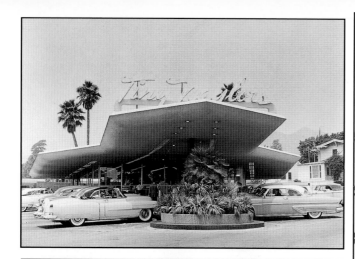

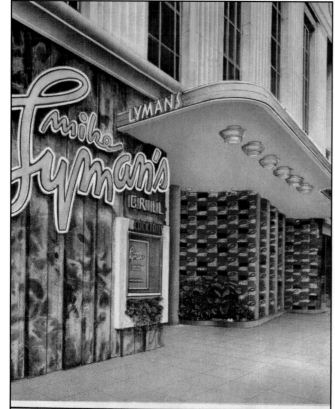

Mike Lyman's Grill
424 WEST SIXTH STREET
LOS ANGELES, CALIF.

"Where the West Eats the Best"

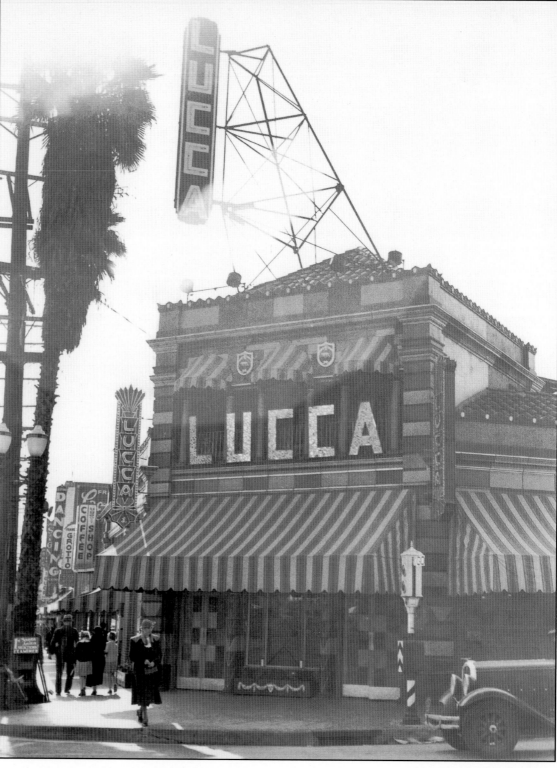

BEVERAGE SUGGESTIONS

Lucca Special Cocktail50
Champagne Cocktail60

California Wines - Lucca Private Stock

DRY	½ Bottle	Large Bottle
Burgundy (Red)	.75	1.25
Sauterne (White)	.75	1.25
Lucca Special Old Reserve Burgundy		1.75
Lucca Chianti½ 1.00	Flask	1.75
Tipo I. S. C.1.10		2.00

SWEET	Glass	Large Bottle
Old Port, Dry Sherry or Muscatel .30		2.00

CALIFORNIA SPARKLING WINES

	Half Bottle	Large
Sparkling Burgundy, Val Bros. 2.50		4.00
Sparkling Burgundy, F. I.		4.50

CALIFORNIA CHAMPAGNE
Naturally Fermented

Padre SecHalf 3.00	Large Bottle 5.00
Ambassador	Large Bottle 5.00
Golden State	Large Bottle 5.00

*

SPECIAL RESERVE WINE
IN BEAUTIFUL SOUVENIR
COLORED JUGS

Sauterne or Burgundy....2.50
Port, Sherry, Muscatel....3.25

*

Eastern Beer35
Local Beer25

For Other Beverage Suggestions
Please Ask for Wine List

SUPREME LUNCHEON

(Served Monday through Saturday

LUCCA ORIGINAL ANTIPASTO
**
MINESTRONE
**
SPAGHETTI — RAVIOLI
**
CHOICE OF ENTREE
Price of Entree Determines Price of Luncheon

Sirloin Tips Saute Mushrooms with Rice .. $1.25

Fried Filet of Sole, Tartar Sauce 1.25

Peach and Cottage Cheese Salad 1.25

Salmon Steak, Saute Meuniere 1.25

Calf Liver Saute with Onions 1.25

Pot Roast of Beef, Savory Sauce 1.25

Fried Scallops, Tartar Sauce 1.50

Fried Louisiana Shrimps, Special Sauce .. 1.50

Breaded Veal Cutlet a la Milanaise 1.60

Fried Unjointed Half Spring Chicken 1.80

SPECIAL LUCCA T'BONE STEAK 2.10
BROILED LUCCA FILET MIGNON 2.30

DESSERT
LUCCA FROZEN SPUMONI
LUCCA HOME MADE PASTRIES
FRESH ROASTED LUCCA SPECIAL BLEND COFFEE

OUR COFFEE FOR YOUR HOME MAY BE
PURCHASED IN OUR COFFEE SHOP

TAKE HOME A BOX OF SMALL PASTRIES
(PETITS FOURS) 20c per Box

A LA CARTE

Spaghetti Lucca	$.85
Spaghetti and Ravioli	.90
Ravioli	.95
Spaghetti and Meatballs	1.00
Broiled Salisbury Steak	1.35
Fried Shrimps	1.35
Chicken Liver Sauté	1.50
Scaloppine Au Marsala	1.50
Fried Chicken	1.60
Chicken á la Cacciatore (for two)	3.50
T-Bone Steak	1.85
Broiled Lucca Filet Mignon	2.00

All above meat orders include vegetable
and potatoes, bread and butter.

American or Swiss Cheese Sandwich	$.50
Hot Dipped Sandwich du Jour	.65
Ham Sandwich	.70
Ham or Bacon and Egg Sandwich	.75
Chicken or Turkey Sandwich	.75
Club Sandwich	.95

French Pastries	.25
Spumone	.25
Petits Fours - Tray	.35

Coffee - Milk or Tea	.10
Coffee Pot	.40

TODAY'S SPECIAL

DELMONICO STEAK

WITH

MUSHROOM SAUCE
$1.25

COMPLETE LUNCHEON

Our SPUMONI, CAKES and PASTRIES
are made on the premises and may be
purchased in our Pastry Shop

See Our
CALIFORNIA POTTERY DISPLAY

Hear
GINO SEVERI'S CONCERT ENSEMBLE

VISIT OUR UNIQUE
POKER CHIP COCKTAIL LOUNGE

Menu from Lucca's. *Authors' collection*

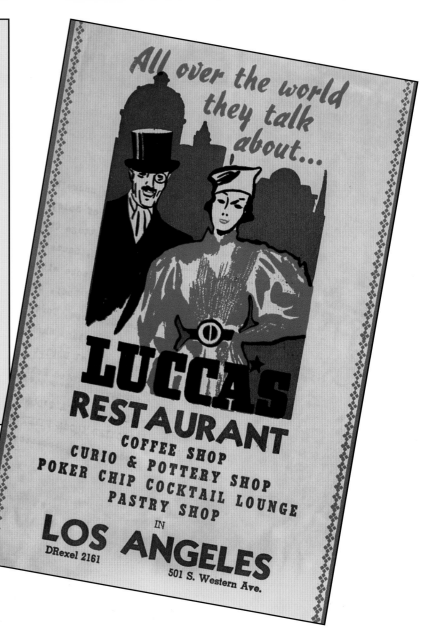

Opposite page, top left: **Tiny Naylors R.I.P.** *Authors' collection*

Bottom left: **Lyman's.** Mike Lyman learned about neon. His grill near Hollywood and Vine was forever overshadowed by the nearby restaurant/nightclubs of The Brown Derby, La Conga and Sardis, among others, but then, it didn't have the signage they did. He opened another Mike Lyman's at Eighth and Hill, but it too suffered from unimpressive signage. His grill at Sixth and Olive, however, pulled out all the stops with this giant neon script. *Authors' collection*

Right: **Lucca's Restaurant on 5th and Western.** This establishment, and the wealth of signage that stretched in all directions, has disappeared, displaced by time and strip malls sprouting Spanish and Korean signage. *Photo Collection /Los Angeles Public Library Photo Collection*.

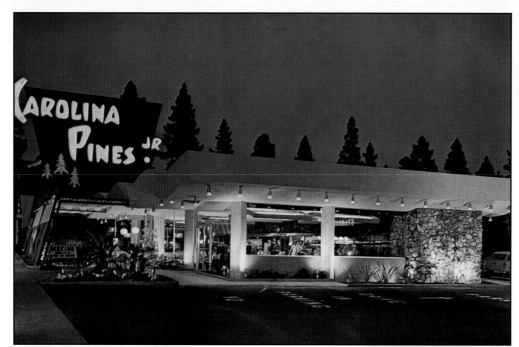

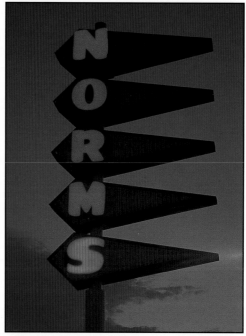

Norm's. Several of these icons of 1950s Los Angeles still stand, proud sentinels against the darkening sky. *Photo by Larry Lytle/MONA*

Carolina Pines Jr. Despite the name, to the developers of this coffee shop, the great Carolina pine forests evoked an expanse of river rock and glass, a folded plate concrete roof, a googie porte-cochere and a giant yellow neon sign. In defense of CPJ, they *did* affix neon pine trees to it. Once sited at the corner of Sunset and La Brea, this Armet & Davis-designed Hollywood landmark has since become a mini-mall. *Authors' collection*

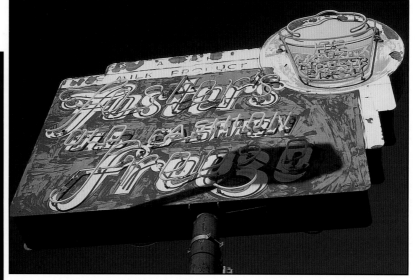

Foster's Freeze. *Photo by John English*

Hot Ice Cream. Once a staple of the Pomona County Fair, but after the grounds became the "Fairplex" this poor neon sign was given the heave-ho. *Photo by Nigel Cox*

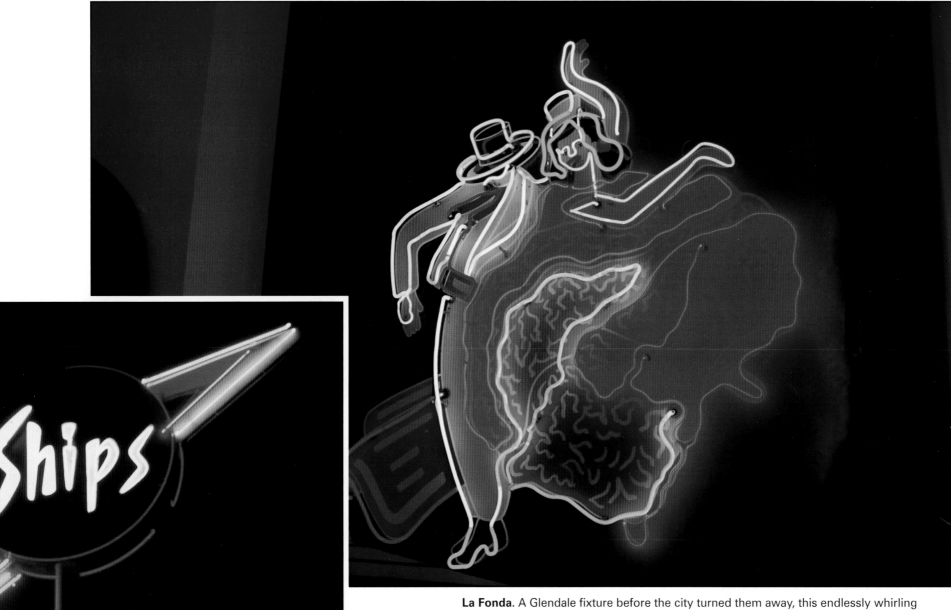

La Fonda. A Glendale fixture before the city turned them away, this endlessly whirling couple now glides across the floor of the Museum of Neon Art. *Photo by Nigel Cox*

Ships. Ships was one of the great Los Angeles institutions, and the day its sign came down was a dark one for the city. Said Scott Hopper, owner of Track 16, who salvaged the sign, "It was easily twenty feet across. The round 'Ships' part was about twelve feet in diameter. It was too much to move and store and it eventually got cannibalized, and now we only have the script." *Photo by John English*

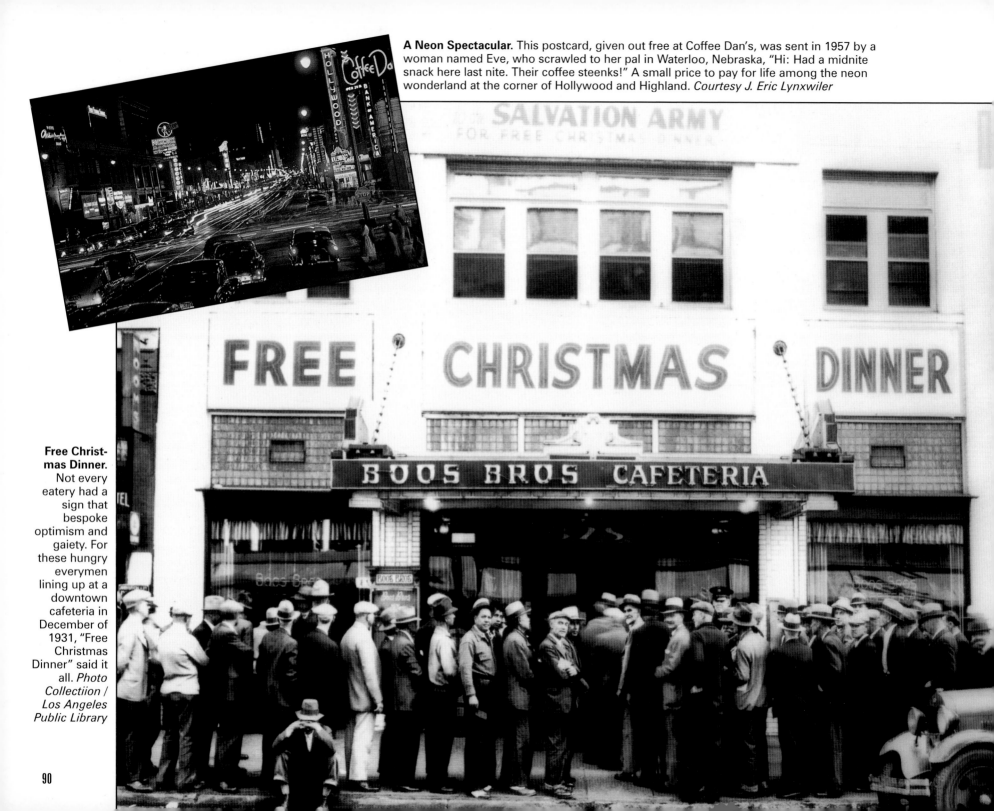

A Neon Spectacular. This postcard, given out free at Coffee Dan's, was sent in 1957 by a woman named Eve, who scrawled to her pal in Waterloo, Nebraska, "Hi: Had a midnite snack here last nite. Their coffee steenks!" A small price to pay for life among the neon wonderland at the corner of Hollywood and Highland. *Courtesy J. Eric Lynxwiler*

Free Christmas Dinner. Not every eatery had a sign that bespoke optimism and gaiety. For these hungry everymen lining up at a downtown cafeteria in December of 1931, "Free Christmas Dinner" said it all. *Photo Collectiion / Los Angeles Public Library*

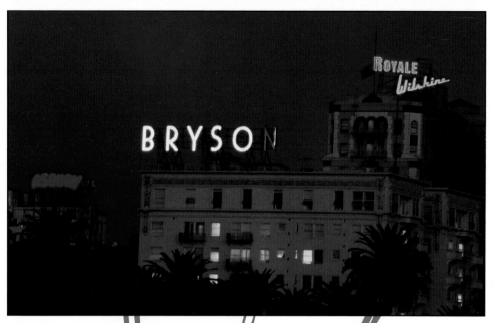

Chapter 4

Gracious Living

"… the Bryson was a white stucco palace with fretted lanterns in the forecourts and tall date palms. The entrance was up marble steps through a Moorish archway, and over a lobby that was too big and a carpet that was too blue…there was a desk and a night clerk with one of those mustaches that get stuck under your fingernail…" -Raymond Chandler, *The Lady in the Lake. Photo by Nigel Cox*

It's a long trek across the desert to reach Los Angeles. Slowly, the city unfolds, rising up, winking, blinking, and vibrating with possibility. The standard mission of any settler: homestead. It'll be a while before your life is on track and you're the proud owner of that little stucco job with its tiny lawn out in some bedroom community. Or you may just decide that such responsibility doesn' t reflect your kinetic energy, and you elect to hang your hat somewhere more fluid. Either way, you'll need a place to stay.

Countless places to put up your feet, to lay your head, to sleep it off, to murmur a million words of pillow talk. Garden apartments. Bungalow courts. Flop house rooms above liquor stores. Swanky Wilshire hi-rise apartment buildings. Rooms by the week, rooms for eternity. Los Angeles, come for a night, stay for a lifetime.

There's a tension: personal living space is introverted. The signage radiating from the top of the apartment complex is extroverted. The grand apartment complex rooftop crowns of the 1920s and 30s were both warm and cool, inviting yet imposing, meant to be read from miles away and yet anchoring the building to its site.

Los Angeles sparkled with over a hundred neon rooftop crowns, until that fateful day in February 1942 when Mayor Fletcher Bowron ordered them shut off. His post-Pearl Harbor jitters weren't totally unjustified; Los Angeles military operations were centered adjacent to Westlake Park, ground zero of neon glory.

While the Japanese bombing runs never materialized (save for the errant torpedoing of a gas line up in Ellwood), many apartment owners didn't feel the impetus to turn their signs back on at the war's conclusion. Signage changed, and the grand old crowns looked

staid compared to the newer, livelier atomic-age asterisks and starbursts of motor hotels (we call them "motels!") that began to cater to a quicker, more mobile society.

The great concentration of these crowns along Wilshire stayed dark. Postwar suburban expansion killed off the boom in residence hotels. Everyone suddenly realized they didn't have to wait – they could have that little lawn and two-car garage *now*.

The signs (and the neighborhood) deteriorated, becoming little more than havens for L.A.'s pigeon population. However, when Adolfo V. Nodal (whose grandfather introduced neon to Havana) joined the Los Angeles Cultural Affairs Department in 1987, it became his mission to relight L.A.'s neon skyline. The CAD joined up with the City Redevelopment Agency (CRA) who were less known for preservation than for bulldozing Victorian mansions. Nevertheless, after ten years and $400,000 in city money, fighting building owners who believed it "too good to be true," and enduring riots and earthquakes, Nodal and the CAD relit more than thirty signs along the Wilshire Corridor and had formed LUMENS—the Living Urban Museum of Electric and Neon Signs. He then turned his attention to Hollywood, relighting apartment houses, theaters, and hotels. (Nodal finally left the CAD to pursue the relighting of Broadway's historic theater core on his own.)

Now, these glorious apartment buildings of Hollywood's golden age are once again in vogue. The interiors have been restored, or at least saved from decrepitude with a re-model, and upwardly mobile young Angelenos wait for a chance to live under a stately neon crown blazing in the night.

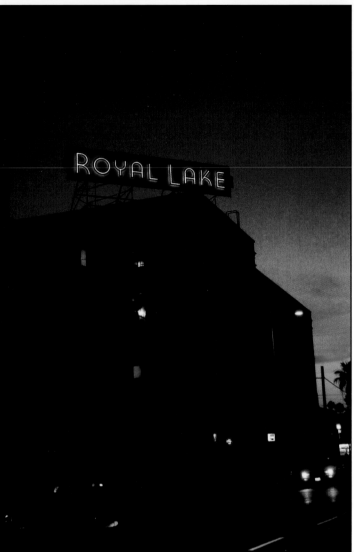

The Royal Lake. It's 1936. A Dusenberg glides down the boulevard, back window concealing the mysterious passenger within. As the chauffeur steers the car under the ornate porte-cochere, a hat-and-glove-clad doorman smoothly steps forward to give his aid.
Thanks to Al Nodal and the C. A. D., this glamorous era, long gone, has (to some degree) returned. *Photo by Nathan Marsak*

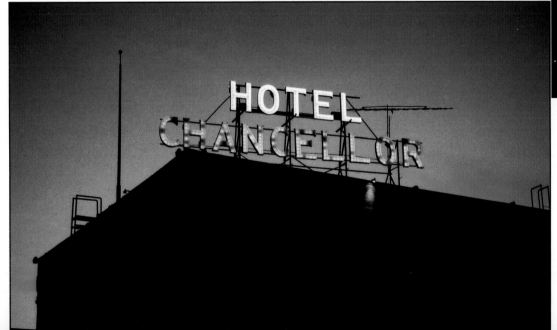

The Hotel Chancellor. *Photo by Nathan Marsak*

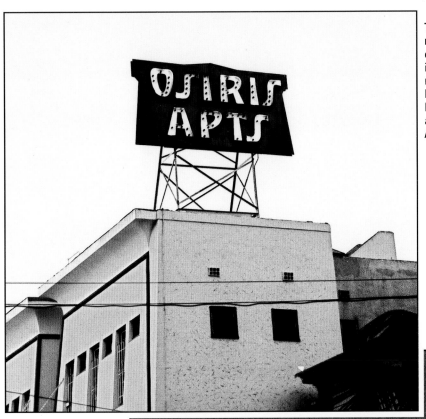

The Osiris Apartments. A rare, extant example of incandescent rooftop signage, lording over a lowly ghost sign across the street. *Photo by Nigel Cox*

The Roosevelt Hotel. This building has two rooftop crowns; one reads "Roosevelt Hotel" and the other "Hotel Roosevelt." They stand guard over Hollywood Boulevard, white in the day, glowing red at night. But once, the signs read: "The Hollywood Roosevelt." Over the years, the "Hollywood" was dropped. This hotel's signs are two of the few that never went dark, as the lavish 1926 hotel, financed by Mary Pickford, Douglas Fairbanks and Louis B. Mayer (and home of the first 1929 Oscar ceremonies) mysteriously survived the Hollywood blight years of the late twentieth century. *Photo by Nigel Cox*

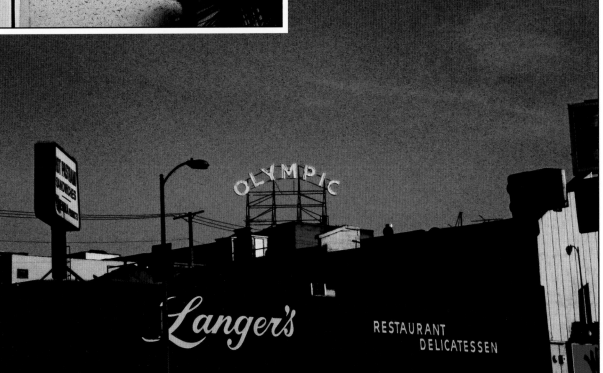

The Olympic at Westlake and 7th. *Photo by Nigel Cox*

The DuBarry. This S. Charles Lee-designed building sports a fanciful script sign to match its Franco-Norman architecture. *Photo by Michael A. Burke*

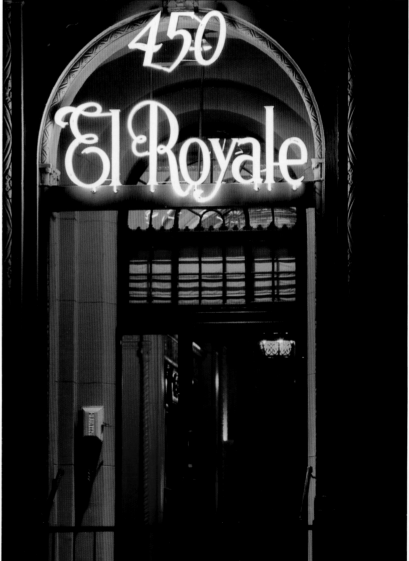

The Ravenswood. Assistant Property Manager Jim Murrey, at age 70, is the history buff attached to the Ravenswood. As he tells it, construction began on the seven-story structure in 1928, and in 1930 it opened its doors. "I was told different stories but apparently Paramount didn't own the building but they did fund construction of it. They wanted a place close to the studio to house their contract players."

Of the 96 apartments, 25 were fully furnished; appointments included doormen, concierges, full-time maids and valet parking attendants. Mae West kept a two-bedroom apartment on the 6th floor. Her all-white décor was filled with white French provincial furniture. "*Everything* in the apartment was white. It was quite a place," Murrey added, "She lived the last 48 years of her life at the Ravenswood." The much-loved building also sports a much-loved sign.

"Everyone who has ever been to Hollywood knows the Ravenswood Sign." Murrey noted. "The letter "R" is 10 feet high, the "D" is 8 feet and the middle letters are 6 feet tall. Each letter is backed by stainless steel, which has oxidized to a gray color. The sign itself is 100 feet long and extends up 40 feet from the rooftop." Murrey added that repair people are called in for upkeep two or three times a year. "Considering its age and size it requires minimal upkeep. It would never live in the Midwest with hailstorms and tornadoes." *Photo by Michael A. Burke*

The Krypton-lit doorway of the El Royale. *Photo by Michael A. Burke*

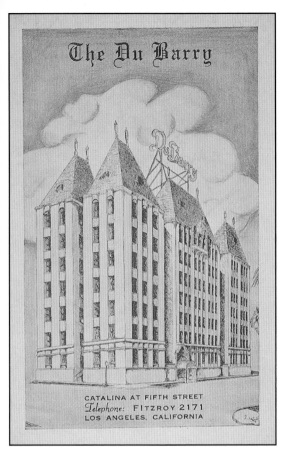

The Du Barry

CATALINA AT FIFTH STREET
Telephone: FITZROY 2171
LOS ANGELES, CALIFORNIA

Courtesy J. Eric Lynxwiler

The Gaylord. Ray Neal, of Standard Electrical Services, relit the Gaylord for the Cultural Affairs Department. Recounts Neal: "There was no gas in the tubing so we had no idea what gas to add, which would determine what color the sign would be. We bandied about different ideas, blues, reds, yellows. I got to chatting with a 90-year-old woman sitting in the lobby and I explained that I was there to relight the sign. She was overjoyed, and told me 'Oh yeah, a long time ago we used to all go out, get drunk, and have to find our way back. Once we could find the green light of the Gaylord sign it was like the North Star, and we would follow it home.' My jaw hit the floor! Here I had a first-hand account that the sign was green. So not only is the sign relit, but it's historically accurate." *Photo by Michael A. Burke*

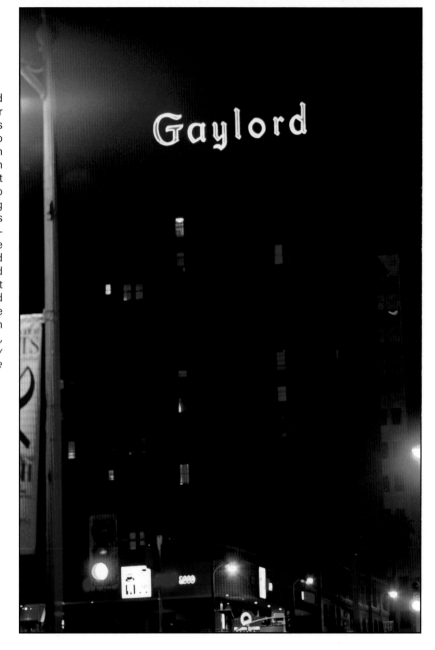

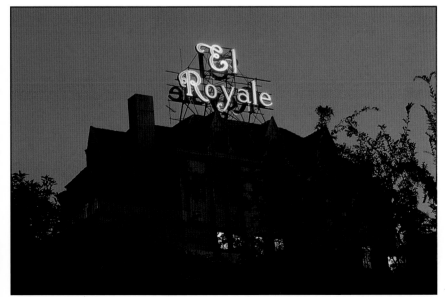

The El Royale. Since 1929, this chartreuse neon has loomed over the Wilshire Country Club. Many consider its sign, perched twelve stories high atop the Spanish Renaissance Revival structure, the most elegant beacon over Los Angeles. Said Property Manager Sandy Griffin, "We had the sign worked on after the energy crisis in the 1970s. And we basically didn't light it during that time. In 1983, we had the sign reconditioned and had a wonderful ceremony relighting it. It's been shining ever since. Although we are cutting back on the number of hours it is lit today because of our latest energy crisis. Poor sign…" she added, "it keeps getting caught up in all these political issues." *Photo by Nigel Cox*

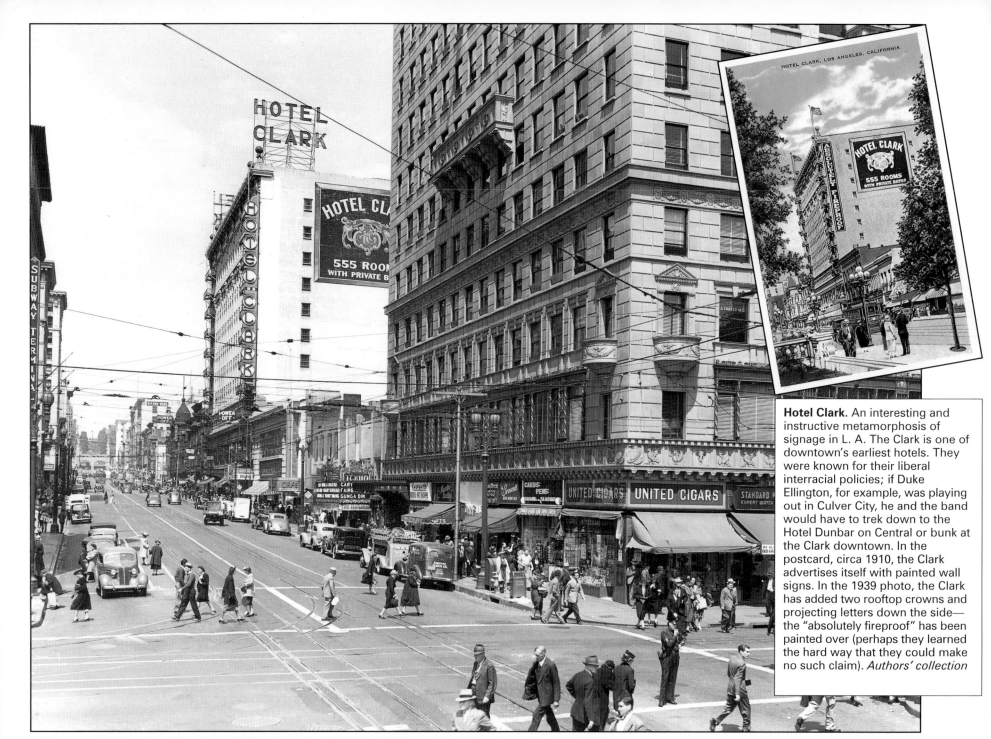

Hotel Clark. An interesting and instructive metamorphosis of signage in L. A. The Clark is one of downtown's earliest hotels. They were known for their liberal interracial policies; if Duke Ellington, for example, was playing out in Culver City, he and the band would have to trek down to the Hotel Dunbar on Central or bunk at the Clark downtown. In the postcard, circa 1910, the Clark advertises itself with painted wall signs. In the 1939 photo, the Clark has added two rooftop crowns and projecting letters down the side—the "absolutely fireproof" has been painted over (perhaps they learned the hard way that they could make no such claim). *Authors' collection*

Courtesy of University of Southern California, on behalf of the USC Specialized Libraries and Archival Collections

The Montecito. This high-deco structure survives today as a retirement home. *Photo by Nigel Cox*

Hotel Californian. These timeworn letters once graced the rooftop of a residence hotel near Sixth Street downtown. Now, they sit across town in a Los Feliz field. Sweet mysteries of life. *Photo by Nathan Marsak*

The Clark today. The ghost sign has disappeared, the crowns are gone, and the round projecting letters advertise nothing. The Clark is boarded up and abandoned. *Photo by Nigel Cox*

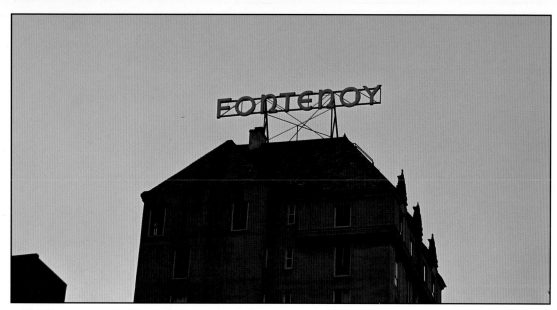

The Fontenoy in Hollywood. *Photo by Nigel Cox*

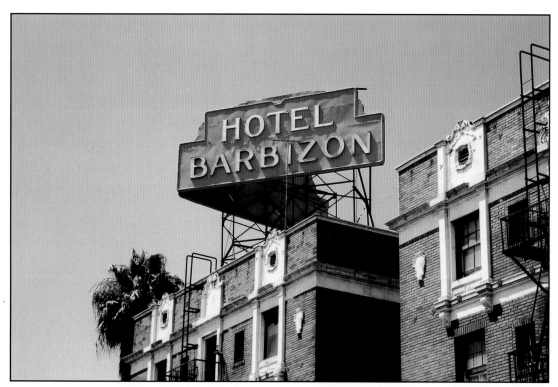

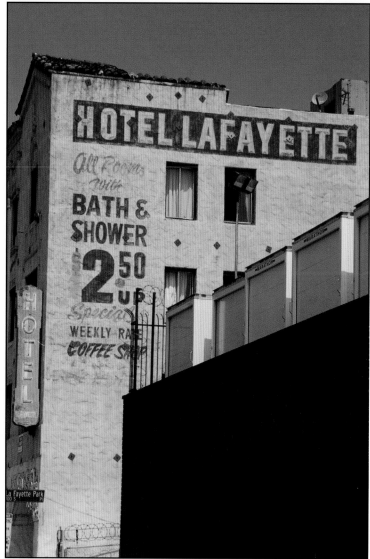

The Lafayette. A ghost sign from a luckless brick pile, down and out as its tenants. This faded hotel wakes bleary-eyed every noon and sinks into stupor every midnight. *Photo by Nathan Marsak*

The Barbizon. *Photo by Nathan Marsak*

Ghosts of Glamour

In the neighborhood bordering Westlake Park, these strongholds of the past proudly raise their crowns to the sky. Before WWII, those who couldn't afford the chic-ness of Mid-Wilshire, but still wanted some swanky digs, chose this area in which to settle. Sadly, the neighborhood has slowly run down over the years, leaving just these remaining tokens to let us imagine what it was once like.

The Ancelle on Gramercy and 7th. *Photo by Nathan Marsak*

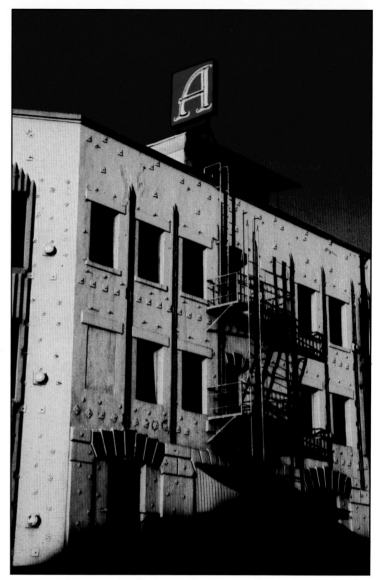

The Adelphia at 1515 West 8th Street. *Photo by Nigel Cox*

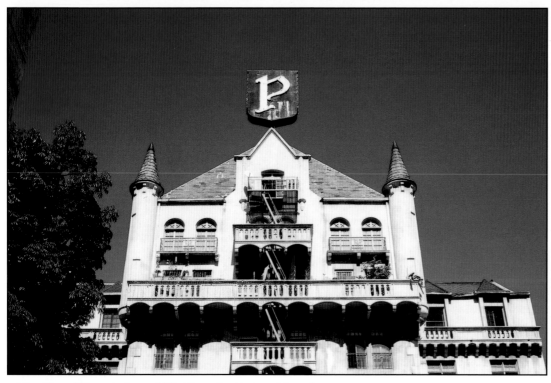

The Piccadilly at Irolo and 7th. *Photo by Nathan Marsak*

The Arwyn at 3835 West Eighth Street. The restored neon has already been defaced with graffiti. *Photo by Nathan Marsak*

The Park Wilshire at Wilshire and Carondalet. *Photo by Nathan Marsak*

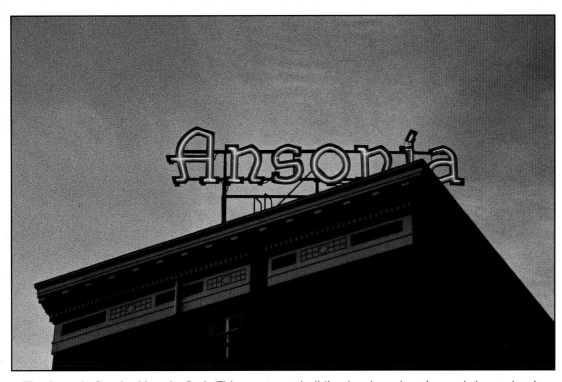

The Ansonia Overlooking the Park. This apartment building has been kept in good shape, despite its shady surroundings. *Photo by Nigel Cox*

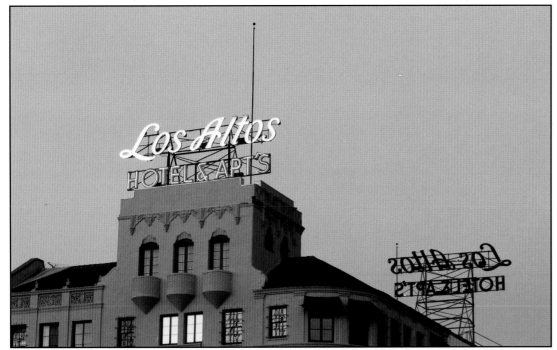

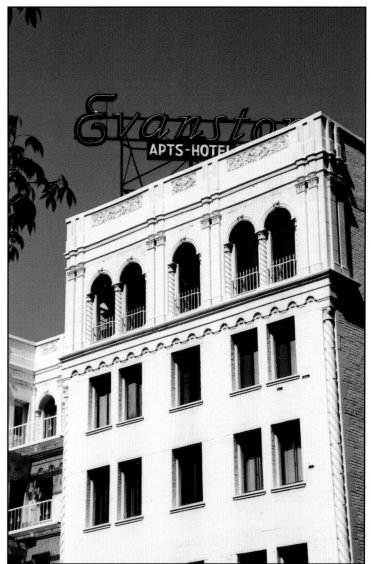

The Evanston. *Photo by Nathan Marsak*

The Los Altos on Wilshire. This once was (and some contend still is) the most prestigious address in Hancock Park. At one time Marion Davies, confidante of Hearst, kept an entire floor here. Its rooftop signs are original to the 1925 Spanish Colonial structure. *Photo by Nigel Cox*

101

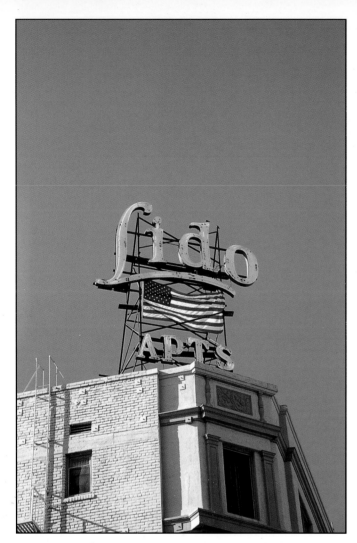

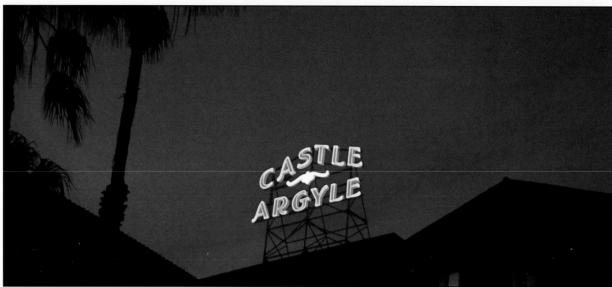

Castle Argyle. This 1929 Castle presided over Hollywood with stately grace; its residents included Howard Hughes, Bugsy Siegel, John Wayne, Paulette Goddard, Clark Gable, and Jean Harlow. It lost a good bit of its charm when a freeway overpass was dropped in its front yard in 1954. Despite its landmark status on the National Register of Historic Places, it sat abandoned and derelict for most of the 1970s and '80s. It has since been brought back as a retirement home, and its neon once again bathes the palms in a sapphire hue. *Photo by Nigel Cox*

The Lido in Hollywood. This rooftop crown (which once read "Hotel & Apts") would be absurdly easy to relight, as all of the neon is original and intact. Reportedly, Council-woman Jackie Goldberg has forbid its relighting. *Photo by Nigel Cox*

Hotel Constance. This comely lass takes care of Pasadena's Hotel Constance neon blade circa 1930. *Photo Collection /Los Angeles Public Library*

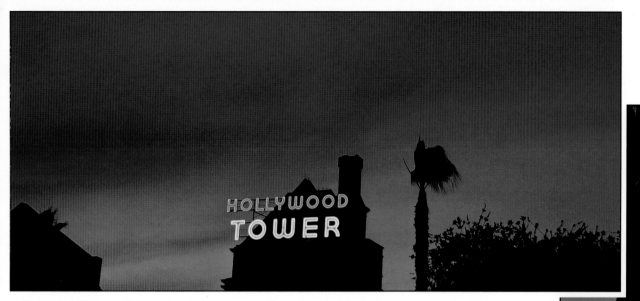

Hollywood Tower. This foreboding structure glares at motorists whizzing by on the 101 Freeway, which was constructed years after the Tower was already a permanent resident. *Photo by Nigel Cox*

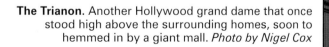

The Trianon. Another Hollywood grand dame that once stood high above the surrounding homes, soon to hemmed in by a giant mall. *Photo by Nigel Cox*

Welcome to L.A.

It's not good enough, in Tinseltown, to just *live* in a neighborhood. That neighborhood has to be advertised—in lights, if possible. Most areas used to have neon signs declaring their borders. They wanted you to know you had entered a special place—someplace *not* part of Los Angeles. Ironic, because only in an urban sprawl like Los Angeles would this happen. Most of these old neons have disappeared, or have been replaced with more sedate, "tasteful" signage. But those that survive are kept in good working order, proud reminders to the residents that after a long day on the freeways, they've come home.

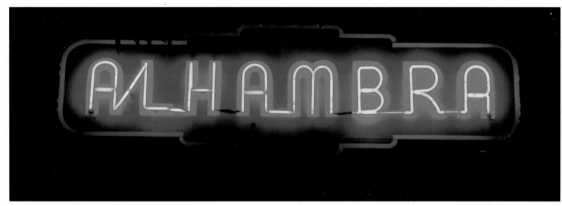

Photo by Nigel Cox

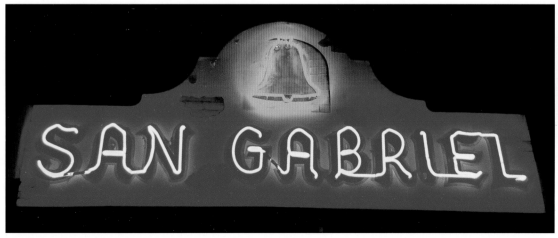

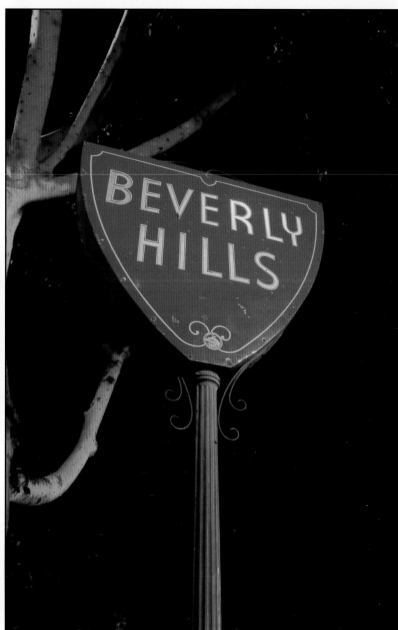

Photo by Nigel Cox

Photo by Nigel Cox

Photo by Nigel Cox

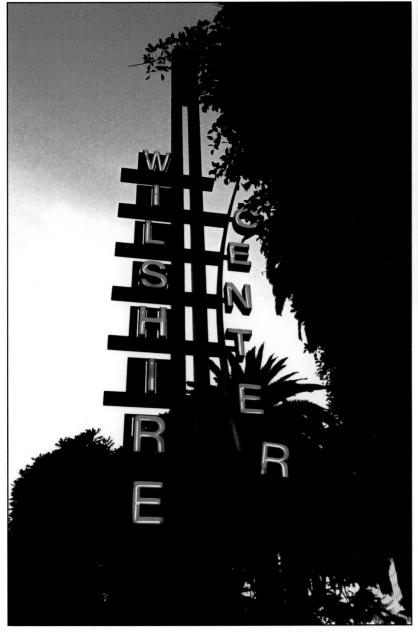

Photo by Nigel Cox

Shopper's Paradise

"I left the freeway and turned onto Ventura Boulevard, where you can buy anything you want, and anything you don't want. The storefronts on this smoggy expressway feature manifestations of every scheme, dream, and hustle the jaded American mind can conceive. It is beyond tragedy, beyond vulgarity, beyond satire. It is supreme guilelessness. There are approximately eight billion of these storefronts—and three billion new and used car lots."

- James Ellroy, *Brown's Requiem*

Photo by Michael A. Burke

They say in New York you can always buy Chinese food at three in the morning. Who wants Chinese food at three in the morning? I'd rather buy a piano by the light of a neon Steinway, or at least buy my shoes in a building shaped like a giant shoe.

Early Los Angeles commercial architecture had its genesis downtown with every city's standard Beaux-Arts-influenced Neoclassical office blocks complete with the requisite shop fronts at ground level. The basin's 1920s population explosion, combined with the advent of the motorcar, dispersed shoppers hither and yon. With eye-catching signage aimed at the street and store entrances directed toward the parking lot, Spanish Colonial and Oriental-themed shopping centers flourished. Commercial development began to stretch away from the city center and down a peculiar stretch of pavement surrounded by scrub named Wilshire Boulevard. Wilshire blossomed with Art Deco towers and modern lo-rise shopping developments, whose signage sprouted up more eye-popping than the next. Much of this strip and its surrounding area have been compromised, losing many exceptional buildings and building many unexceptional ones.

The shopping world of Los Angeles was definitely not confined to city proper. Commerce shot northwest to the Valley and southeast to Orange County. These and other outlying areas enticed the shopper with wide boulevards, luring shoppers with brilliant and decadent signs that could be seen for miles.

"Fifth Avenue of the West"

Mighty Wilshire Boulevard, sixteen miles from downtown to the Pacific. Containing, of course, the Miracle Mile, that automobile-savvy commercial strip of moderne buildings and outstanding signage. H. Gaylord Wilshire, Marxist millionaire inventor of quack medical devices, developed Wilshire Boulevard in the 1880s.

It was still mostly bean fields and scrub-brush when, in the 1920s, a gent named A. W. Ross decided to buy up the area roughly between La Brea and Fairfax for commercial development. Everyone scoffed, and it was deemed "Ross' Folly." It was said that if his scheme ever got off the ground it would be "a miracle." But Ross pioneered synchronized traffic signals, parking limits, ornamental streetlights, and modern buildings oriented to the automobile, and Ross' Folly became the Miracle Mile.

*Photo Collection /Los Angeles
Public Library*

Photo by Nigel Cox

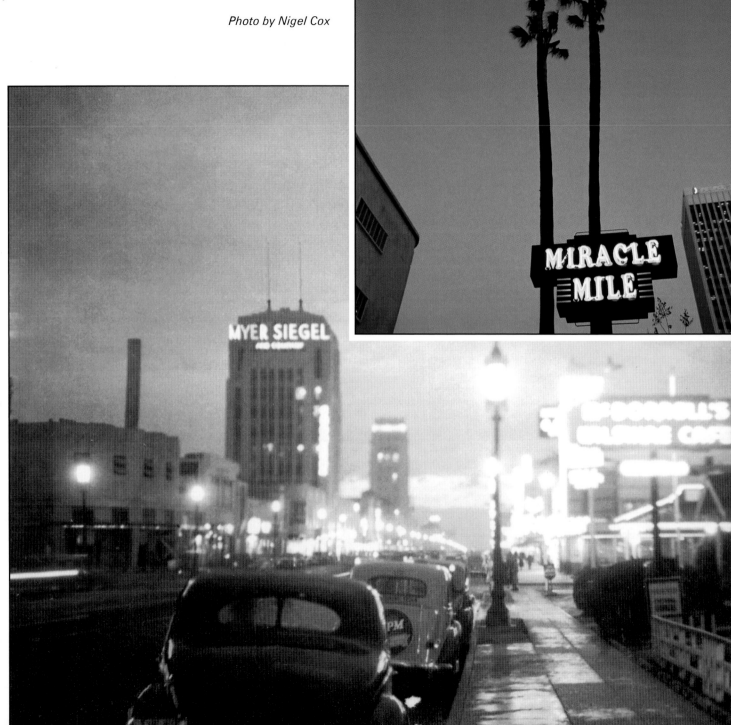

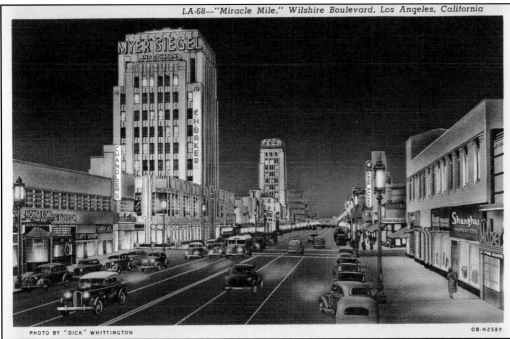

LA-68—"Miracle Mile," Wilshire Boulevard, Los Angeles, California

PHOTO BY "DICK" WHITTINGTON
OB-H2587

Miracle Mile, c. 1940. *Authors' collection*

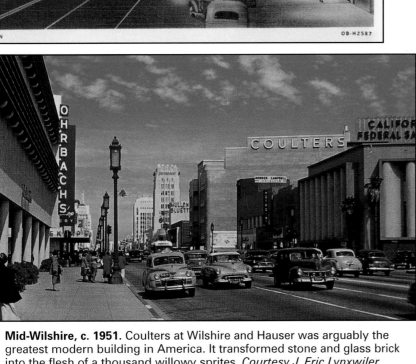

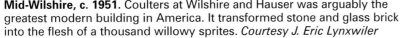

Mid-Wilshire, c. 1951. Coulters at Wilshire and Hauser was arguably the greatest modern building in America. It transformed stone and glass brick into the flesh of a thousand willowy sprites. *Courtesy J. Eric Lynxwiler*

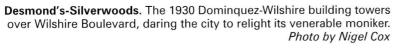

Desmond's-Silverwoods. The 1930 Dominquez-Wilshire building towers over Wilshire Boulevard, daring the city to relight its venerable moniker. *Photo by Nigel Cox*

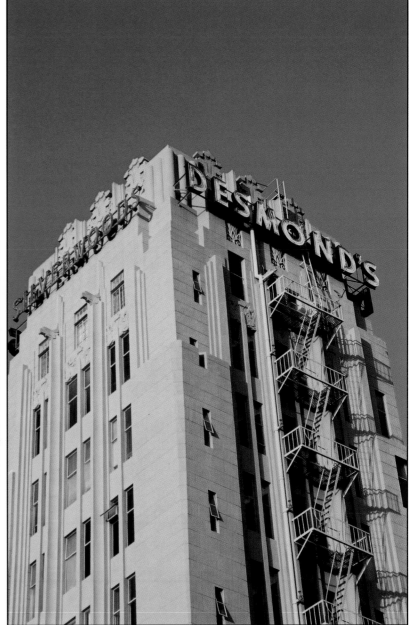

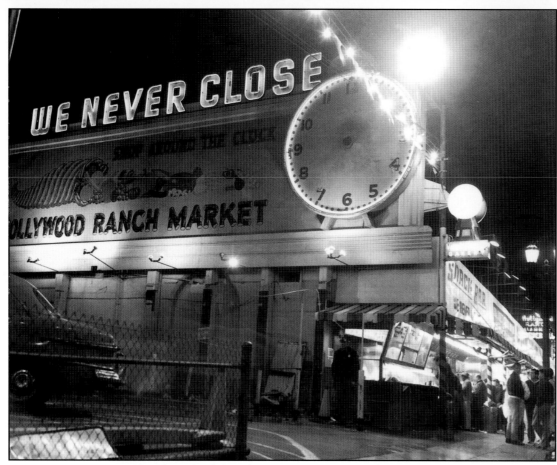

Retting Guns. This firearm-shaped neon sign in Culver City isn't in use today because of another type of weapon. "I got tired of replacing the tubes," the owner, Robert Retting, said. "Kids were always throwing rocks at the sign and breaking the neon tubing." The sign was first put up in 1958 after Retting moved his gun shop from another location in Culver City. Retting has had better luck with the "ghost signs" painted on the concrete blocks outside the building. "We keep refreshing them," he said. "There's no way we could put these up today due to city restrictions. They were grandfathered in." *Photo by Nigel Cox*

Hollywood Ranch Market. A huge, neon-lit clock face sans hands. Time had no consequence here, as eager patrons could "shop around the clock." Once at the Southeast corner of Fountain and Vine, it stayed open, just as it promised—until the daytime stopped, and it closed for good. *Photo Collection /Los Angeles Public Library*

The Helms Bakery. The old sign still graces the roof of this blocks-long monolith, which has been converted into a plethora of stores specializing in home furnishings. Silent now, this unassuming wraith used to burst with all the excitement of the best incandescent spectaculars downtown. The star at the lower left would explode, sending fragments of light hurtling through the "E.L.M.S." to land in a red, white, and blue extravaganza in the large patriotic shield, proclaiming "Helms." Ray Neal is currently in the process of relighting this early stunner, and soon it will shine proudly once again. *Photo by Nathan Marsak*

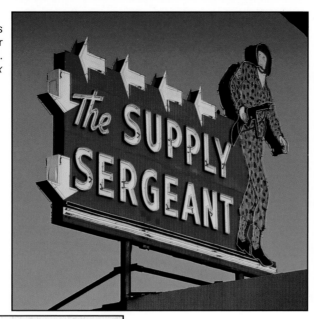

The Supply Sergeant. This giant camo-clad soldier stalks Hollywood Boulevard. *Photo by Nigel Cox*

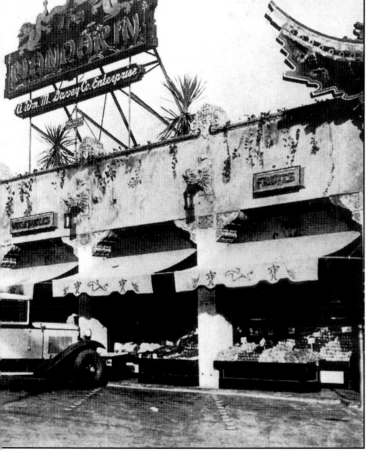

The Mandarin Market. This shopping center was a nice piece of drive-in Orientalia on Vine, built c. 1929. The neon dragons prefigured those at the Chinese theater by some thirty-odd years. *Photo courtesy Los Angeles Public Library*

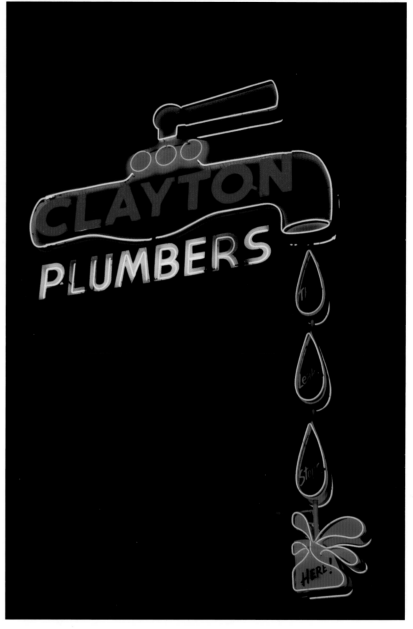

Clayton Plumbers on Westwood Boulevard. "The leak stops here!" declares this 1947 animated faucet high above Westwood Boulevard. *Photo by Nigel Cox*

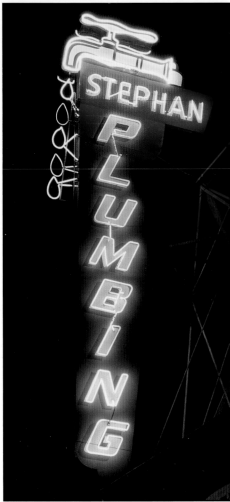

Stephan Plumbing.
Photos by Nigel Cox

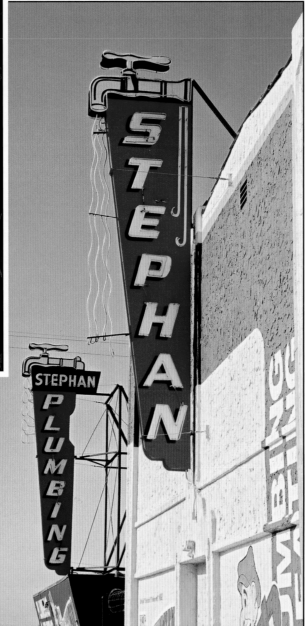

Neon Welder. Bill Williams' historic company has been sold, but our pal the welder is looking forward to being relit by the new owners. His stinger—the welding tool he held—used to blink in the night, signifying the act of welding, until the Long Beach airport told management to turn it off. *Photo by Nigel Cox*

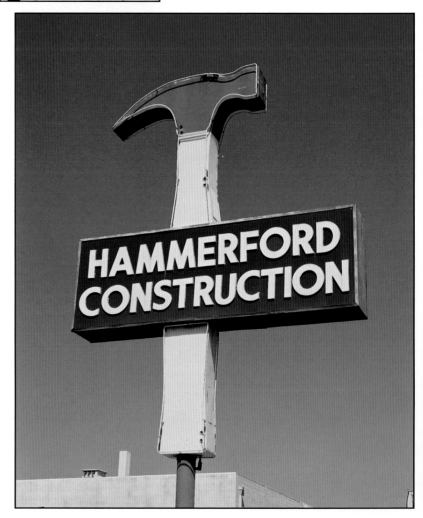

Hammerford Construction. *Photo by Nathan Marsak*

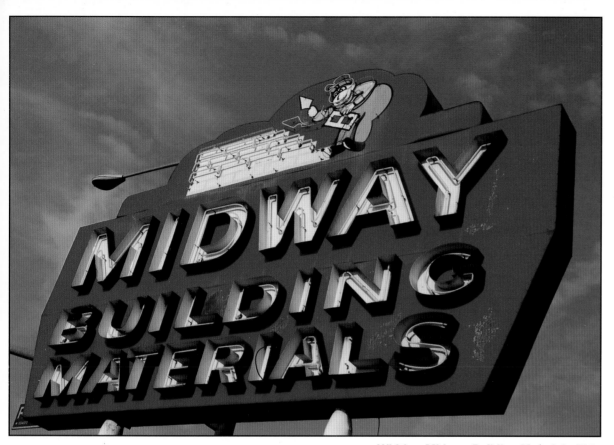

Whither Midway Building Materials. This animated mason used to build his wall every evening since 1953. The 1930s brick office building, with "Midway" spelled out in contrasting red-and-green brick, is slated for demolition, and the unlit, jolly mason presides over an empty field. *Photo by Nigel Cox*

Pool Supplies in Ladera Heights.
Photo by John English

Bottom left: **The Atomic Age.** These 1950s-era nuclear starbursts announced: "We're the future! Be part of it!" *Photo by John English*

Bottom center: **The Agitator.** *Photo courtesy Charles Phoenix*

The Satellite Center. The City of Anaheim, step-child of the Disney Corporation, decreed that no signs or poles were allowed near Disneyland. Therefore Satellite Shopland's revolving, blinking Sputnik of a sign would have to go. The landmark intoned: "…at the signpost up ahead…a brave new world …inter-planetary excitement!" But when it came to Anaheim, Disney had a lock on "excitement," and the owners were told there was nothing they could do. The day the wrecking balls arrived, the sign was spirited off and has joined the American Sign Museum in Las Vegas. *Photo by John English*

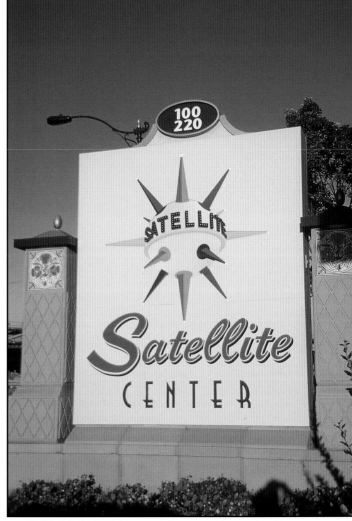

The Satellite Today. This type of sign is known as a "monu-ment sign," fitting, in that it gives the appearance of a tombstone. *Photo courtesy Model Colony History Room / Anaheim Public Library*

Whistle Stop Trains. The Whistle Stop began in 1951 and fought the city of Pasadena—even then—to put up a giant and marvelous sign. The wheels turn, the engine emits animated smoke. How this particular bit of wonderment slipped through the interstices of Pasadena's 1990s sign-destruction campaign is a mystery and a blessing. *Photo by Nigel Cox*

Money Lenders. Now residing at Track 16 in Santa Monica, this pot of dough spent most of its life on Colorado Boulevard in Pasadena. *Photo by Nigel Cox*

Samuel's Florist. This shop has been serving Burbank since 1937. Recently, the owners, who are justifiably proud of their rose, had it revamped and relit. *Photo by Nigel Cox*

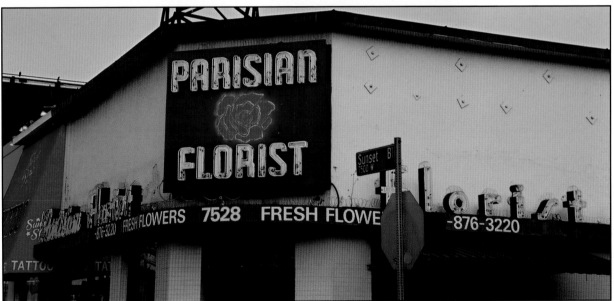

Parisian Florist on Sunset Boulevard. *Photo by Nigel Cox*

The Dark Room. Designed by Marcus P. Miller and Associates in 1938, the camera has gone through many changes. It has metamorphosed over the years, from a camera/photo-finishing store to now, a Cuban restaurant—with a few transformations in between. But the body of the camera is still there, made of black Vitrolite. The thin, white Vitrolite strips simulate the metal banding. *Photo by Nigel Cox*

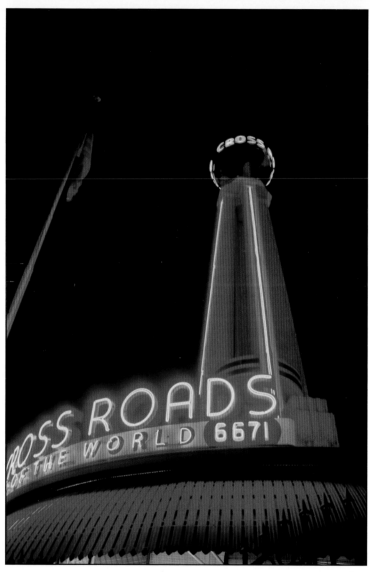

Crossroads. A 1936 retail center on Sunset Boulevard, Crossroads of the World was designed by the same ship-happy gent who brought us the Coca-Cola Bottling Plant, and it shows. A remarkable "porthole & railing" modern, surmounted by a spinning neon globe. *Photo by Nigel Cox*

The Coca-Cola Building. The Coca-Cola Bottling Plant isn't just a factory, it's a steamship. A modern, efficient, hygienic machine-age ocean liner plowing its bow into a streamlined future of prosperity and good times (to be enjoyed with the "pause that refreshes," of course). *Photo by Nathan Marsak*

116

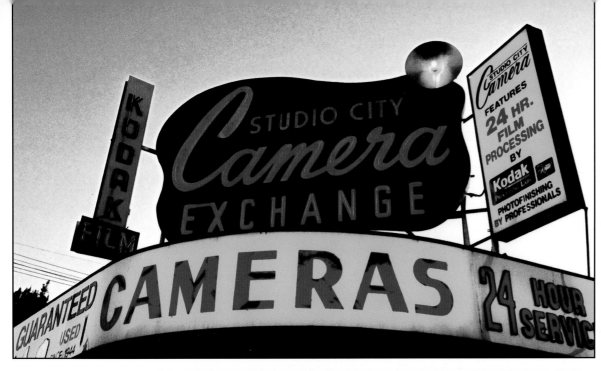

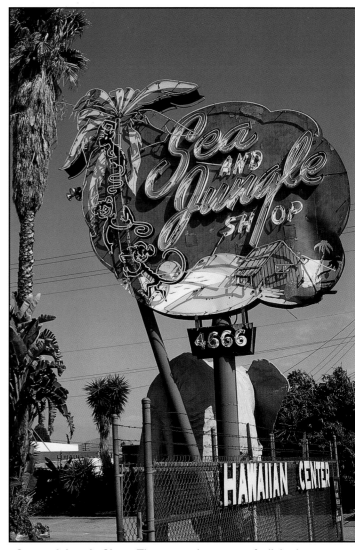

Studio City Camera. This 1944 wonder with blinking flashbulb is well maintained, happily shapping shots of those who traverse Ventura Boulevard. *Photo by Nigel Cox*

Sea and Jungle Shop. These monkeys once frolicked among the palms along San Fernando Road. *Photo by Robert Landau*

Twin Palms Village. Two palm trees were in fact planted at this mall in 1959; they now tower over their neon brethren. *Photo by Nathan Marsak*

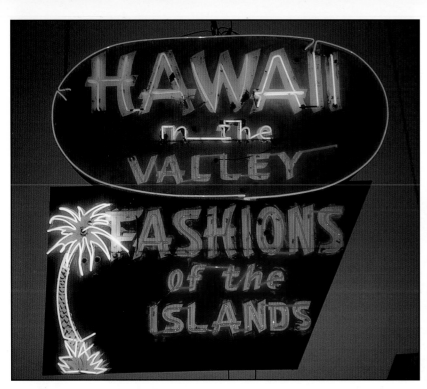

Hawaii In The Valley. Post-war Polynesian for the swingin' Luau set. *Photo courtesy Scott Hopper, Track 16*

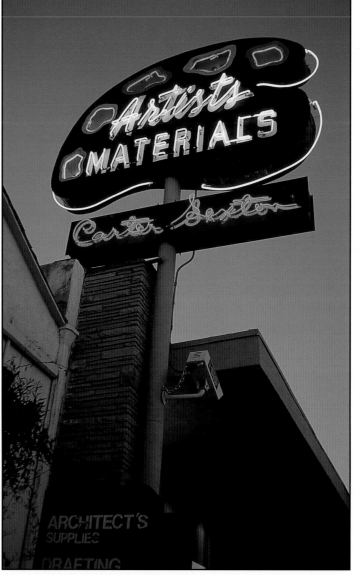

Carter Sexton's Neon from 1947. *Photo by Larry Lytle/MONA*

Opposite page, top left: **Zinke's at MONA**. These animated late 1940s signs are kept up beautifully. Every night the hammer pounds away at that perpetually loose heel.

118

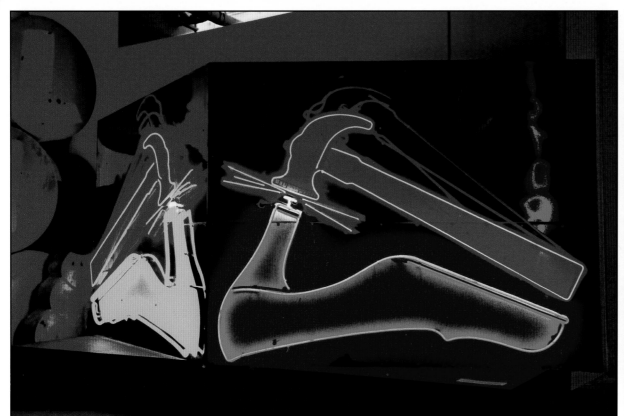

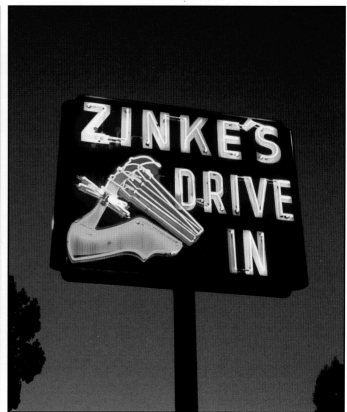

Zinke's Pasadena. *Photo by Nigel Cox*

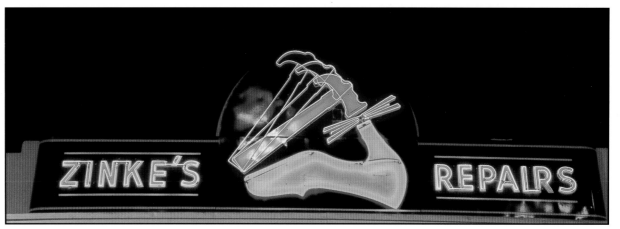

Zinke's Glendale. *Photo by Nigel Cox*

Atlas Sausage. Family owned since the early 1930s, the Atlas Sausage lineage made the mistake of selling the company in 1990. According to the owner's daughter, their sign spent seven years unlit. The family had had enough. They bought back Atlas Sausage, relit the sign, and it enchants once again. *Photo by Larry Lytle/MONA*

119

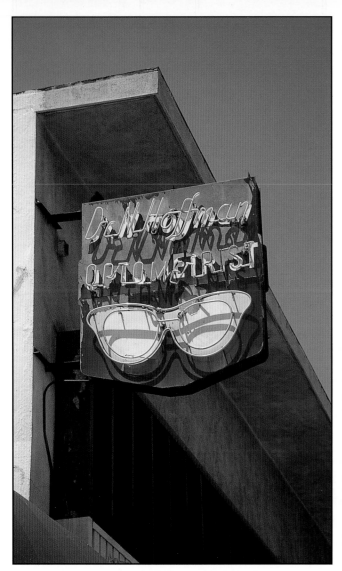

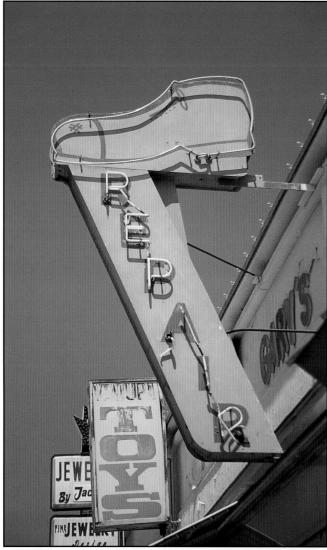

Cat's Eyes in North Hollywood.
Photo by Larry Lytle/MONA

Optometrist on Lankershim Boulevard.
Photo by Larry Lytle/MONA

Shoe Repair. Back when the automobile was not the primary means of transport, shoes would, believe it or not, wear out. There are very few shoe repair shops left, much less those that sport their original signage. *Photo by Larry Lytle*/MONA

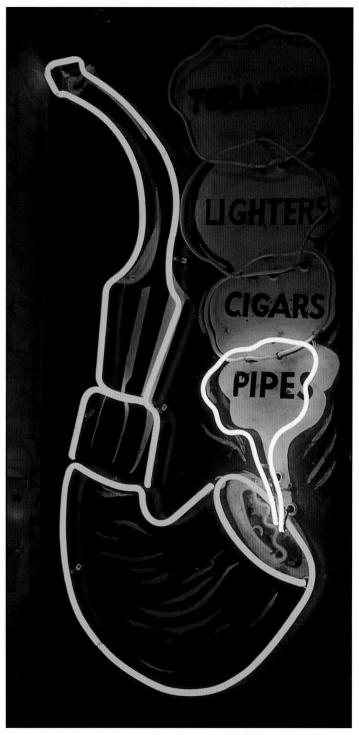

Pipes and Tobacco from Hollywood Boulevard. *Photo courtesy Scott Hopper, Track 16*

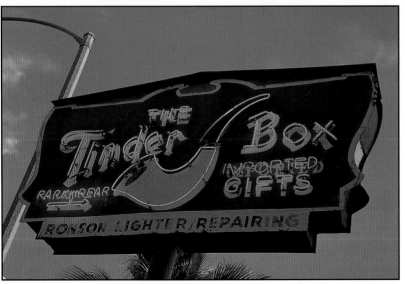

The Tinder Box in Santa Monica. *Photo by Nigel Cox*

Chinatown

When tourists visit Chinatown, they often remark: "It looks like a movie set." They don't know how right they are.

In 1934, the city of Los Angeles evicted 3,000 Chinese residents from their homes in order to construct Union Passenger Station. These displaced Asiatics' subsequent enclave was eventually built with help from a Paramount Studios set designer, which meant lots of curved rooflines, octagonal windows, and other Chinoiserie. "New Chinatown" opened on June 28, 1938, with 18 stores, a bean cake factory, and an enormous amount of neon. Much of the neon is still *in situ*, especially along Gin Ling way. One of the important pieces—the Li Po Restaurant neon, animated to represent a man riding backward on a donkey—was saved from destruction, and is in the permanent collection of the Museum of Neon Art. There has been much talk of late about "modernizing" Chinatown, which will most likely rob it of its neon, and its charm.

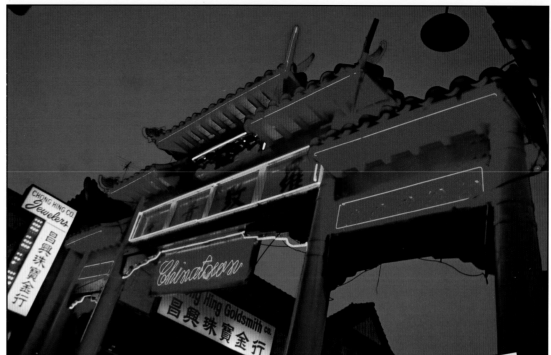

The Gateway to Chinatown. *Photo by Nigel Cox*

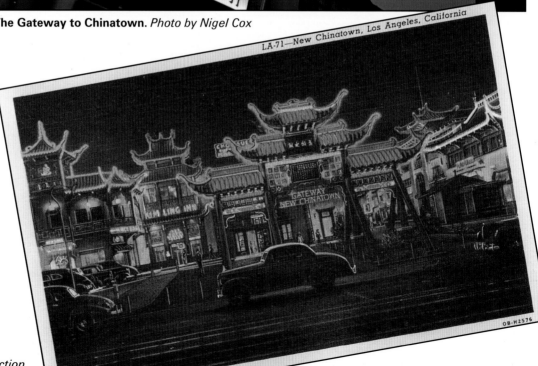

New Chinatown, c. 1940. *Authors' collection*

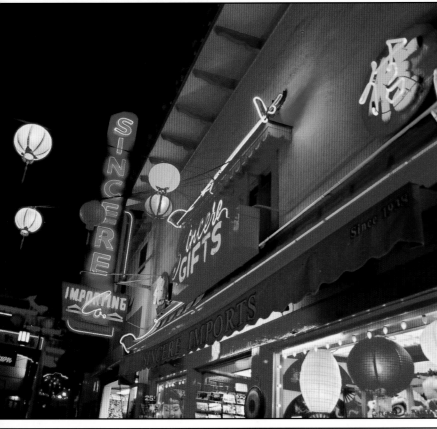

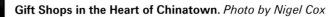
Gift Shops in the Heart of Chinatown. *Photo by Nigel Cox*

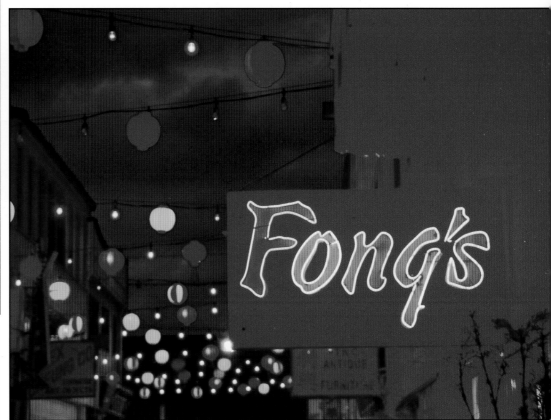

A Lantern-lit Passageway. *Photo by Nigel Cox*

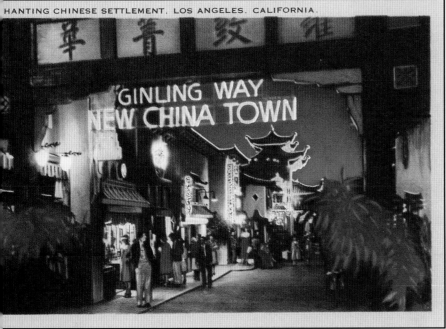

"Enchanting Chinese Settlement," c. 1940.
Authors' collection

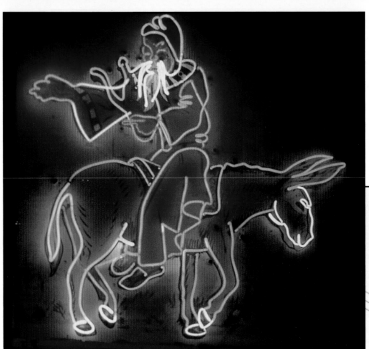

The Remains of Li Po. In China, poets were once known as "drunken dragons," and Li Po proudly lived up to the nickname. He declared that without drink, he could not write, and praised "the rapture of drinking and wine's heady joy." According to legend, he met his end one night when he climbed into a sampan and pushed himself out on a lake to admire the moon mirrored in still water. Suddenly, he felt he must possess the beauty of the night. As he leaned down to embrace the pearlescent reflection, he fell overboard and drowned.

This Li Po didn't fall in a lake, but simply fell into disrepair when the restaurant, on which he once rode his donkey and swung his wineskin, closed down. He now awaits restoration at the Museum of Neon Art. *Courtesy MONA*

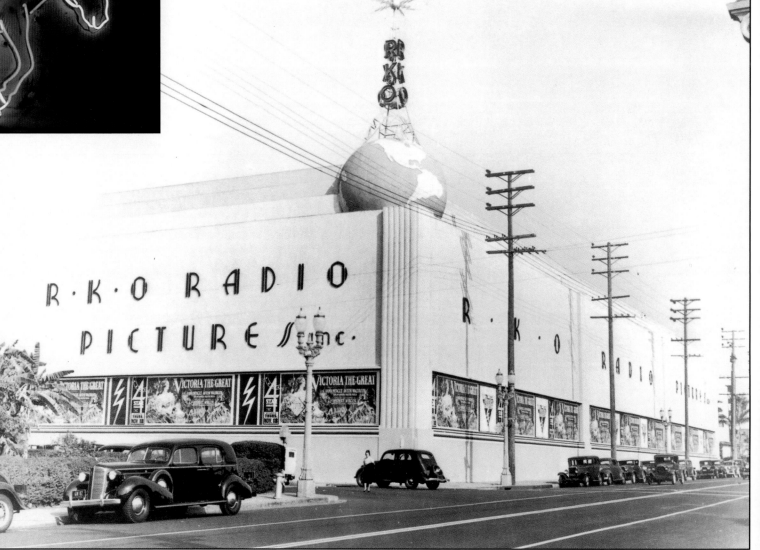

R.K.O. When out-on-the-town in, say, 1935, nothing could afford more pleasure than taking in a picture produced by RKO, home of the most remarkable B-movies and bizarre Westerns—pictures that capture interest in a way the overrated "classics" of today never can. The RKO lot was gobbled up by Paramount, who remarkably retained the globe, where it can be seen to this day on Melrose Avenue. *Photo Collection /Los Angeles Public Library*

KFWB Radio Station. KFWB used to be over on 6419 Hollywood Boulevard, but they moved up to Yucca in 1977 for larger quarters and cheaper rent. Their neon call letters and giant microphones "date back to the rock n' roll days, before we became a news radio station," recounts Richard Rudman of KFWB. "That neon was a big deal on Hollywood Boulevard, and with the move some people figured it was time to get rid of it. Back in '77 I made sure that the neon came with us. And we make sure to keep it lit-up." *Photo by Nigel Cox*

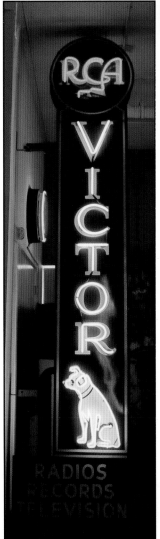

RCA. Nipper the pooch now cocks his head in the Museum of Neon Art. *Photo by Nigel Cox*

The Glory of the Richfield at Night. *Courtesy J. Eric Lynxwiler*

The Richfield Building. This 1928 structure, by Morgan, Walls, and Clements, was an unbelievable zigzag-moderne *tour de force*. Its skin was black-glazed terracotta over-glazed with pulverized gold particles—get it? Oil company? Black gold? Its wealth of stylized carvings on the building also referred to the oil industry and the industries it aided. Most striking was the eighty-foot neon sign tower, designed to resemble an oil derrick. The entire structure was razed in 1968 to make way for ARCO plaza. (While a tragic loss, the Richfield's replace-ment, the twin ARCO towers, by Albert C. Martin & Assoc., are the best post-1970 buildings in the Southland.) *Authors' collection*

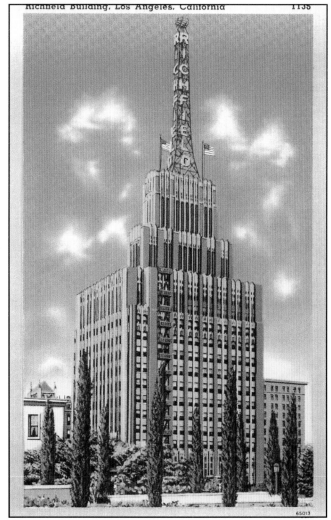

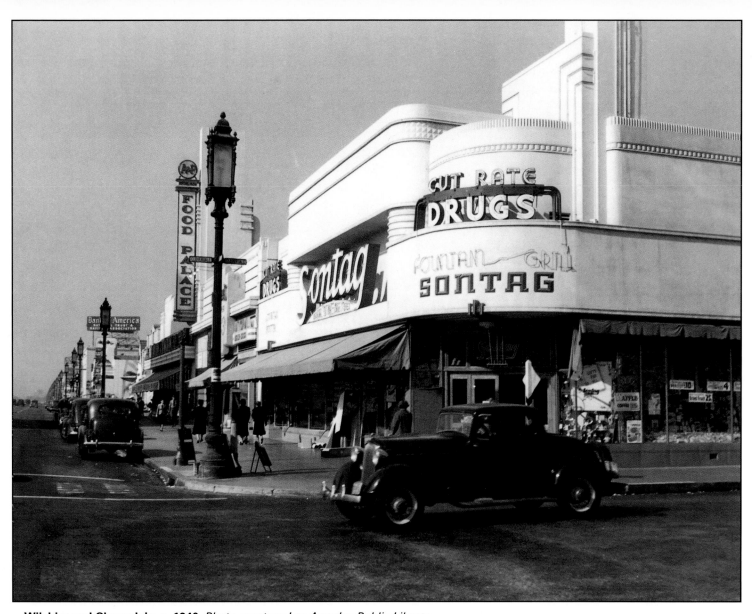

Wilshire and Cloverdale, c. 1940. *Photo courtesy Los Angeles Public Library*

RX. The people of Los Angeles consume more prescription drugs than the three Pacific states combined. As such, it is necessary to find a pharmacy quickly and easily. Hence the animated neon mortar and pestle. Unfortunately for the citizens of East L. A., this pill dispenser became a cut-rate Pharmacia before being recently boarded up. *Photo by Nathan Mar*sak

A Mortar and Pestle on Westwood Boulevard. *Photo by Nigel Cox*

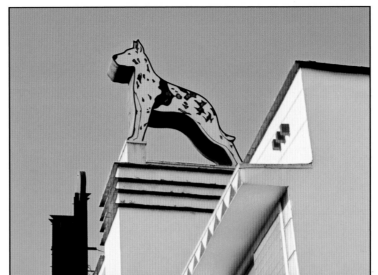

A Dog and Cat Hospital. No longer a pet hospital, this L. A. landmark is now a design studio. *Photo by Nigel Cox*

Western Exterminator. This neon masterpiece used to feature a scurrying rat that would eventually get whacked by our pal in the top hat. The city forced the company to shut off the sign, citing incidences where motorists would slow on the 101 to gaze at the spectacle. The rodents haven't been reanimated, despite the fact that Wilshire and Sunset Boulevards are now littered with giant television screens.

127

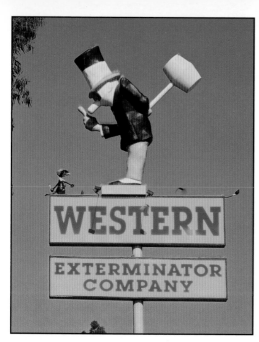

The Exterminator in Long Beach.
Photo by Nigel Cox

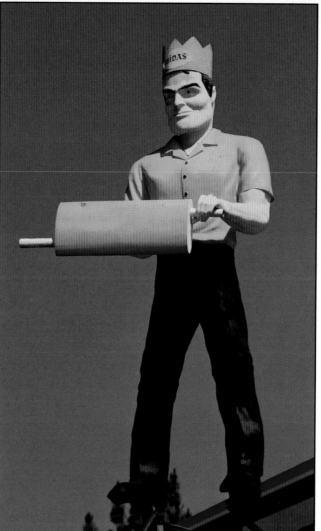

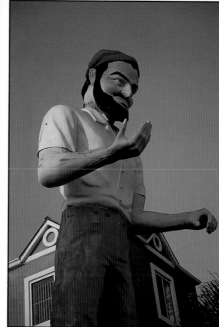

Empty-handed. This is another common reworking, turning our colossal friend into a Paul Bunyon. *Photo by Larry Lytle/MONA*

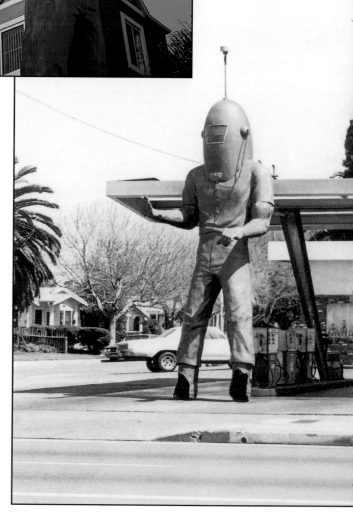

Muffler Man. There are a hundred-plus documented "Muffler Men" in America, with scores hiding, waiting to be discovered. There are ten known in the Los Angeles area alone. Here, the classic Muffler Man, right hand up, left hand down, grips his muffler. More often than not, the giants were turned to other purposes—cowboys, Indians, Mexican chefs. International Fiberglass built and installed America's muffler men from the mid-1960s to early `70s; most of L. A.'s were situated in the San Fernando Valley. *Photo by Nathan Marsak*

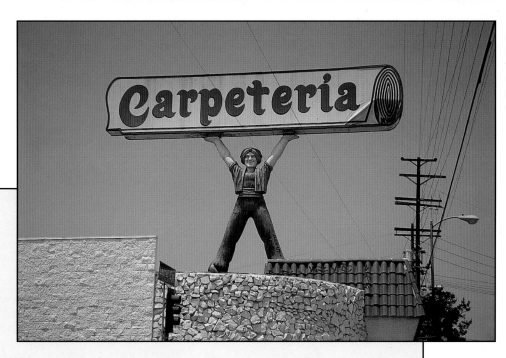

Carpeteria Genie. First cousin to the Muffler Man is this mid-1960s behemoth who raised carpet on high to assert his dominance over the floors of the Southland. Once innumerable, this Saudi strongman is one of the few to survive. His particular North Hollywood enclave is now shuttered and he, too, may be forced into the lamp of non-being, carpet and all. *Photo by Larry Lyttle/MONA*

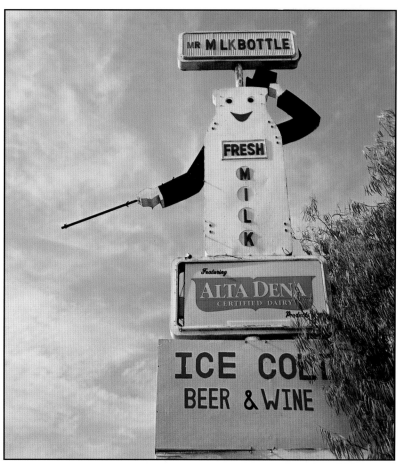

Mr. Milk Bottle. This jaunty fellow sports a top hat and cane. He maintains his happy-go-lucky attitude despite having lost all his neon. *Photo by Nigel Cox*

Outer-space Muffler Man. Are the Muffler Men really a race of interplanetary travelers, beings who walk among us, cleverly disguising their outward appearances to avoid detection? All we know for sure is that this spaceman, once at the corner of Atlantic and 57th recently, mysteriously disappeared... *Photo Collection /Los Angeles Public Library*

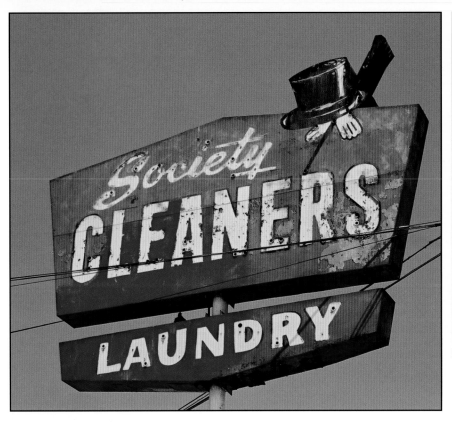

Society Cleaners. *Photo by Nathan Marsak*

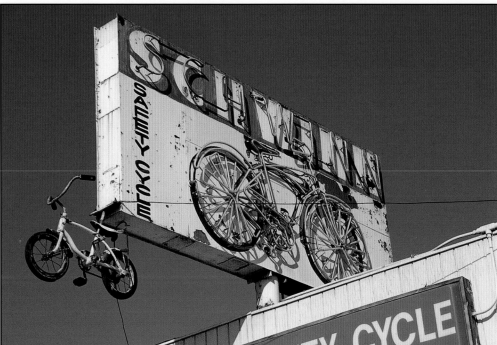

Top right: **Schwinn Bicycle Store.** An incredible neon Schwinn "safety cycle." spotted on Western Avenue. The addition of the `70s kid's bike nailed to the sign is a nice touch. *Photo by Nigel Cox*

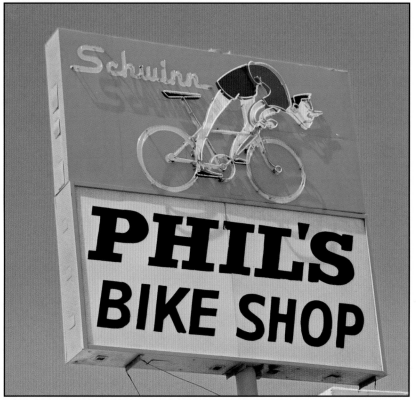

Phil's 1960s Cyclist. *Photo by Nathan Marsak*

Name Yer Poison

Before Los Angeles acquired its reputation as a cocaine-fueled and ecstasy-ridden party land, there was booze. Consumed in the local bar, yes—but more significantly, the drink consumed behind closed doors. Hollywood parties with champagne and Chablis. Swinging tract-home couples with gin and sangria. The Bukowski-esque, down at heels flophouse with Night Train and stale cigarettes. And no matter the social status—millionaire or bum—all that libation has still gotta be purchased somewhere.

The City of Angels has the highest concentration of Alcoholics Anonymous chapters in the world, and a fully stocked liquor store to match each one. Chicago has its whiskey, a cultural connection to prohibition and the hootch trade. New Orleans and alcohol are synonymous, an integral part of its people's life. And so is liquor a part of the Los Angeles dream. Adrenaline-fueled, or desperation-fueled, the 80-proof ichor that flows through this city's veins is born of good times and bad times, desperation and perspiration. Every liquor store owner is akin to William Mulholland, providing firewater to Angelenos not only for refreshment, but also for life.

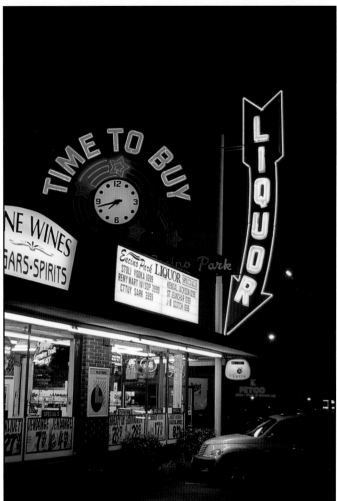

Encino Park Liquor. *Photo by Larry Lytle/MONA*

Booze can energize and define a city with a hundred million billion gallons of rocket fuel pumped into its arteries like the noble gasses pumped into a neon tube. Or booze can defile a city, leaving it empty, broken and spent like a neglected "cocktails" sign hanging gray and crooked in the bright midday sun.

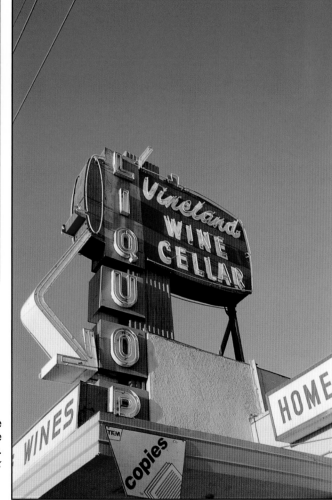

Vineland Wine Cellar. Not as cellar-like as the name implies, but the neon wine cask makes up for that negligible fault. *Photo by Nigel Cox*

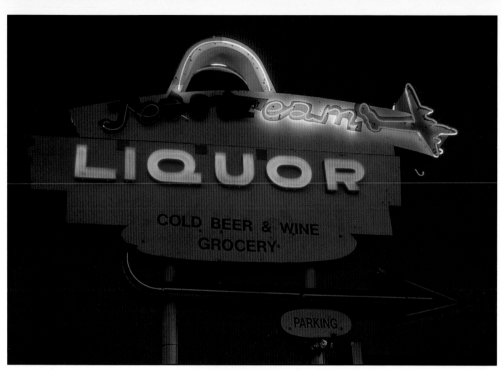

Jet Stream Liquor. *Photo by Larry Lytle/MONA*

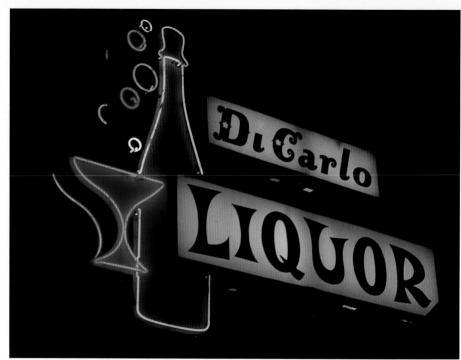

Di Carlo Liquor. *Photo by Charles Phoenix*

Mustang Liquor. This animated neon horse gallops brilliantly in the Valley night. *Photo by Larry Lytle/MONA*

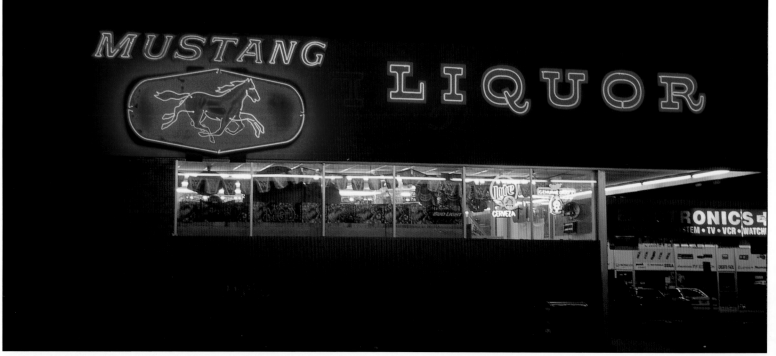

Another Southland liquor-beast kicks up its hooves.
Photo by John English

Al's Liquor. Al's was one of the great liquor stores of all time, its signage taller and more affecting than any within miles. That was precisely the reason the City of Anaheim declared it "aberrant" and sent the wrecking crew. Preservationists raced to the scene and Al's is now part of the permanent collection of Museum of Neon Art in Los Angeles. *Photo by Daniel Paul*

Al's IQ. The wisdom of Al's, here seen jealously protected by Eleanor Paul, on the way to the sign's just reward. *Photo by Daniel Paul*

Seal Beach Liquor. These wonderful seals were once animated to flash back and forth. The owners down in Seal Beach decided that such was folly, and tore out the neon. *Photo by Nathan Marsak*

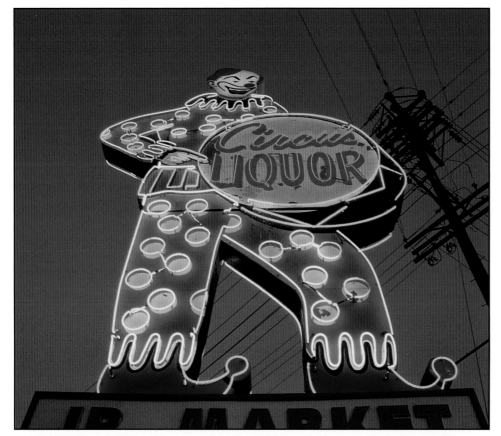

Circus Liquor. Imagine: a booze-addled alcoholic clown banging his drum outside your window. Why not? Kids love clowns! All the world loves a clown. Everybody loves a clown, so why don't you? *Photo by Nigel Cox*

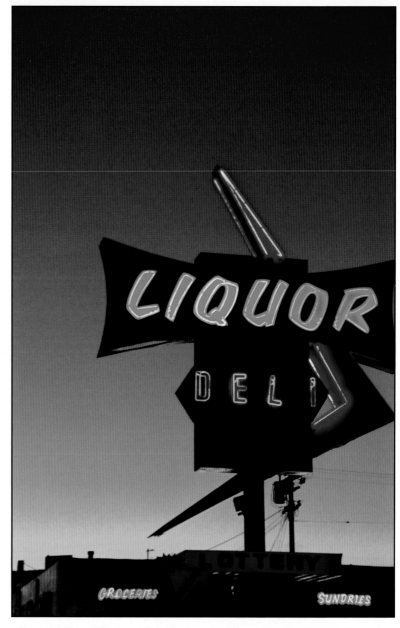

Beverly Mart. The true Angeleno recognizes that the historic boundaries of Los Angeles are Eastern and Western Avenues, and no Angeleno can breathe easy, when over on the West side, until they've finally made it east of Western. When crossing over the psycho-geographic divide (on Beverly, of course, the premier east-west bisect of Los Angeles), the first great neon one encounters (besides Western Exterminator looming in the distance) is the Beverly Mart near Normandie. Who hasn't made that reckless left turn against traffic, careened into the parking lot, and sauntered into the store cool as ice for libations and foodstuffs? *Photo by Nigel Cox*

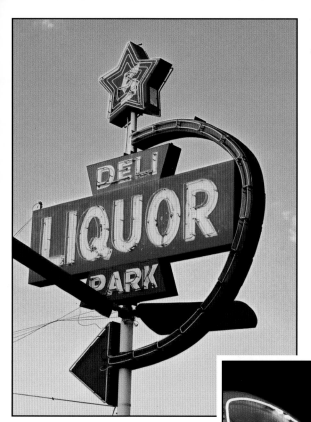

Five Star. A Bellflower shocker. *Photo by Nathan Marsak*

The Pla-Boy. This nifty back-lit features a top hat, martini, and still sports its original pre-1960 HOllywood telephone exchange. Pla-Boy? Remember, the martini is not a Y, otherwise that would read "Playboy" and therefore would be subject to all sorts of copyright trouble. On the second floor, in the room next to the sign, legendary film auteur Edward D. Wood Jr. lived the last fifteen years of his life. *Photo by Nigel Cox*

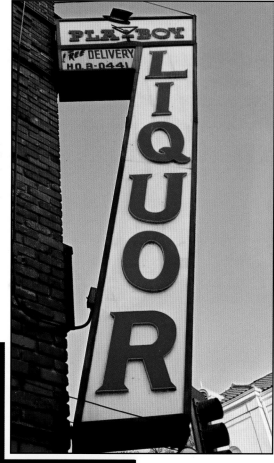

The House of Spirits in Echo Park. This store promises ghouls, ghosts, and good times from a bottle. *Photo by Nigel Cox*

135

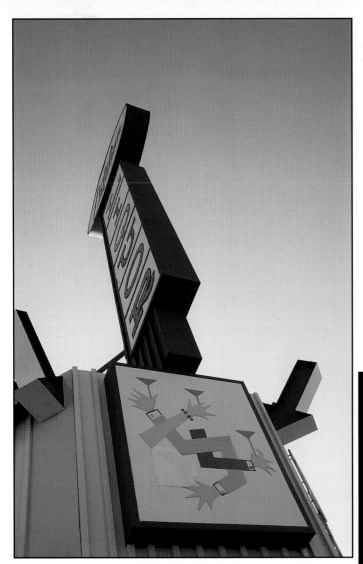

Catalina Liquor. This type of stylized, backlit plastic is just the type of sign that L. A. is losing in droves. Not appreciated by neon purists, the backlits are fast disappearing and will surely be missed by our next generation. They are difficult to save, as well, in that the very materials of which they are made are rapidly decomposing. *Photo by Nigel Cox*

Top Hat Liquor. Nothing speaks of class quite like a top hat, especially one made of neon. While the 1959 Top Hat establishment is situated unfortunately close to a freeway overpass, and is therefore frequented by those people who frequent the dark recesses beneath a mass of concrete, everyone is on their best behavior in light of the Hat. *Photo by Nigel Cox*

Religion

Los Angeles is routinely criticized for its materialist culture, which many consider shallow. But the Angeleno shops for salvation just like any other citizen of this great country.

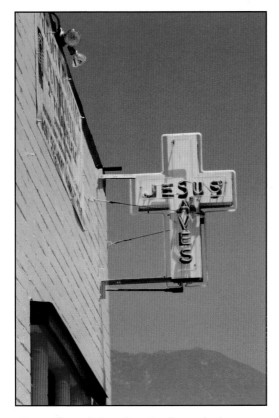

Jesus Saves! Los Angeles is routinely criticized for its materialist culture, which many consider shallow. But the Angeleno shops for salvation just like any other citizen of this great country. *Photo by Nathan Marsak*

Photo by Nigel Cox

A Masonic Temple in Glendale.
Photo by Nigel Cox

The Angelus Temple Today. A pale blue neon cross replaces the giant broadcast towers of the 1920s, from which Aimee Semple McPherson transmitted her "Sunshine Hour" until the requisite sex scandal took her down. *Photo by Nigel Cox*

Callanan's on Western. Anyone who understands life in Los Angeles also understands that the dead, and their disposition, are endemic to L. A.'s dynamic. It seems fitting that the city's mortuaries should feature blood-red neon, out of respect for our life's blood. *Photo by Nigel Cox*

Lorenzen in the Valley. *Photo by Larry Lytle/MONA*

Fun and Games

So, you've gone out to see *Shakespeare in Love II: Revenge of the Bard*. And you're thinking: "Why did I just waste nine bucks on that?" Then you went out to that hot new eatery, "Chez Hipster," and you're thinking: "Why did I just spend $42.50 for a burger and fries?" So you try to find solace in the mall, but when you get home and try on those trendy new Italian trousers, you're thinking: "Why did I just spend $230 on polyester pants?" Then suddenly, it hits you: You could've spent the evening in a much more exciting, less expensive, but infinitely more rewarding way. You could've gone bowling.

Certainly, most Angelenos find their entertainment in the large-scale distraction of cinema and consumer culture, but there exist the brave and intrepid few who refuse be pacified by these soulless activities. Such characters still haunt the bowling alleys of yore, searching for that mystical land where the beer flows freely, the shoes are fragrant, and a billowy bowling shirt not only proclaims one's name for all to see, but also tastefully covers that ever-expanding midsection. And they wish to do so under an enormous, electrified, revolving boomerang that flashes: "Coffee, Cocktails, 36 Lanes!"

Bowling alleys have always had outstanding signage. Their signs are intended to express fun and liveliness and *Whammo!* and *Action!,* which is probably why you don't see giant spinning boomerangs on, for example, funeral homes.

Bowling signage is by and large well preserved, in that bowling alley owners realize their kooky illuminated calling cards bring in a loyal clientele, and have the good sense to leave the signs as they are. Nevertheless, the AMF bowling league (whose acronym they insist stands for "Always Means Fun") is buying up the old alleys and tearing down the old signs, forcing the previously

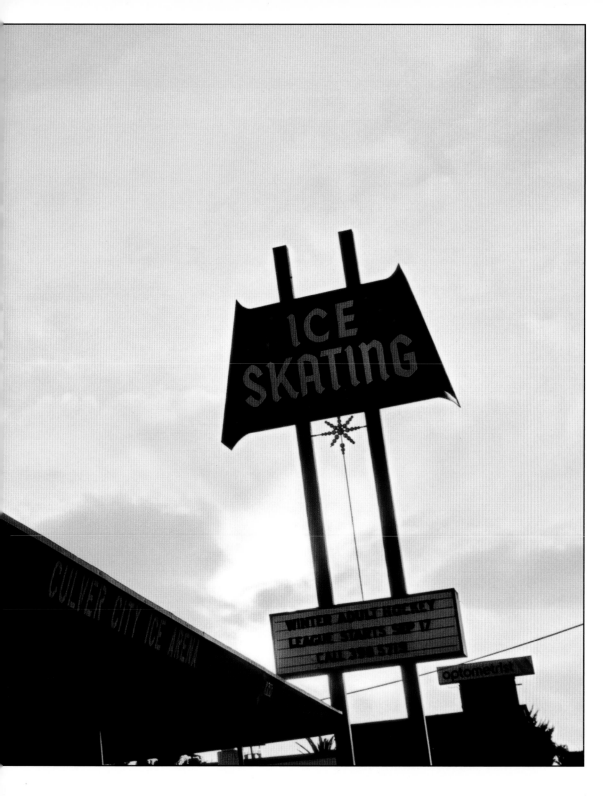

outstanding lanes to comply with small, modern plastic signage that might as well read "Bowling in Dullsville" or, if you will, "Bowl at the Funeral Home." The Bowlium in Pomona, once the granddaddy of sixty-foot Googie bowling signs, recently fell to the AMF's wrecking ball.

Bowling is by no means the only way to have fun and get some modicum of exercise in the sweltering Southland. Entrancing signs beckon us to ice skate and golf, or play skee-ball on a crumbling pier. Granted, none of these activities burn many calories, and most Angelenos these days prefer treadmills to roller rinks, but when was the last time a health club had a really good piece of signage?

Jensen's Recreation

Viewed from hundreds of hilltop homes, and more importantly, eyed by thousands of Sunset Boulevard motorists every day, this Bowler enraptures all. His arm pulls back...it swings forward...and blink...blink...blink...the ball rolls down the lane...and...blammo! The pins bust up, flashing wildly! Then the lights flash in order: "Jensens," "Recreation," then "Center." You tell yourself you're only going to watch it one more time. Twenty minutes later, your engine overheating as you idle at the curb, you've seen him roll twenty more strikes.

Henry Jensen, who supplied many of the bricks for Los Angeles' structures, was a health nut who decided in 1919 that a two story bowling alley and billiards parlor would be copasetic for the burgeoning community of Echo Park. He designed a grand Italianate structure, added barbershops and eateries, but failed to navigate his endeavor through the Great Depression. This animated went dark in the 1930s, and sat deteriorating for sixty some-odd years. The original recreation center and bowling alleys, wooden pins and all, are gone, but the sign remains. This sign was the first to be restored under the aegis of Adolfo Nodal and the Cultural Affairs Department in LA. Ray Neal, owner of Standard Electric, and who refurbished LA's signs for

Nodal, recounts: "As we were working on the sign, we found it impossible to tell what the original colors of the bowler's shirt, pants, hair, and so on were. We pulled out a screw and from underneath discovered that his hair had once been blonde. We're redoing his hair yellow, the original color, but of course, no one in that neighborhood has had blonde hair for thirty years. All the neighborhood Mexican kids were up there on the roof with me, razzing me about it, so I took all their names, wrote them down on strips of paper, and closed them up in a mason jar. Then I sealed up the mason jar inside the head of the bowler. Now all these kids—Armando, Ruiz, Jorge—they know that they're permanently part of the sign and the community."

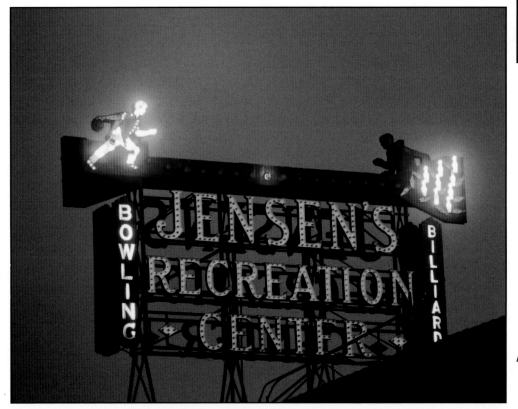

Photo by Nigel Cox

Photo by Nigel Cox

Photo by Nigel Cox

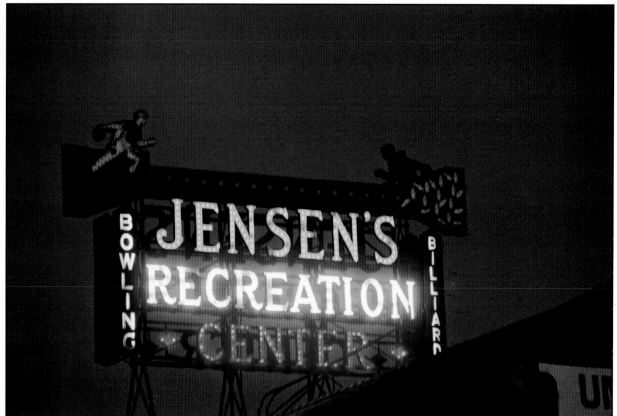

143

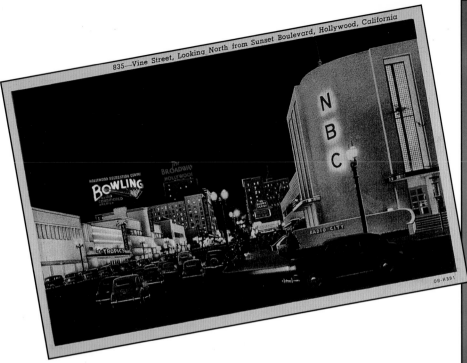

835—Vine Street, Looking North from Sunset Boulevard, Hollywood, California

Once, You Could Bowl at Hollywood and Vine. In this image, peering up Vine, circa 1937, the most prominent signage is the animated bowling spectacular. The sign, and the alleys, disappeared during the war; the building changed hands a number of times, which is chronicled here in Chapter Two, *"A Night on the Town." Courtesy of J. Eric Lynxwiler*

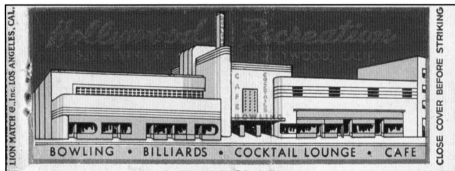

Hollywood Recreation Center. *Authors' collection*

The 1958 Corbin Bowl. *Photo by Larry Lytle*/MONA

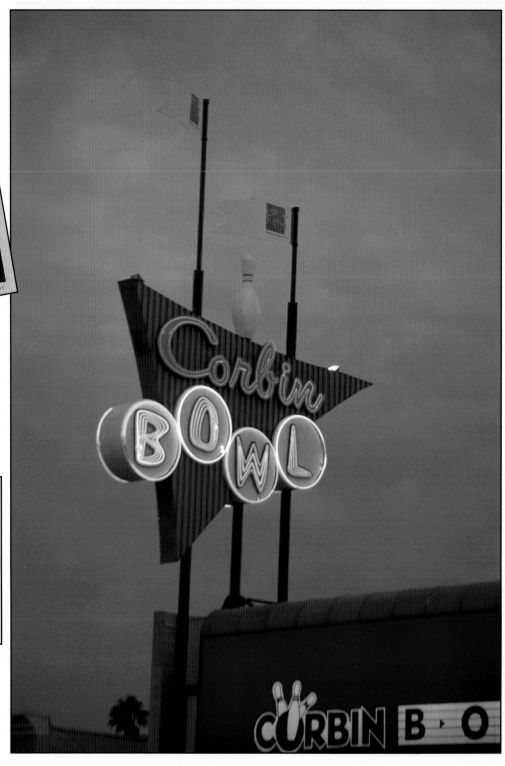

Java Lanes. One might assume that the Java Lanes in Long Beach will always be with us, like a Victorian lighthouse or a trusted friend. But Java is up for sale, and as Los Angeles has learned the hard way a hundred times, never trust that your trusted friend will remain. *Photo by Nathan Marsak*

The Crazy Flashing Star at H. S. L.

Hollywood Star Lanes. Back when East Hollywood was still Nowheresville, Hollywood Star lanes had the guts to open with 32 lanes in October of 1960. East Hollywood may still be Nowheresville to some, but Hollywood Star lanes perseveres, despite attempts by the Unified School District to shut them down and turn the structure into a warehouse and book depository. Fans of the *"bowling noir"* sub-genre of motion pictures (of which there are few, both fans and pictures) will recognize the H. S. L. from the Coen Brother's film *The Big Lebowski. Photo by Nigel Cox*

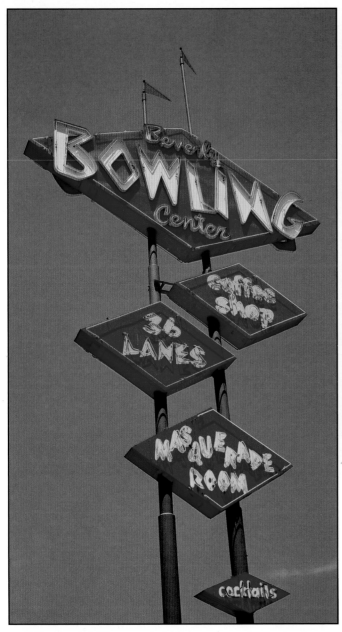

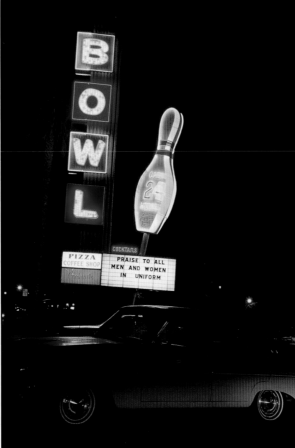

Lindbrook Bowl. Anaheim's premier bowling alley. A giant 1957 bowling pin spins in the night. *Photo by Nigel Cox*

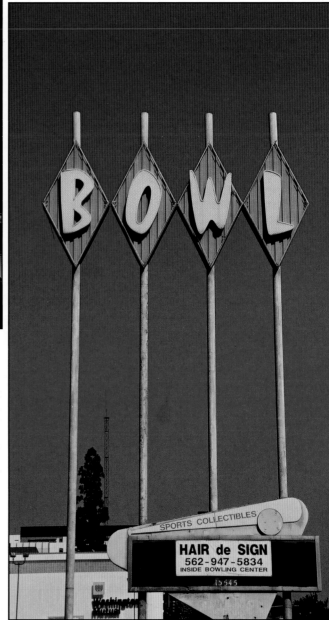

Friendly Hills Bowl. The colossal "BOWL" signage at Friendly Hills lanes, in Whittier, weeps. It weeps because, after having been purchased by AMF, the sign was turned off. General Manager Susan Hatfield stressed that there was no move afoot by Corporate to tear down the sign; they just didn't see the point in putting money into upkeep. *Photo by Nathan Marsak*

Beverly Bowl. The shocking 1959 Beverly Bowl signage is visible for miles, as one traverses Montebello. The Masquerade Room is one of the most sublime enclosed spaces in the history of American architecture, completely filled as it is with resin mosaics of kings, queens, and chimeras. *Photo by Nathan Marsak*

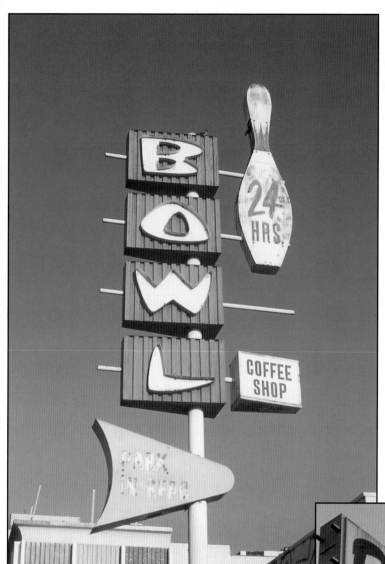

Torn Down. *Photo by John English*

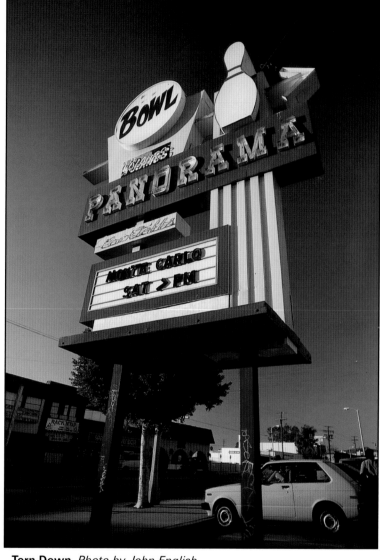

Torn Down. *Photo by John English*

Torn Down. *Photo by John English*

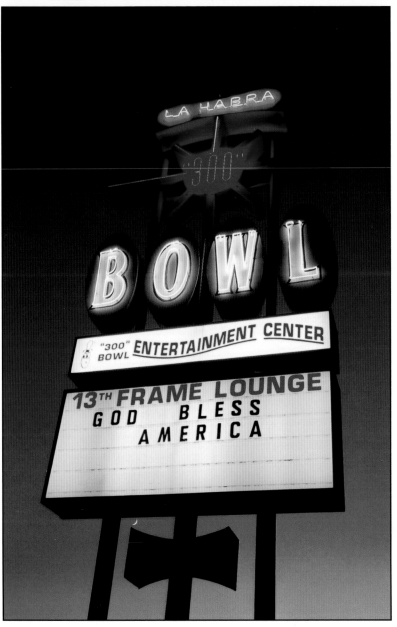

La Habra Bowl. La Habra Bowl manager Mickey Curley has been with the alley since 1965. "I practically came with the sign," she remarked, noting that the signage was erected with the bowling alley in 1960. "We repair it every few years. You have to get up there with a crane. You can see it from all over Whittier Boulevard. But one thing is certain; there would never be a sign like that again because of city rules." In addition to its famous sign, the La Habra Bowl has another claim to fame. "On July 2, 1982, Glenn Allison bowled the first 900 series in bowling history" said Ms. Curley. "We are really proud to be a 900 bowling alley." *Photo by Nigel Cox*

Covina Bowl. Covina Bowl is a favorite stop for bowling fans. The Society for Commercial Archaeology, when taking a tour of Los Angeles, oohed and ahhed at the bowling alley and came to a consensus that C. B. is one of America's great bowling landmarks. *Photo by Nigel Cox*

Southwest Bowl. Bowling for dollars? Or trophies? While some bowling alleys tend to attract kids and bored parents, the fifties splendor of Southwest Bowl is a magnet for L. A.'s Asian, African, and Mexican-American bowling aficionados, who roll frames with tremendous earnestness. *Photo by Nigel Cox*

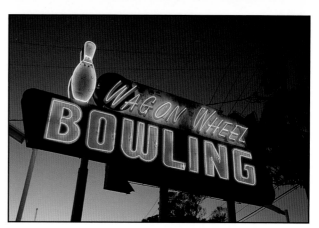

The Wagon Wheel. One of the most common exclamations heard in Los Angeles is, "let's get out of town for the weekend!" While motoring up to Santa Barbara, who wouldn't pull off the 101 at the Wagon Wheel Junction exit to knock down some pins (and beers) at this Ventura landmark? *Photo by Nigel Cox*

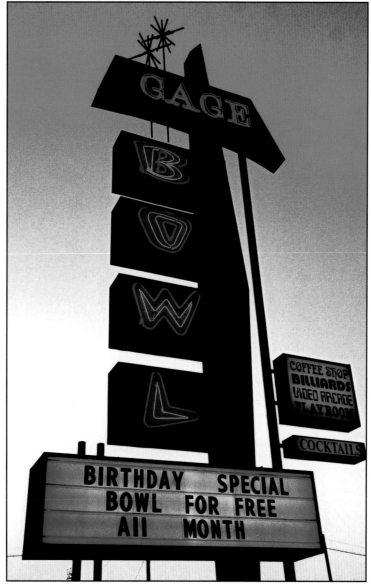

Gage Bowl. Maywood's Gage Bowl is still independently owned and operated, and dutifully maintains its stacked, early 1960s signage. *Photo by Nigel Cox*

Holiday Bowl. The focal point of the Crenshaw district, the remarkably intact 1950s Holiday Bowl was shuttered and scheduled for demolition to make way for…nothing at all. Holiday Bowl and its coffee shop had become famous for its confluence of Japanese and African-American clientele. Now its signage is curiously matched by the handbills plastered on the boarded windows. Support from the community has staved off its destruction. *Photo by Nathan Marsak*

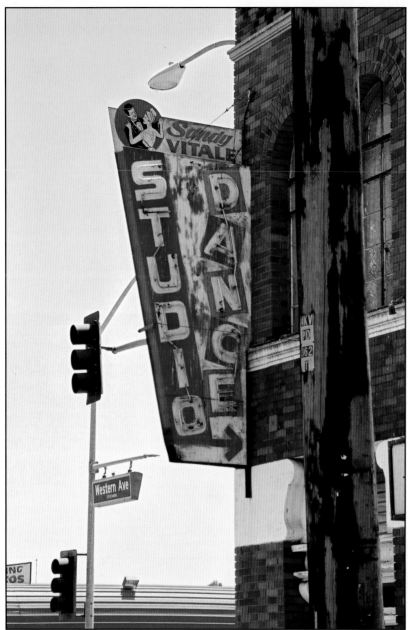

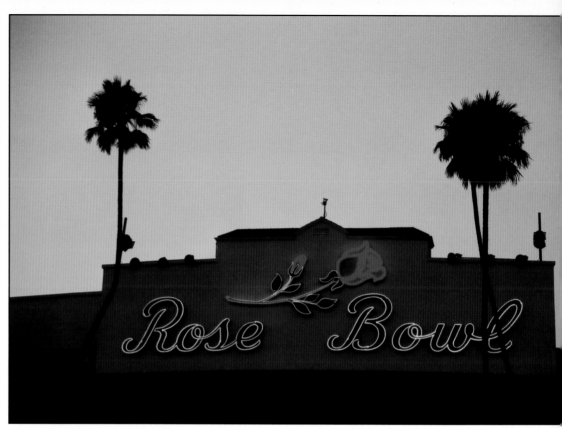

Rose Bowl. Not a bowling alley, but a stadium, this is an icon of Pasadena, which is probably best known for its roses—the Rose Parade, the Rose Bowl football games, and the giant neon rose on the Rose Bowl itself. *Photo by Nigel Cox*

Dance Studio. A trip down Western will net you a look at this handsome couple dancing, c. 1950. This former Criminal Courts building was converted to Sandy Vitale's dance studio sometime around then, although now it is the home to dance instructor Atsu Kamoka, the premier teacher of ancient Japanese movement. *Photo by Nathan Marsak*

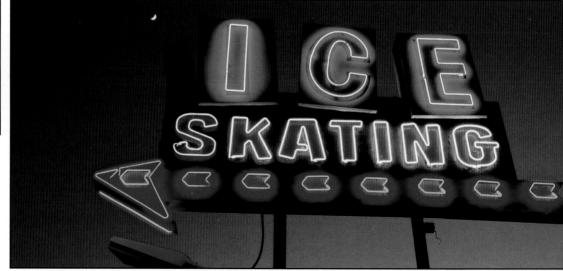

Sporting Events. The Los Angeles County Fair in Pomona was not only America's largest, but also the county fair filled with America's most eye-catching signage. The Fun Zone arch, built by Williams Sign Company in 1950, was 100 feet across and 40 feet high, signaling the entrance to the carnival area. It lasted a scant thirty years before being demolished. The Sport Events neon was another fair attraction, also no longer with us. *Photo courtesy Charles Phoenix*

Studio City Golf Course. Joe Kirkwood, Jr. was a Studio City entertainment mogul with a bowling alley, skating rink, and here, a golf course, all of which bore his name. He opened this 18-hole masterpiece in 1955, complete with gigantic light-up golf balls perched atop gigantic tees. *Photo by Larry Lytle/MONA*

Ontario Ice Rink. Giant ice cubes have frozen this sign in time and space. Of the dwindling ice and roller skating rinks in Los Angeles (any 1960s L. A. phone book lists hundreds), Ontario Ice Rink ranks as the number one coolest, especially as they keep their 1957 sign in such lovely shape. *Photo by Nigel Cox*

The Fun Zone. *Photo courtesy Charles Phoenix*

On the Move

"As I passed through the far-flung Southern suburbs of L.A. proper
around dawn on the 405, it was as familiar as the sigh of an old lover: the
same hazy sunshine, smog, billboards, blacktop, and boredom. Even the
Santa Monica Freeway Eastbound, with its view of West
L.A. as a green plateau and the Wilshire Boulevard
skyscrapers and the Santa Monica Mountains in the
distance, yielded nothing but a dull verisimilitude. But it was
good to be back."
- James Ellroy, Brown's Requiem

Mention Los Angeles; the word "car" isn't far behind. With more vehicles than people, the auto has become one of our defining symbols. LA: The drive-in, the drive-up, the drive-through, the drive-by shooting. Endless car dealerships and acres of wrecking yards. A million 4x4s that will never see action off-road other than accidentally backing over the curb. Five hundred square miles of roads. Ten million collective hours a year of Angelenos idling in traffic. Innumerable car clubs: low riders, hot rods, and hearses. Customizers cranking out Munster Koaches and Monkeemobiles. Anything to catch the eye. Los Angeles personal ad: "Chance Meeting. Traffic jam on 405 North. You, blonde, sunglasses, Honda Civic. Me, brown hair, goatee, Jeep Cherokee. We smiled, waved. Soul mates? Call box 733." The car alarm—an annoyance that's tolerated but never responded to. The symphony of a million car alarms after every earthquake. A city that once had the largest electric train system in the world, until it was illegally dismantled by General Motors, Firestone Tire and Standard Oil. A city that is building subways again, although with parking lots at each station, because one must naturally drive to the subway. Whole neighborhoods torn down or cut up by freeways. A new language, that sounds like mathematical gibberish to the uninitiated: "Since it's 3:30 on a Thursday, don't do the 10 to the 710 to the 5 to the 110, take the 105 to the 101 to the 60 to the 210." A vast decentralized horizontal city with its autos crawling across pavement like scurrying ants.

The car means freedom. The car means subservience. The two great tenets of our great city.

With the advent of the automobile came a new style of architecture: by the 1920s, designers had learned not to expend their energies on street front façades; details and showmanship were redirected to the parking lot. The nature of signage changed as well: the flashier the better, and no longer oriented to the lowly pedestrian, but to the motorist whizzing by—even from miles away, the electric sign was ready to bewitch us all.

The Wagon Wheel Inn. This Ventura landmark is part of the Wagon Wheel Complex, whose bowling alley is seen in Chapter Six, "Fun and Games." This magnificent coach and rider were recently relit, after standing dark for decades. *Photo by Nathan Marsak*

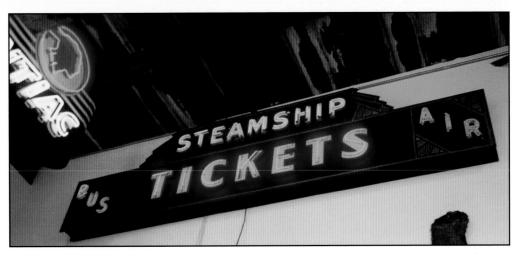

A Long-gone Long Beach Steamship Company. *Photo courtesy Scott Hopper, Track 16*

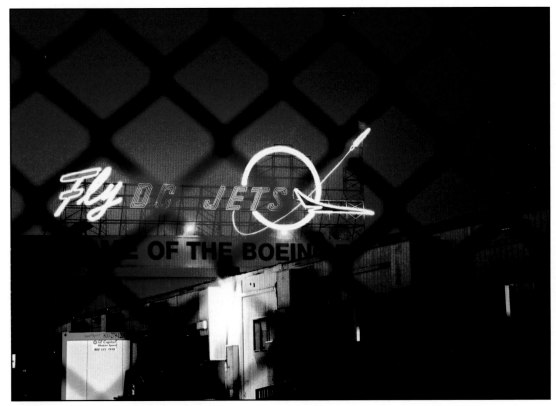

Fly DC Jets. The Douglas Aircraft plant down in Long Beach never went so far as to produce actual rocket-fired spacecraft for commercial travel; perhaps that's why they eventually folded and were bought-out by Boeing. *Photo by Nigel Cox*

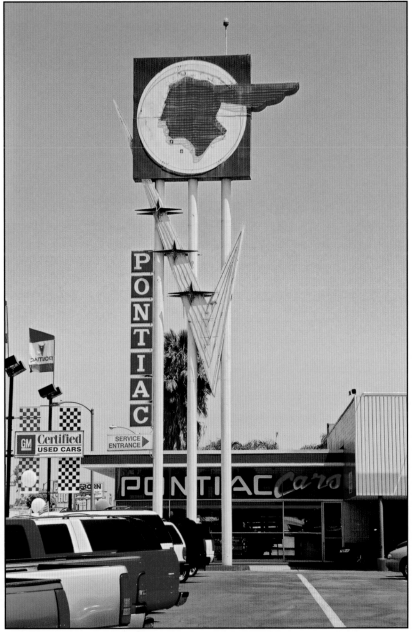

Scott Pontiac. The most massive Pontiac signage left in the world. When asked why it wasn't lit, the manager indicated that the effort wasn't necessary in that they were looking to shift operations elsewhere. An endangered species of American history? *Photo by Nathan Marsak*

5235 YORK BLVD.

Bathrick Pontiac, Inc.
"The Best Deal in Town"
HIGHLAND PARK (L. A. 42) CALIF.

5317 YORK BLVD.

Pontiacs of Highland Park, c. 1950. The historic Arroyo Seco Parkway—the United States' first freeway—shoots the traveler northeast from downtown L. A. to Pasadena. Along the way, off-ramps offer egress (at five miles an hour) to Garvanza, Montecito Heights, Highland Park, and other forgotten once well-to-do enclaves of gracious Craftsman living immersed in the now impenetrable gangland gloom. Bathrick Pontiac struggled through 1950s Highland Park, only to disappear with H.P.'s now-mythic prosperity. *Authors' collection*

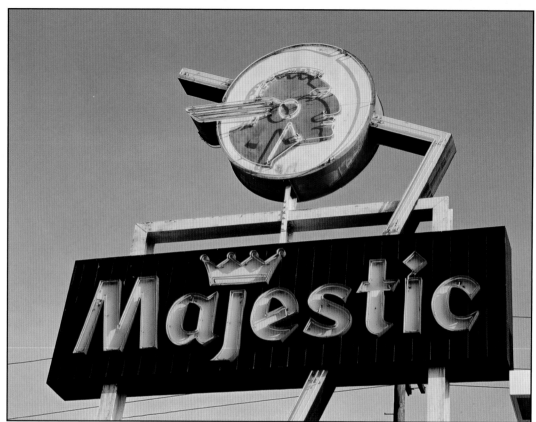

Majestic Pontiac. This Native American now faces a wrecking ball. The Majestic complex is abandoned, its fate uncertain. It should be noted that it is situated adjacent to the Crenshaw district's famed Holiday Bowl, a completely intact fifties bowling alley and coffee shop that awaits demolition itself. *Photo by Nathan Marsak*

In Los Angeles
PONTIACS TEMPEST
New & Used
Authorized
SALES - SERVICE - PARTS
High Trade in Values
COMPLETE AUTO SERVICE
Budget Terms
"Where the Customer is KING"

AX 3-7111

Majestic PONTIAC

3740 CRENSHAW BLVD.

The Majestic Signage from the 1960 Los Angeles Phonebook. *Authors' collection*

155

Restored Pontiac. Courtesy of the Museum of Neon Art, this taciturn face oversees the throngs that shuffle their way through Universal Citywalk. *Photo by Nigel Cox*

Another Pontiac at Track 16. *Photo by Nigel Cox*

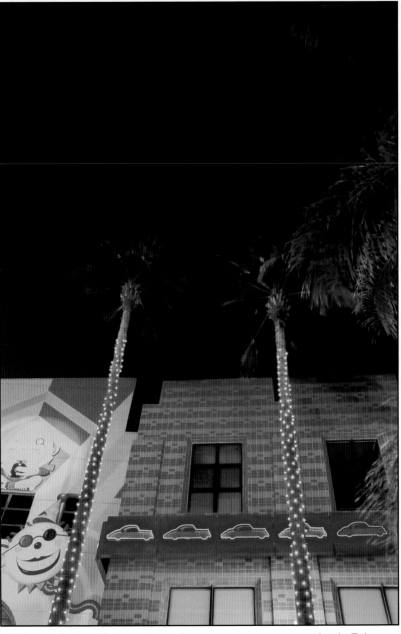

Whizzing Autos. These animated cars were once on a market in Echo Park, perhaps proclaiming the new "auto-friendly" type of grocery. The neon has all been replaced, and the sedans now zoom around a corner at Universal Citywalk, courtesy of the Museum of Neon Art. *Photo by Nigel Cox*

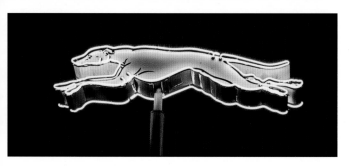

The Greyhound. The Hollywood bus station up and relocated in 2000, during which time neon nuts raised a collective eyebrow over the fate of the neon pooch. Greyhound had the sensitivity to transplant everyone's favorite speeding canine to the new location. *Photo by Nigel Cox*

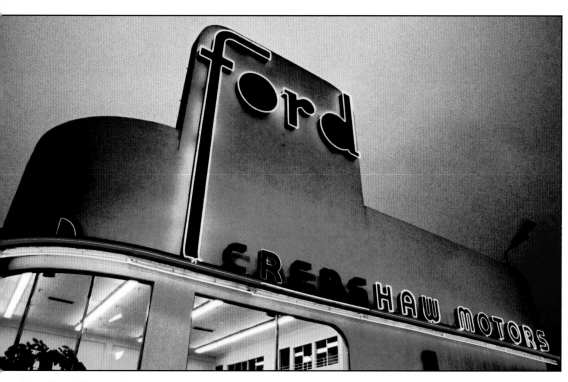

Crenshaw Motors. This auto dealer is the oldest surviving intact Ford dealership in America. *Photos by Nigel Cox*

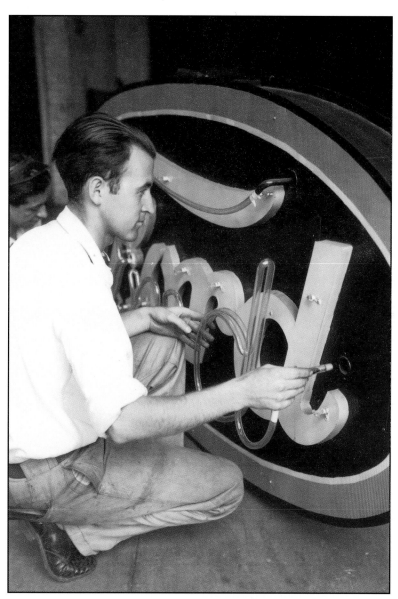

Constructing A Sign. An expert of the neon craft busy fitting tube housings for a South-Central Ford dealership, c. 1933. *Photo Collection /Los Angeles Public Library*

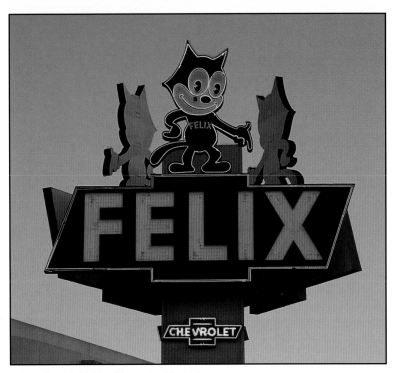

The Iconic Felix. *Photo by Nigel Cox*

Casa de Cadillac. Vintage Cadillac dealerships abound, but one must know where to look. Nine times out of ten, the building has been converted. The Valley's 1947 Casa de Cadillac endures, a superb Modern building with appropriately clean-lined neon accoutrement. *Photo by Larry Lytle/MONA*

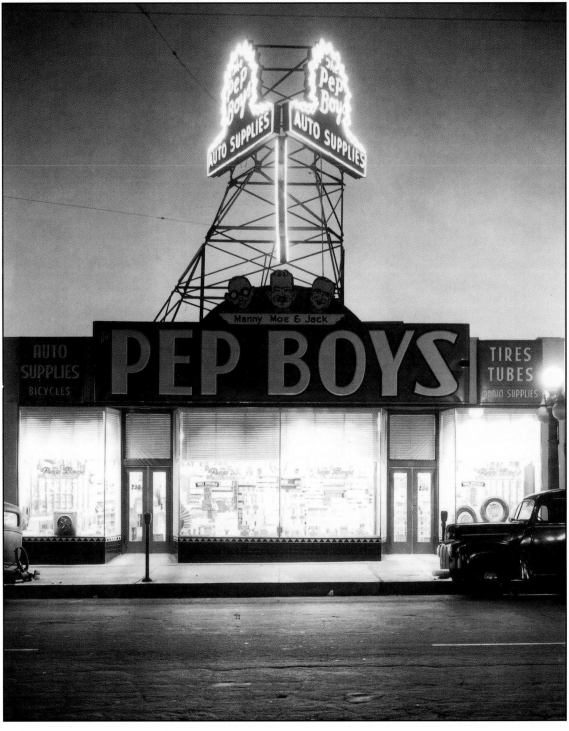

The Pep Boys. For all your automotive needs. *Courtesy Los Angeles Public Library Photo Collection*

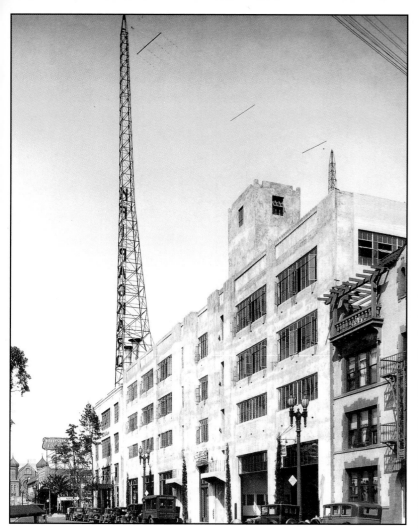

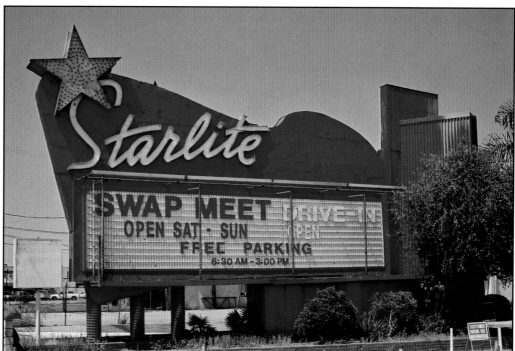

First Neon in America. This is the only known photo of the blue and orange Packard sign that Earl C. Anthony ordered from France in 1923. It is affixed above his doorway at Tenth and Hope Streets, in downtown Los Angeles. *Photo Collection /Los Angeles Public Library*

Valley Drive-In Theater. Packard may have had the first neon in the U.S., but Montclair boasted the largest. All 4000 square feet of this eight-story neon, designed and built by the Ontario Neon Company in 1948, was bulldozed in 1980. A forlorn used car lot now stands in its place. The mural featured perhaps the only neon Spanish Father that ever existed, as well as an animated neon stream. Old timers still speak of the fact that the outdoor screen towered over more people in the parking lot than actually lived in the Pomona Valley at the time. *Photo courtesy Ontario Public Library*

Pacific's Neon. Now in a private collection. *Photo courtesy Scott Hopper, Track 16*

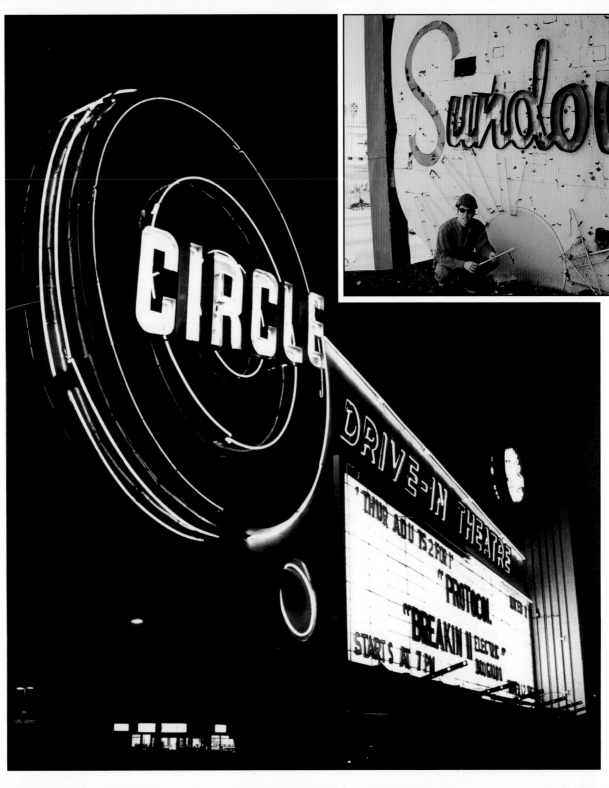

Sundown of The Sundown. Preservationist John English surveys the neon remains of a once-grand, drive-in edifice. *Photo courtesy Chris Nichols Collection*

The Circle Drive-In. Here were once projected the great drive-in movies of American cinema, including the Los Angeles premier of H. G. Lewis' seminal *Blood Feast,* on its release in 1963. In this photo, the redoubtable drive-in has been reduced to featuring the 1981 masterpiece of curious break-dancers Boogaloo Shrimp and Shaba-Doo. The Circle was bulldozed shortly thereafter. *Photo courtesy Herald Examiner Collection /Los Angeles Public Library*

The El Monte Drive-In. Although its neon was left to rot, nothing could dampen the spirits of this shockingly sexy dancing *señorita*…that is, until the puritanical city elders had her (and her adoring fan) plowed under. *Photo courtesy Chris Nichols Collection*

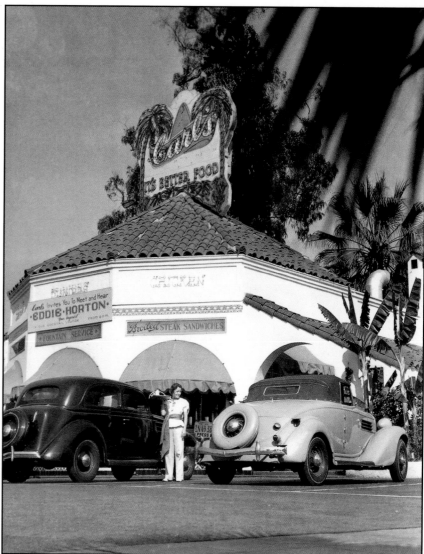

Carl's, 1936. The only thing that kept the public's eye off of the giant palm trees and hat were the gals in Mexican pants-suit carhop uniforms. *Photo Collection /Los Angeles Public Library*

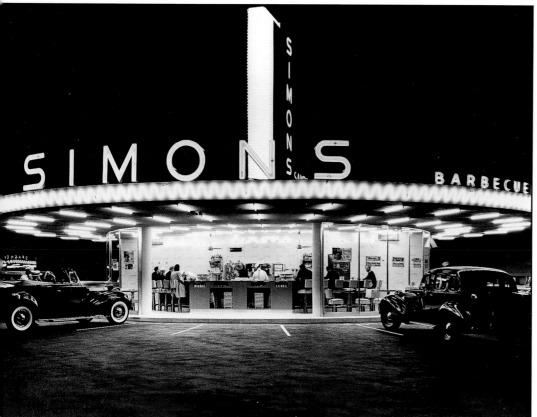

Simon's. In twenties Los Angeles, the dirt fields that pockmarked Santa Monica and Beverly Hills were dotted with octagonal buildings surmounted by modest, light-bulb-lit signs that read, "sandwiches." Model A's and the odd Overland Touring Six would pull under the rusty canopy for a spell. By the thirties, drive-ins like Simon's fed the motorized populace, with newer, slicker, more streamlined signage that spoke of a brave new world of consumption. *Courtesy of University of Southern California, on behalf of the USC Specialized Libraries and Archival Collections*

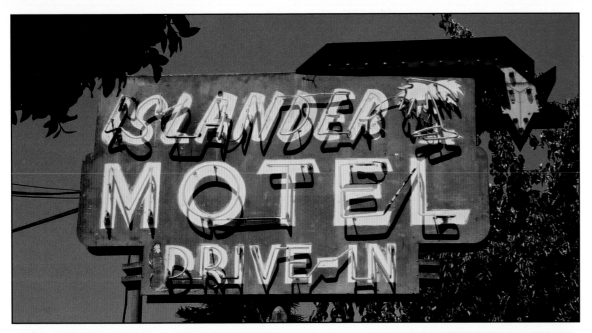

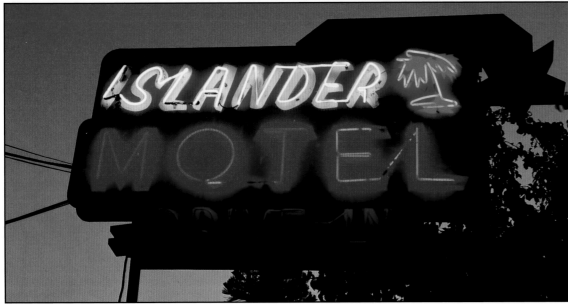

The Islander. An Eagle Rock motel for those in need of a South Seas getaway. *Photos by Nathan Marsak*

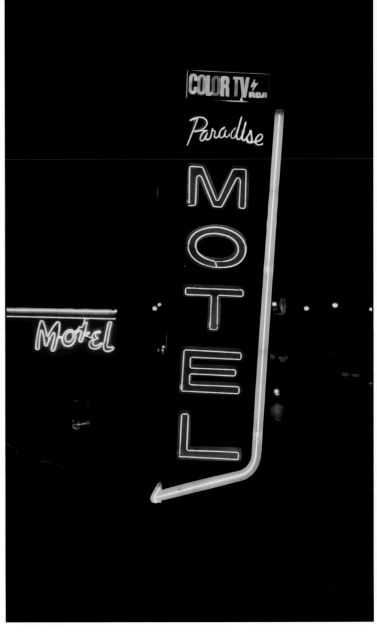

The Paradise Motel. A Sunset Boulevard study in purple. *Photo by Nigel Cox*

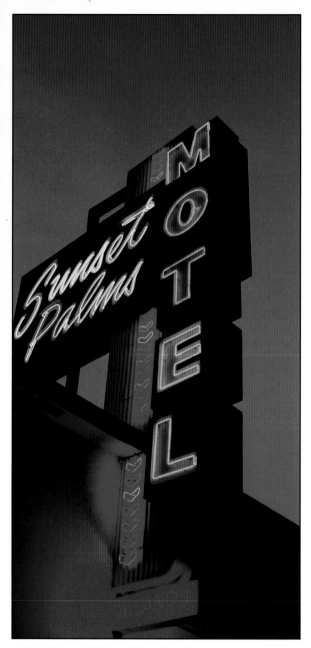

The Sunset Palms. *Photo by Nigel Cox*

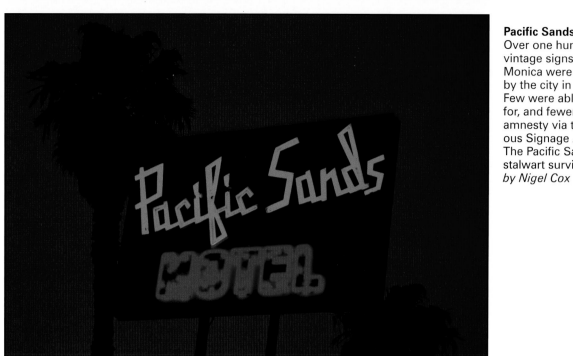

Pacific Sands Motel. Over one hundred vintage signs in Santa Monica were torn down by the city in the 1990s. Few were able to apply for, and fewer to win, amnesty via the Meritorious Signage Application. The Pacific Sands is one stalwart survivor. *Photo by Nigel Cox*

Steele's Motel. This perpetually somersaulting diver plunges into her pool at Universal Citywalk, courtesy of the Museum of Neon Art. *Photo by Nigel Cox*

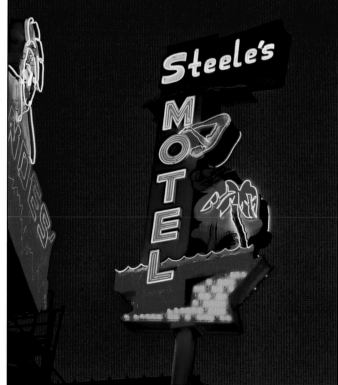

The Cleansing of Anaheim

Disneyland is famous—infamous to some—for tearing out its space-age attractions in favor of kinder, blander, more "up-to-date" amusements. In the mid-1990s, Disney wanted to give Anaheim a "face-lift," which entailed requiring businesses to replace "free-standing" neon signs with uniform "monument signs." Many historic signs were removed and destroyed—many more than could be included here.

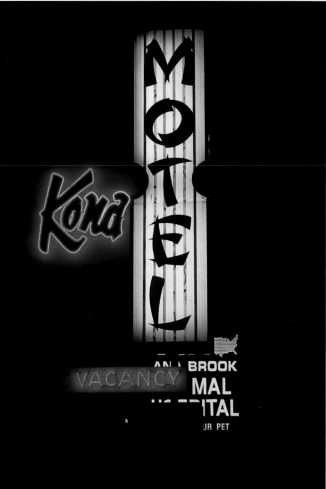

Kona Motel. *Courtesy Model Colony History Room / Anaheim Public Library*

Samoa Motel. *Courtesy Model Colony History Room /Anaheim Public Library*

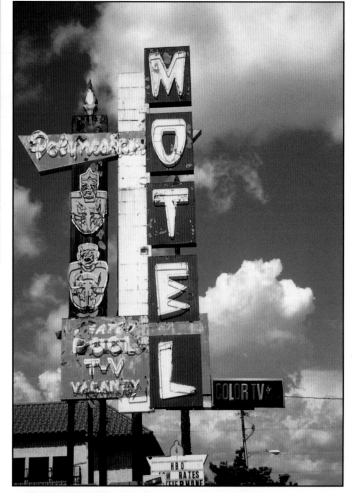

The Polynesian. *Courtesy Model Colony History Room / Anaheim Public Library*

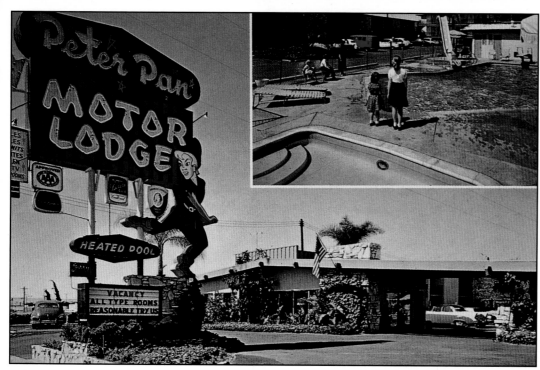

Peter Pan. *Courtesy Model Colony History Room /Anaheim Public Library*

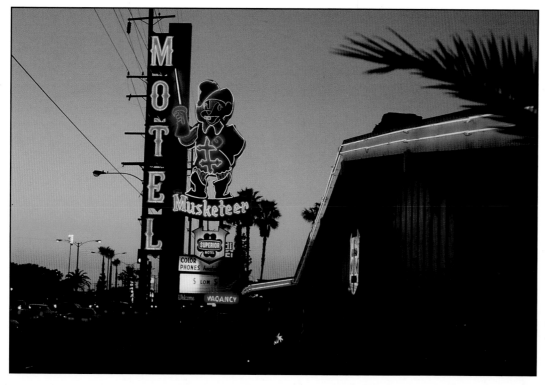

The Musketeer. *Photo by Robert Landau*

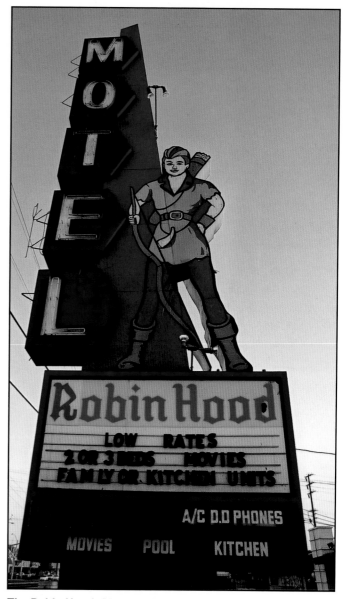

The Robin Hood. *Photo by Nigel Cox*

Half Moon. The moon neither waxes nor wanes at this Culver City haven of those who worship Luna. *Photo by Nigel Cox*

Silver Moon. The Anaheim Resort Plan couldn't reach far enough over to Beach Boulevard, so the Silver Moon and Robin Hood still stand. *Photo by Nigel Cox*

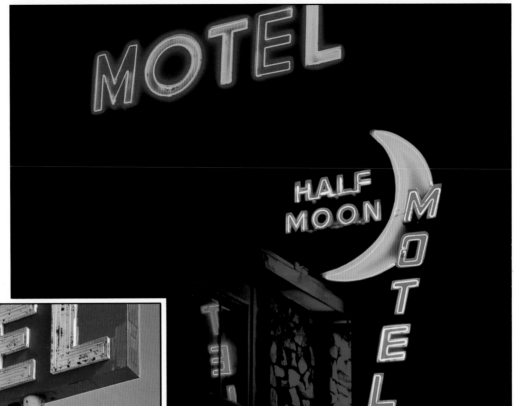

Below: **The Safari Inn.** Built in 1950, the Safari Inn added this wonder, designed by the Flasher Neon Display Corp, in 1958. The Inn is still the stop for those motorists wishing to sleep by the light of a giant spear and shield. Think of them as giant jungle-themed totems of protection! Robin Donovan, General Manager of the Safari Inn, commented, "Nothing had been done to the sign for 25 or 30 years. It was ready to go, but we kept it because it is such a cultural icon here in Burbank. We also knew if we took it down to fix it, we wouldn't be allowed to put it back up again. So we got a sign company who did a great job, they patched the metal work, put new transformers and replaced the neon that was out. The face-lift wasn't cheap. But then, it is famous." *Photo by Nigel Cox*

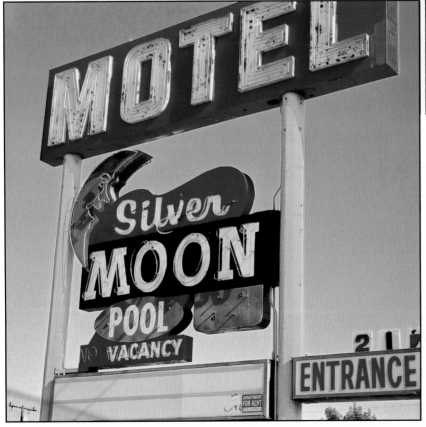

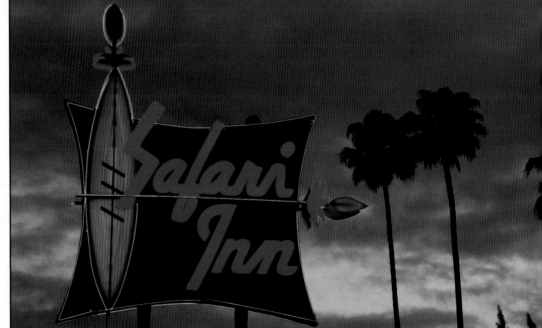

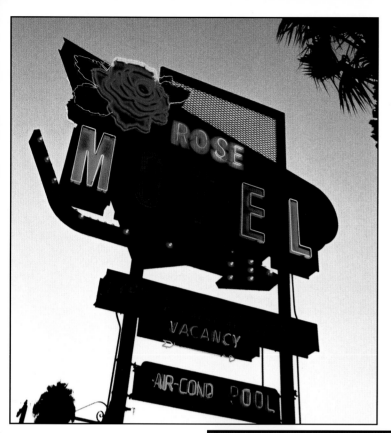

The Rose Motel. It appears that the owners of neon roses, and there are many in Los Angeles, have a predilection toward keeping them in fine order. *Photo by Nigel Cox*

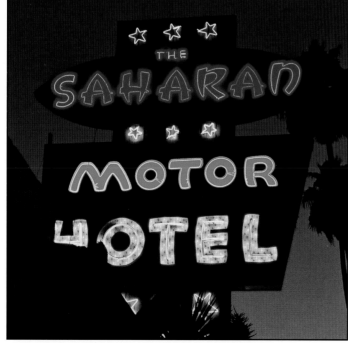

Saharan. The Saharan is a bit of exotica out on Sunset; not desert, but a flashing oasis in the night. *Photo by Nigel Cox*

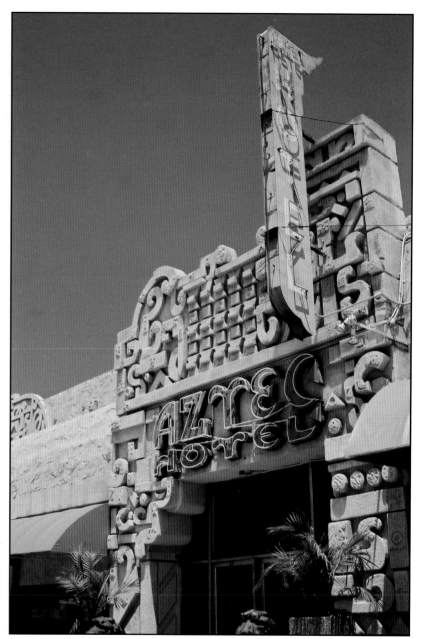

The Aztec. Robert Stacy-Judd's interpretation of pre-Columbian ornament erupts from every inch of this 1927 Route 66 landmark. *Photo by Nathan Marsak*

167

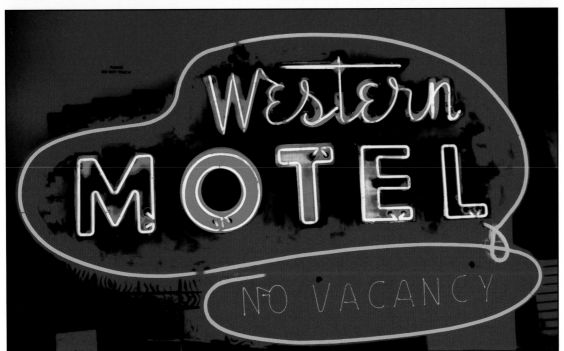

The Western Motel at MONA. *Photo by Nigel Cox*

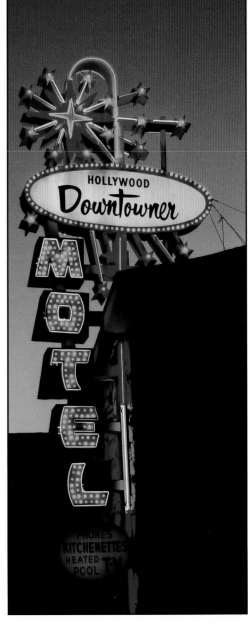

The Downtowner. The Hollywood Downtowner is the most shocking of the Hollywood Motels. The owners have thankfully seen fit to delight patron and passerby alike with a reverential upkeep of this sign's mind-warping genius. *Photo by Nigel Cox*

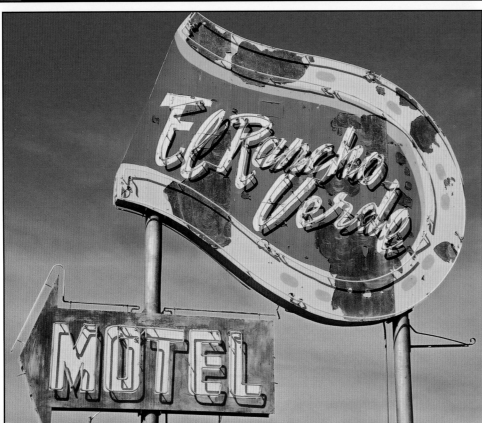

El Rancho Verde. Los Angeles is surrounded by desert, it being at one time a desert itself. Therefore, any motor trip east into the barren plains gives one a feeling of what pre-water Southern California must have been. The same tumbleweeds seen outside of this abandoned motel (nothing "*verde*" in sight) probably rolled out here from Hollywood Boulevard decades ago. *Photo by Nigel Cox*

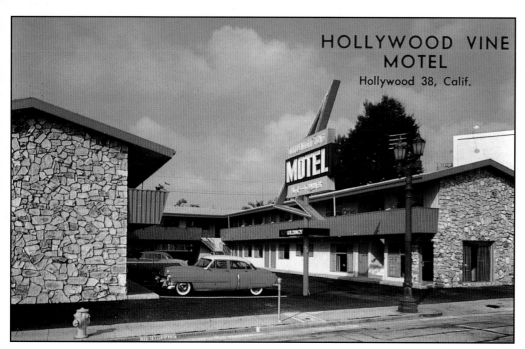

HOLLYWOOD VINE
MOTEL
Hollywood 38, Calif.

Hollywood Vine Motel. Success is a blessing. Success is a curse. The Hollywood Vine Motel was built in 1955, just south of what had been the legendary U.S. Hwy 66. The construction of the Hollywood Freeway a few hundred yards to the north gave birth to innumerable motels; travelers aplenty patronized this roadside inn to such an extent that by the 1970s the owners decided that they had made enough money to redo the complex. Gone are the rock walls and neon; of course, and after the 1970s, gone were the Hollywood tourists, too. In these times of retro-regeneration, it is sad to see the Hollywood Vine descend into reworked obscurity. *Authors' collection*

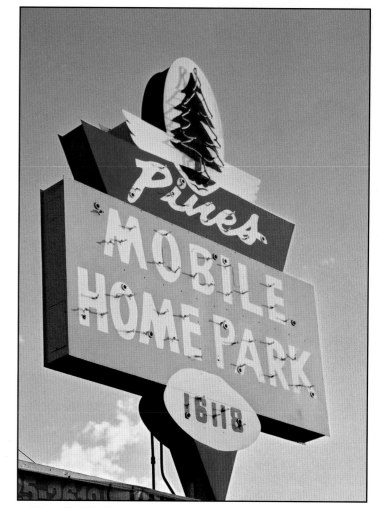

Pines Mobile Home Park. There are no pine trees for miles in any direction, but this mobile home park more than makes up for their lack in neon. *Photo by Nathan Marsak*

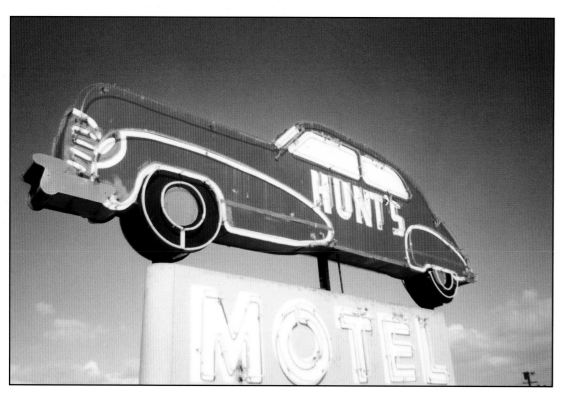

Hunt's Motel. The neon from this red 1940s sedan blazed over the town of Compton, California, until it was nabbed and put in a private collection. *Photo courtesy Scott Hopper, Track 16*

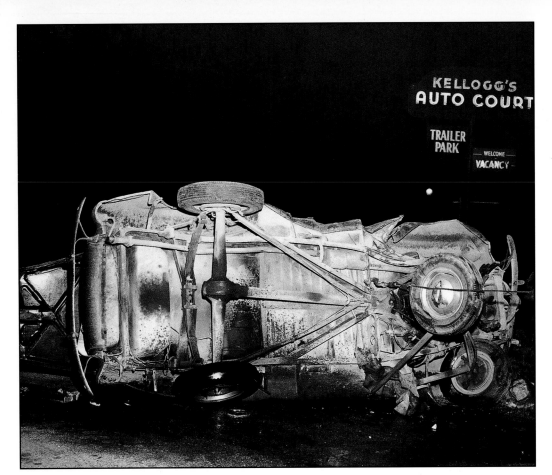

Kellogg Motor Court. The driver of this car walked away unscathed; even the neon survived unharmed. *Authors' collection*

Biltmore Motor Inn. This North Hollywood paean to streamline modern still stands, although she's lost her signage. *Authors' collection*

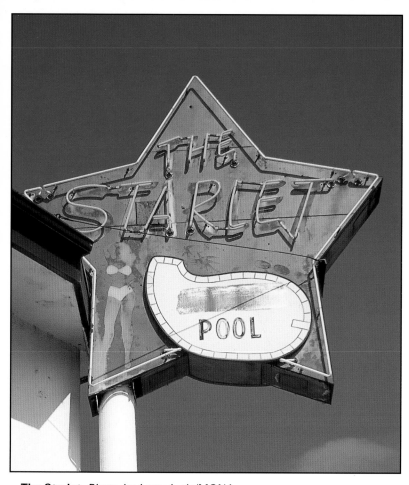

The Starlet. *Photo by Larry Lytle*/MONA

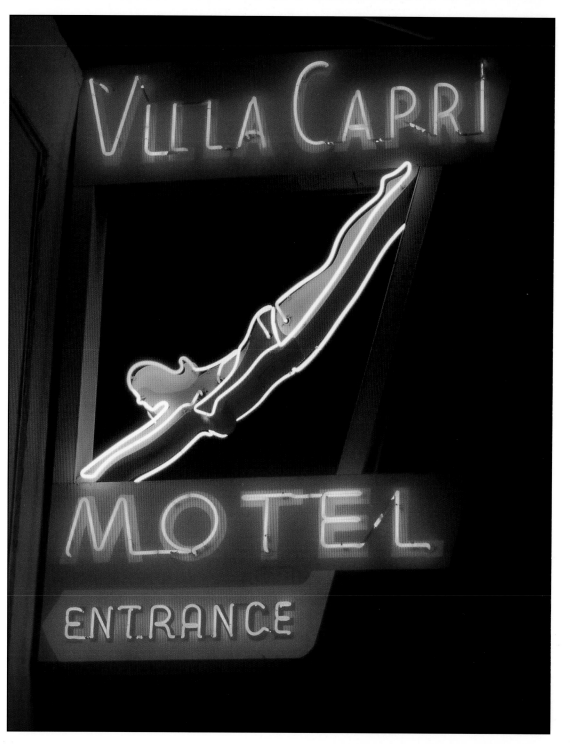

Villa Capri. *Photo by Robert Landau*

Banham, Reyner. *Los Angeles: The Architecture of Four Ecologies*. New York: Harper & Row, 1974.

Caughey, John and LaRee, eds. *Los Angeles: Biography of a City*. Los Angeles: University of California Press, 1977.

Chase, John. *Glitter, Stucco and Dumpster Diving*. New York: Verso Press, 2000.

Davidson, Len. *Vintage Neon*. Atglen, Pennsylvania: Schiffer Publishing Ltd., 1999.

Federal Writers' Project of the WPA for the State of California. *California, A Guide to the Golden State*. New York: Hastings House Publishers, 1939.

Gebhard, David; Winter, Robert. *A Guide to Architecture in Los Angeles and Southern California*. Santa Barbara: Peregrine Smith, 1977.

Gebhard, David. *LA in the Thirties, 1931-1941.* New York: Peregrine Smith, 1977.

Gebhard, David. *The National Trust Guide to Art Deco in America.* New York: John Wiley and Sons, 1996.

Heimann, Jim. *California Crazy & Beyond*. San Francisco: Chronicle Books, 2001.

Heimann, Jim. *Out with the Stars*. New York: Abbeville Press, 1985.

Julian, Robert; McGrew, Patrick. *Landmarks of Los Angeles.* New York: Harry N. Abrams, 1994.

Kaplan, Sam Hall. *LA Follies.* Los Angeles: Cityscape Press, 1989.

Kaplan, Sam Hall. *LA Lost and Found*. New York: Crown Trade Paperworks, 1987.

Kirsten, Sven A. *The Book of Tiki*. Cologne, Germany: Taschen, 2000.

Margolies, John; Gwathney, Emily. *Signs of Our Time*. New York: Abbeville Press, 1993.

McWilliams, Carey. *Southern California: An Island on the Land*. Salt Lake City: Peregrine Smith, 1988.

Moore, Charles; Becker, Peter; Campbell, Regula. *The City Observed: Los Angeles*. New York: Random House, 1984.

Parker, Robert Miles. *L.A.*. New York: Harcourt Brace Jovanovich, 1984.

Phoenix, Jim Charles. *Cruising the Pomona Valley*. Los Angeles: Horn of Plenty Press, 1999.

Pitt, Dale; Pitt, Leonard. *Los Angeles A to Z*. Los Angeles: University of California Press, 1997.

Stern, Rudi. *The New Let There be Neon*. Cincinnati, Ohio: ST Publications, 1996.

Tucker, Kerry. *Greetings from Los Angeles*. Los Angeles: Steam Press, 1982.

Valentine, Maggie. *The Show Starts on the Sidewalk*. New Haven: Yale University Press, 1994.

Wallace, David. *Lost Hollywood*. New York: St. Martin's Press, 2001.

The Museum of Neon Art is an organization committed to displaying the work of neon artists past and present, as well as being dedicated to the collection and restoration of vintage signs. The Museum also conducts narrated, open-air, nighttime "neon cruises" aboard a double-decker bus.

Museum of Neon Art
501 W. Olympic Blvd.
Los Angeles, CA 90015
(213) 489-9918
http://www.neonmona.org

Those interested in preserving LA's rich architectural heritage should contact the Los Angeles Conservancy:

Los Angeles Conservancy
523 W. Sixth St. Suite 1216
Los Angeles, CA 90014
(213) 623-2489
http://www.laconservancy.org

The Modern Committee, an offshoot of the Conservancy, has been instrumental in saving many historic modern structures. They have also helped rescue and restore a great deal of historic signage, and are busy at work on a comprehensive Signage Survey of Los Angeles.
http://www.modcom.org

These websites also provide links to many other important sites concerning architecture and preservation, such as the Art Deco Society of Los Angeles, the Southern California Society of Architectural Historians, the City of Los Angeles Cultural Heritage Commission, plus sites on Disneyland, modern architects, googie buildings, and countless other resources.

I smelled Los Angeles before I got to it. It smelled stale and old like a living room that had been closed too long. But the colored lights fooled you. The lights were wonderful. There ought to be a monument to the man who invented neon lights.
—*Raymond Chandler,* The Little Sister

Photo by Nigel Cox